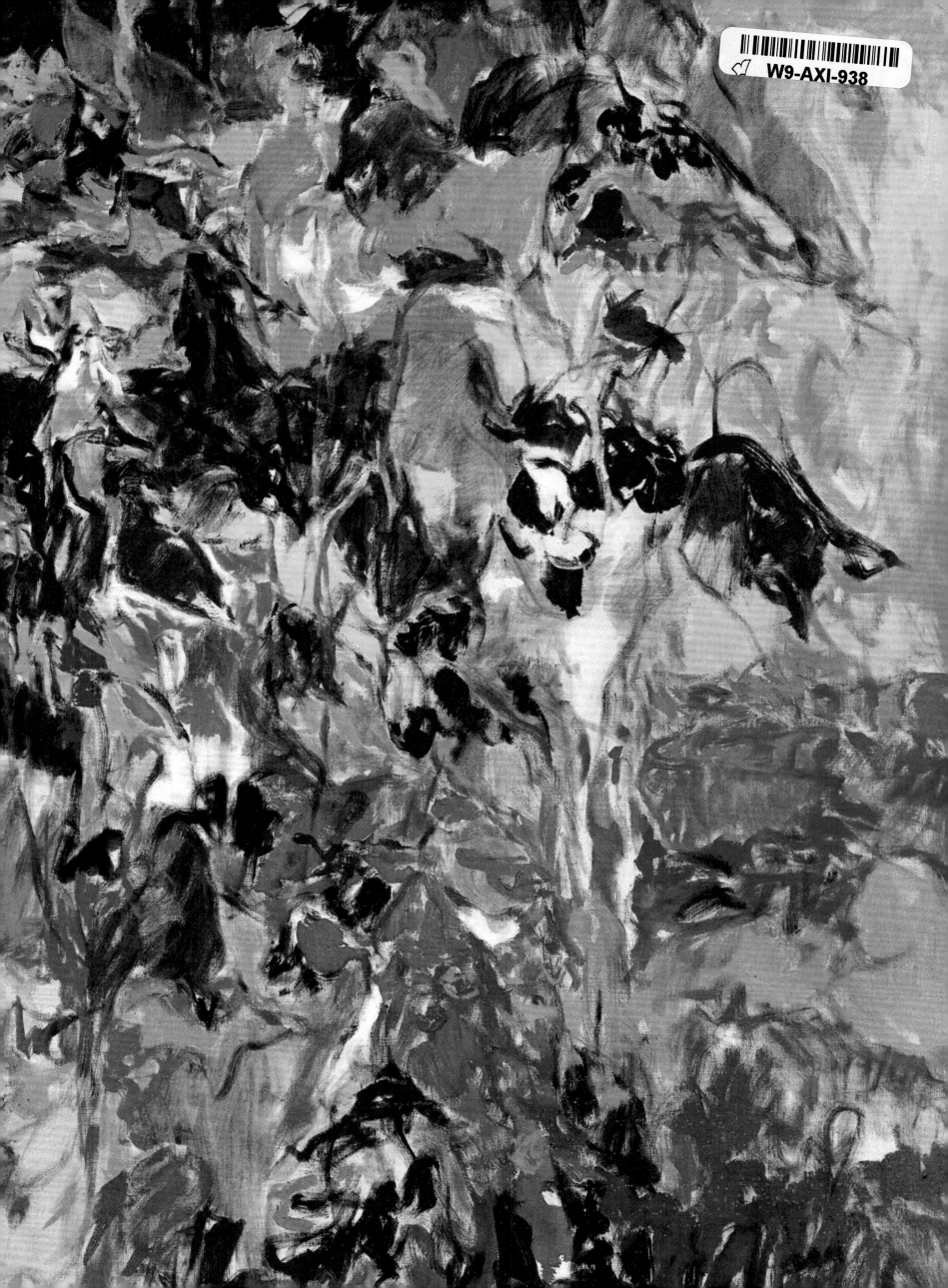

IN THE SAME ORIGINAL FORMAT, GENERAL EDITOR AND DESIGNER DAVID BROWER:

This Is the American Earth, by Ansel Adams and Nancy Newhall

Words of the Earth, by Cedric Wright

These We Inherit: The Parklands of America, by Ansel Adams

"In Wildness Is the Preservation of the World," by Eliot Porter

The Place No One Knew: Glen Canyon on the Colorado, by Eliot Porter

The Last Redwoods: Photographs and Story of a Vanishing Scenic Resource, by
 Philip Hyde and Francois Leydet

Ansel Adams: A Biography. Volume I: The Eloquent Light, by Nancy Newhall

Time and the River Flowing: Grand Canyon, by Francois Leydet

Gentle Wilderness: The Sierra Nevada, text from John Muir,
 photographs by Richard Kauffman

Not Man Apart: Photographs of the Big Sur Coast,
 with lines from Robinson Jeffers

The Wild Cascades: Forgotten Parkland, by Harvey Manning,
 with lines from Theodore Roethke

Everest: The West Ridge, by Thomas F. Hornbein, with
 photographs from the American Mount Everest Expedition

Summer Island: Penobscot Country, by Eliot Porter

Navajo Wildlands: As Long as the Rivers Shall Run, photographs by
 Philip Hyde, text by Stephen Jett, edited by Kenneth Brower

Kauai and the Park Country of Hawaii, by Robert Wenkam
 edited by Kenneth Brower

Glacier Bay: The Land and the Silence, by Dave Bohn

Baja California and the Geography of Hope, photographs by Eliot Porter,
 text by Joseph Wood Krutch, edited by Kenneth Brower

Central Park Country: A Tune Within Us, photographs by Nancy and Retta
 Johnston, text by Mireille Johnston, introduction by Marianne Moore

Galapagos: The Flower of Wildness (both volumes edited by Kenneth Brower)

1. *Discovery*, photographs by Eliot Porter, introduction by Loren Eiseley,
 with selections from Charles Darwin, Herman Melville, and others; and

2. *Prospect*, photographs by Eliot Porter, introduction by John P. Milton,
 text by Eliot Porter and Kenneth Brower

THE EARTH'S WILD PLACES

Maui: The Last Hawaiian Place, by Robert Wenkam,
 edited, with Kipahulu Sketches, by Kenneth Brower

Return to the Alps, by Max Knight and Gerhard Klammet,
 edited, with selections from Alpine literature, by David R. Brower

The Primal Alliance, Earth and Ocean, by John Hay and Richard Kauffman,
 edited by Kenneth Brower

Earth and the Great Weather: The Brooks Range, by Kenneth Brower

Eryri, the Mountains of Longing, by Amory Lovins,
 with photographs by Philip Evans, edited by David R. Brower

A Sense of Place: The Artist and the American Land, by Alan Gussow,
 with illustrations by fifty-nine painters, and foreword by Richard Wilbur

Micronesia: Island Wilderness, by Kenneth Brower and Robert Wenkam

Guale, the Golden Coast of Georgia, James P. Valentine, Robert Hanie,
 Eugene Odom, John P. Milton *et al.*, edited by Kenneth Brower

(*endpaper*) ALAN GUSSOW: LOOSESTRIFE AND WINEBERRIES, 1965
 Courtesy Peridot Gallery, New York

The tiniest grain of sand upon the shore,
the humblest flower in the field and the single dewdrop
are just as wonderful as the highest cliff,
the mightiest tree or the fiercest storm.
Back of them all is the irresistible urge of the Universal Impulse.
Yesterday there was a storm. The clouds gathered,
the wind raged and hurled everything before it,
but I could not think of the storm apart from myself.
It spoke to me only of the immensity and vastness
of the whole of which I am a part . . .
　　　　　　　　—Van Dearing Perrine (1869-1955)

A SENSE OF PLACE

THE ARTIST AND THE AMERICAN LAND

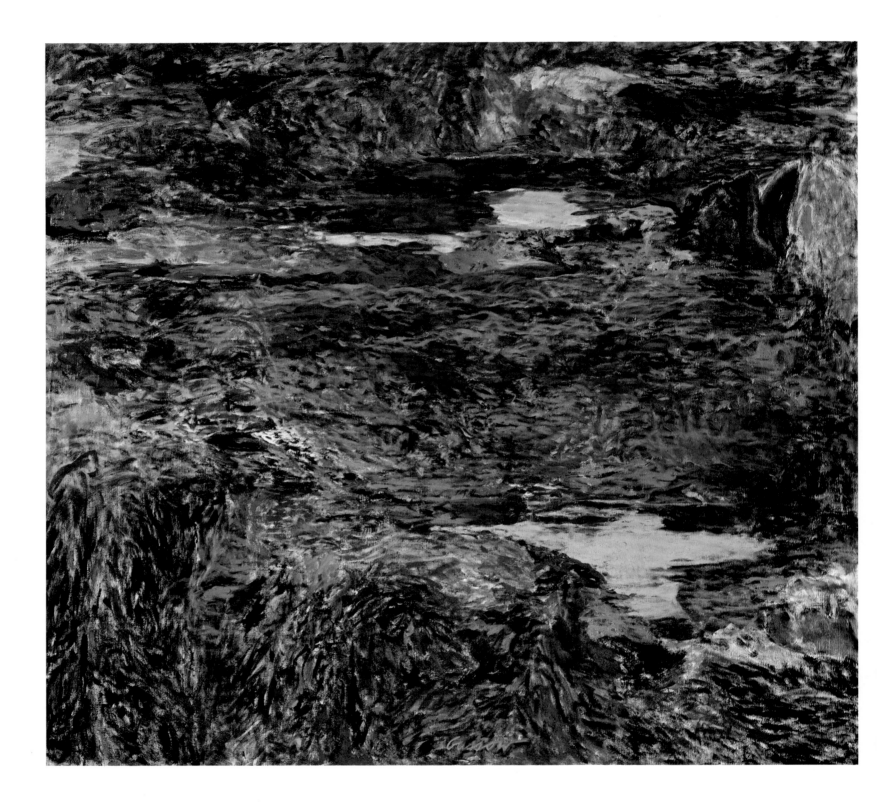

PROLOGUE

*R*ock Weed at Neap Tide was prompted by my idle foraging among the tide pools on Monhegan, a rock-bound Maine island that rides on the ocean like a hulking, hump-backed whale. When I first tried painting the tide pools, I seemed to include too much, showing not only the pools but also where the pools were, adding a horizon line and a view of the distant ocean. Finally, it occurred to me that I really wanted to paint the pools themselves and nothing else. The ocean is nevertheless in the picture, everywhere moistening the weed, showing itself in small surfaces; and the sky, too, but only as revealed in reflections.

Islands, by definition, are places unto themselves, but Monhegan is also a place within me—finite, singular, and entire. My relationship with it began slowly when I first vacationed there in 1949. I was attracted to the picturesque—lobster pots, fishermen's houses smelling of herring bait in big brine-filled barrels, and activities of the harbor. Then my interest moved toward more elemental things—the rock-strewn, prehistoric landscape of the far side, where each headland meets the ocean in its own way, and the changing ocean and the separate skies.

Now the place the tides own fascinates me. There is a sense of danger in venturing down into this slippery world—a place filled with slurping, sucking sounds. Tide-pool watchers have their favorite time, and mine is always on the ebb side of low tide. I move past the dry boulders on shore, edging across the rockweed, down beyond the brown and black weed into the region of the felty, green, spongy weed, past occasional irish moss, feeling my way like a primitive man lured back to the source of life. June's very low tides let you descend further and deeper, to crevasses filled with snails and whelks, surfaces of barnacles and mussels and, at the final edge, strands of glistening brown kelp and glimpses of sea urchins and limpets. You get the feeling of being below the level of the ocean itself.

There is also a sensual dimension, enhanced by the seaweed's falling from the rocks like the long, flowing hair of a seductive goddess, protecting, you find on parting it, whole miniature worlds of brittle starfish and sea anemones. And always there is the ocean preparing to return, always the knowledge that your time is short and you should see things faster, yet always an assurance: you know the way of tides because their rhythm is within you.

ALAN GUSSOW: ROCK WEED AT NEAP TIDE, 1970
Courtesy Peridot Gallery, New York, o/c, 52 x 58.

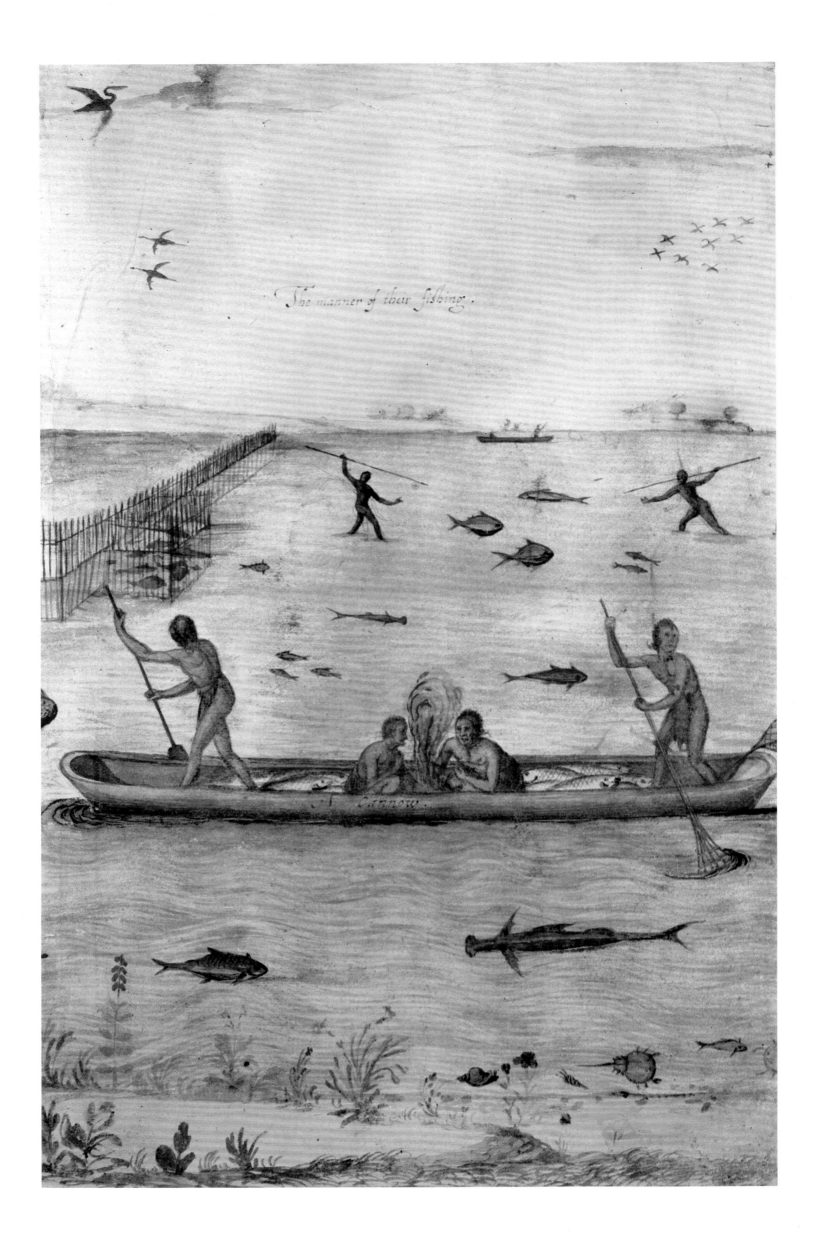

The manner of their fishing.

Cannow

John White (active 1585-1593)

In 1585 Englishman Richard Hakluyt, the Elder, wrote advising all sea captains that "a skillful painter is also to be carried with you . . . to bring back descriptions of all the beasts, birds, fishes, trees, townes, etc." John White arrived off the Carolina Banks in April 1585 as part of a colony organized by Sir Walter Raleigh; he became the first artist to make drawings of the Indians and of the flora and fauna of the country. Of White's watercolors, only seventy-five survive. They are believed to be the first authentic non-native pictorial records of life in the New World. After returning to England, he set out again for Virginia in May 1587, arriving this time as Governor and having responsibilities that apparently prevented his ever again having so artistically productive a time as he did in 1585-1586. Thomas Hariot, an outstanding mathematician and the scientist of the early expedition, described his observations in a book, A Brief and True Report of the New-Found Land of Virginia *(1588), which complements White's watercolors and which is excerpted below. Into a natural and harmonious wilderness came the white men, first merely as observers, soon thereafter as colonizers. White's remarkable watercolor "Indians Fishing," perhaps the first landscape painting of this unknown world, describes that fleeting moment of change, a time when the new man's presence had not yet put a mark upon the land.*

THEY HAVE a remarkable way of fishing in their rivers. As they have neither steel nor iron, they fasten the sharp, hollow tail of a certain fish (something like a sea crab), to reeds or to an end of a long rod, and with this point they spear fish both by day and by night. Sometimes they also use the prickles and pricks of other fish. And they make traps with reeds or sticks set in the water and narrowing at the ends . . . They have different kinds of fish, many of them never found in our waters, and all of an excellent taste.

It is a pleasing picture to see these people wading and sailing in their shallow rivers. They are untroubled by the desire to pile up riches for their children, and live in perfect contentment with their present state, in friendship with each other, sharing all those things with which God has so bountifully provided them.

Albert Bierstadt (1830-1902)

Capable of organizing hundreds of extras, juggling overpowering mountains and arranging for the sun to shine in just the right location, Albert Bierstadt brought to nineteenth-century landscape painting every skill that Cecil B. DeMille was to employ in twentieth-century movie-making. Bierstadt was born near Dusseldorf, reared in New Bedford, Massachusetts, then schooled in art in Dusseldorf. He took on every landscape challenge with enormous bravado and consummate facility. Judged by popular taste of the time, he was equal to every natural wonder. In a letter dated, Rocky Mountains, July 10, 1859, he described the scene later recreated in an epic painting.

If you can form any idea of the scenery of the Rocky Mountains and of our life in this region, from what I have to write, I shall be very glad; there is indeed enough to write about—a writing lover of nature and Art could not wish for a better subject. I am delighted with the scenery. The mountains are very fine; as seen from the plains they resemble very much the Bernese Alps, one of the finest ranges of mountains in Europe, if not the world. They are of a granite formation, the same as the Swiss mountains and their jagged summits, covered with snow and mingling with the clouds, present a scene which every lover of landscape would

JOHN WHITE: INDIANS FISHING, c. 1585
Collection, British Museum, London, watercolor, 13⅞ x 9¼.

ALBERT BIERSTADT: THE ROCKY MOUNTAINS, 1863
Collection, The Metropolitan Museum of Art, New York, Rogers Fund, 1907, o/c, 73¼ x 120¾.

[7

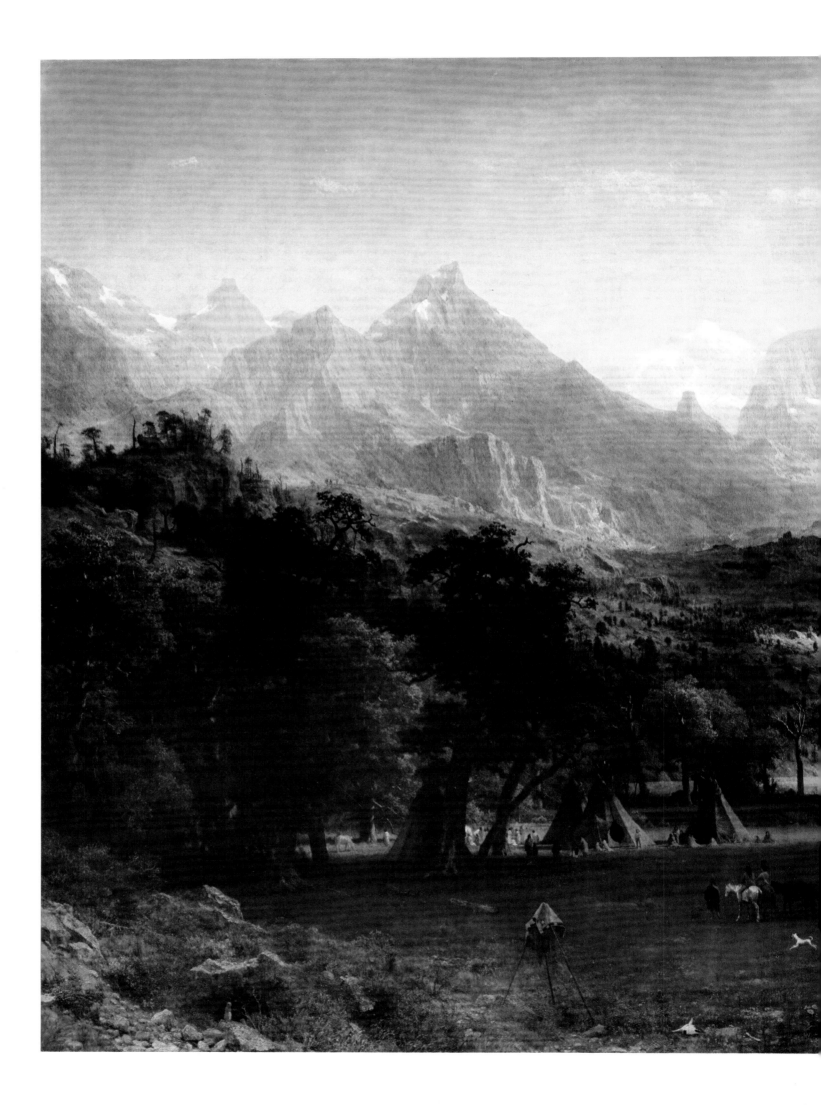

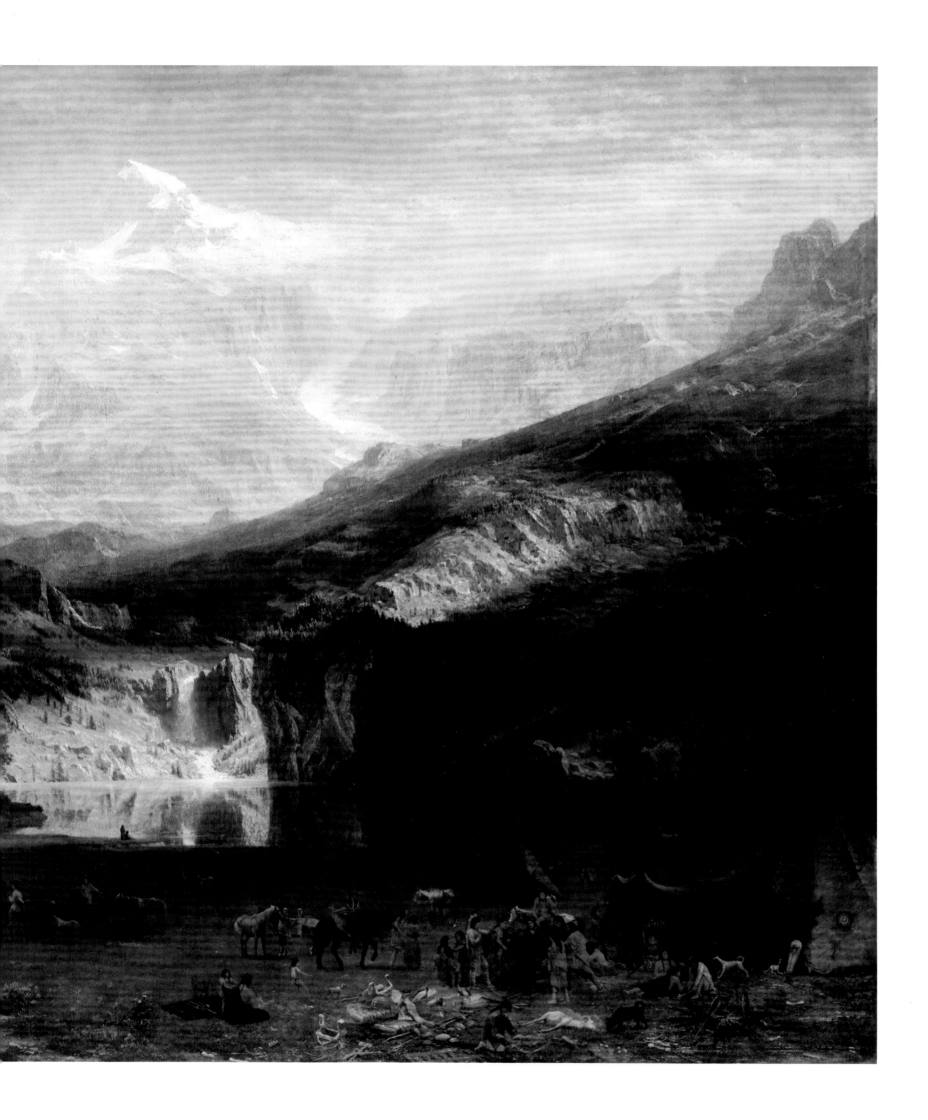

gaze upon with unqualified delight. As you approach them, the lower hills present themselves more or less clothed with a great variety of trees, among which may be found the cotton-wood, lining the river banks, the aspen, the several species of the fir and the pine, some of them being very beautiful. And such a charming grouping of rocks, so fine in color—more so than any I ever saw. Artists would be delighted with them—were it not for the tormenting swarms of mosquitos. In the valleys, silvery streams abound, with mossy rocks and an abundance of that finny tribe that we all delight so much to catch, the trout. We see many spots in the scenery that remind us of our New Hampshire and Catskill hills, but when we look up and measure the mighty perpendicular cliffs that rise hundreds of feet aloft, all capped with snow, we then realize that we are among a different class of mountains; and especially when we see the antelope stop to look at us, and still more the Indian, his pursuer, who often stands dismayed to see a white man sketching alone in the midst of his hunting grounds. We often meet Indians, and they have always been kindly disposed to us and we to them; but it is a little *risky*, because being very superstitious and naturally distrustful, their friendship may turn to hate any moment. We do not venture a great distance from the camp alone, although tempted to do so by distant objects, which, of course, appear more charming than those near by; also by the figures of the Indians so enticing, traveling about with their long poles trailing along on the ground, and their picturesque dress, that renders them such appropriate adjuncts to the scenery. For a figure painter, there is an abundance of fine subjects. The manners and customs of the Indians are still as they were hundreds of years ago, and now is the time to paint them, for they are rapidly passing away; and soon will be known only in history. I think that the artist ought to tell his portion of their history as well as the writer; a combination of both will assuredly render it more complete. . . .

I have told you a little of the Wind River chain of mountains, as it is called. Some seventy miles west from them, across a rolling prairie covered with wild sage, the soap-plant (?) and different kinds of shrubs, we came to the Wahsatch, a range resembling the White Mountains. At a distance, you imagine you see cleared land and the assurances of civilizations, but you soon find that nature has done all the clearing. The streams are lined with willows, and across them at short intervals they are intersected by the beaver dams; we have not yet, however, seen any of their constructors. The mountains here are much higher than those at home, snow remaining on portions of them the whole season. The color of the mountains and of the plains, and, indeed, that of the entire country, reminds one of the color of Italy; in fact, we have here the Italy of America in a primitive condition.

Sidney Goodman (1936-)

Sidney Goodman was born in Philadelphia, won a Guggenheim Fellowship, and enjoyed a rapid rise in public acclaim. His striking paintings of nudes, either sitting on handy tables or striding about suburban swimming pools, are marked by a cool, detached air which ultimately intensifies the eroticism. The same qualities, plus or minus the eroticism, invade his paintings of the land, usually industrial and characteristically seen with utmost clarity. His letter starkly states the case for our curious, personal ambivalance about what is happening to the environment and to us:

"LANDSCAPE with Four Towers" was not any specific locale. It is a composite growing out of observation of landscape approaching New York City on the N.J. Turnpike.

There are certain features, structures, weather, light, visual phenomena, that have always affected my senses. Perhaps I would have to sense some aspect of an occurence that triggers a reaction in me so as to justify translating the experience into a visual form.

I have been interested in the way man-made structures too often violate a place or the landscape. I both recoil at this intrusion, and find myself drawn to it . . . in much the same way that one witnesses a horrible or indecent act. There is a sense of astonishment and incomprehension towards what I'm seeing. Are we mute participants, transfixed by changes that may alter us irrevocably?

SIDNEY GOODMAN: LANDSCAPE WITH FOUR TOWERS, 1970
Courtesy Terry Dintenfass Gallery, New York, o/c, 54½ x 66½.

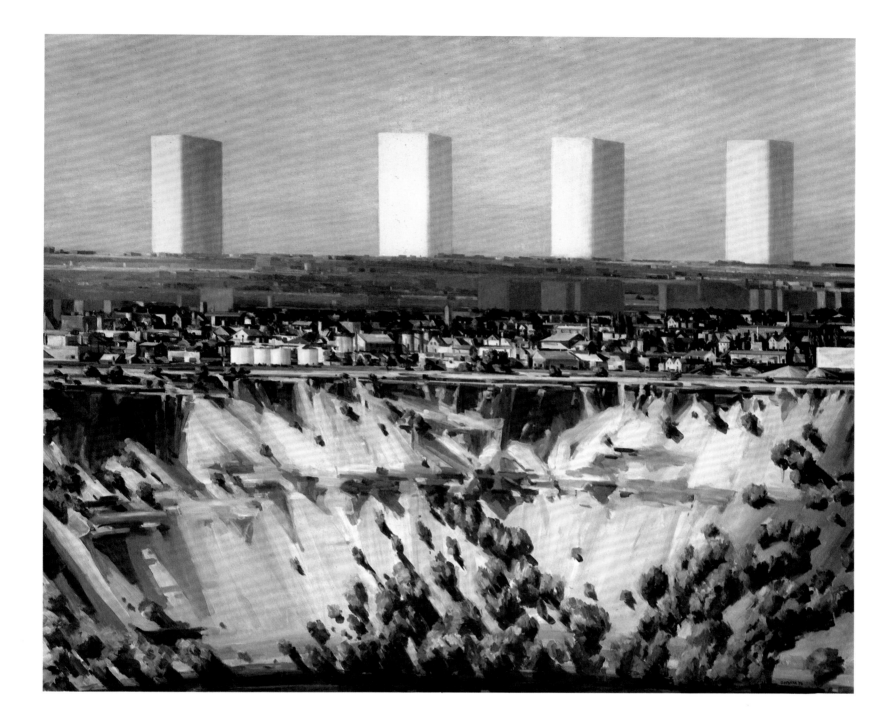

Milton Avery (1893-1965)

Milton Avery has been labeled the "Matisse of puritanism" and an art critic has referred to his work as "a miracle of untroubled clarity and lyric grace." What is undeniable about Milton Avery is that his paintings possess a sure sense of form, the illusion of having been instantly abstracted from observation, a quality of appearing totally improvised and totally enduring at the same time. Avery's landscape is comprised of delicious colors set in growing forms, a landscape derived from the natural world but determined by one man's unerring visual intelligence. Avery was a precursor of American color-field painting and one of the first of the cool artists. He never severed the bonds that connected him to New England mountains or the sunny beaches of Cape Cod. His wife, Sally, an artist in her own right, reflected in an interview not long ago on her husband's relationship to nature:

MILTON was always ready. He was a believer in working all the time: don't wait for inspiration. Though Milton was very in tune with nature, there was nothing sentimental about it. He felt an instant in nature very deeply and he tried to catch that instant. Each painting was an experience. He didn't feel any compulsion to make the sky blue because it was blue. It was the painting that came first. The subject was not the object of the painting. The object of the painting was a series of relationships of form and color in which nature was the binding force. Milton's interest was in order, like the high order in nature in which everything worked.

MILTON AVERY: Sea Grasses and Blue Sea, 1958
Collection, The Museum of Modern Art, New York, gift of friends of the artist, o/c, 60⅛ x 72⅜.

Foreword

GO OUT TO WALK with a painter, and you shall see for the first time groups, colors, clouds, and keepings, and shall have the pleasure of discovering resources in a hitherto barren ground, of finding as good as a new sense in such skill to use an old one.

The words are Ralph Waldo Emerson's, in his journal of October 13, 1837, quoted by Hans Huth, a remarkable man whose "Yosemite: The Story of An Idea," is one of the most important contributions to the history of the national park idea that has been made. Dr. Huth's article, published in the *Sierra Club Bulletin* in March 1948, led to his extraordinary book, *Nature and the American*, a beautiful work that *A Sense of Place: The Artist and the American Land*, beautifully complements. Dr. Huth's article was about a place he had not yet seen and about an idea he wished to see expand. Special places, he knew, are where you keep them, and not where they are so paved or otherwise modified for momentary convenience that they lose their ability to keep roots alive.

For one thing, Dr. Huth reiterated that Yosemite, not Yellowstone, was the first park of national importance, and asked historians to abandon the common assumption that the national park idea was born at a campfire in Yellowstone in 1870. Six years before that campfire, Congressional action had already been taken to set aside Yosemite Valley, that it might be enjoyed in perpetuity as a scenic resource for all the people. Among the seventy sources he quotes, Dr. Huth in his article refers to George William Curtis's *Lotus-Eating: A Summer Book* (1850) in which Curtis remarks that there is a "positive want of the picturesque in American scenery and life." But picturesqueness should not be the yardstick, he said; "space and wildness are the proper praises of American scenery . . . We have only vast and unimproved extent, and the interest with which the possible grandeur of a mysterious future may invest it."

Five years later, on June 20, 1855, a California pioneer artist, Thomas A. Ayres, sketched a general view of an important part of that "unimproved extent," then called the Yo Semite Valley, the "first ever taken." Ayres's drawings did much to convince travelers of the magnificence of Yosemite scenery.

What grandeur the "mysterious future" has now invested in so extraordinary a place is not too clear. Richard Wilbur, Alan Gussow, and a host of witnesses herein shine helpful light onto the transition that occurred and it is not easy to add to what they say—unless you happen to be Arthur Hoppe, columnist for the San Francisco Chronicle, and looking into the future in an article entitled, "Our Preserves Are in a Jam" (August 30, 1971):

Yosemite National Parking Lot, August, 1984.—The Western Regional Wilderness Preserve, a 3.6-acre site just north of here was dedicated in appropriate ceremonies today.

The Preserve, along with a similar one in Maine, was established by an act of Congress as the successful culmination of a long fight by Ralph Nader, the Sierra Club and other conservation groups.

As the President said in his message read at today's ceremonies, "This act keeps safe for all time unspoiled wilderness areas from Maine to California where generations yet unborn may view our precious national heritage of God-given scenic beauty."

The entire 3.6 acres of the Wilderness Preserve here is surrounded by 12-foot-high electrified fence to keep out timbermen, miners, cattlemen, real estate salesman, road builders and motel operators.

Visitors, on payment of $1 admission fee, enter through the West Gate and are formed in groups of 20 for guided tours of the whole preserve. The tour lasts an hour.

The first point of interest is the Governor Ronald Reagan Memorial Forest. This towering white pine tree is believed to be more than 70 years old, which would make it the oldest living tree in Western America.

The tour also includes a walk along the Izaak Walton Trout Stream. In keeping with the wilderness concept, the stream is not stocked and therefore contains no fish. However, it has actually been certified by pollution experts to be still safe for swimming. "And to keep it that way," as the guide carefully explains, "no bathing is permitted."

But the high point of the tour for the young ones is Crystal Pure Spring. This spring, which bubbles forth from a mossy cleft in the rocks, is probably the last spot in America where one can drink water just as it comes from the ground.

While the youngsters are impressed by the fact that once all of America's rivers and streams were drinkable, they don't care much for the water. Without chlorine or other chemicals, as one little boy put it, wrinkling his nose, "it sure is tasteless."

In addition, the Preserve offers three authorized camp sites available by reservation. So far, there have been no applicants. The modern camper, of course, vastly prefers the amenities offered by the up-to-date Yosemite National Parking Lot.

The new Yosemite campground here was created following the monumental traffic jam on the valley floor over the July 4th weekend of 1973. Unsnarling it proved impossible. So it was paved over.

This offered an excellent opportunity, however, to construct the very latest in up-to-date campgrounds. It features Astro-Turf, tiled bathrooms, waterfalls (from 9 a.m. to 5 p.m. daily), an ample supply of Presto-Logs for those who like old-fashioned campfires, and the huge "Ol' Fishing Hole" into which 10,000 trout are dumped at 11 a.m. daily for the benefit of an equal number of fishermen.

Naturally, there is a long waiting list for each of the 10-by-12-foot camp sites. And the campground has turned a nice profit every year. By contrast, experts fear the Wilderness Preserve will operate at a loss.

But as the President said in his message today, "No price is too high to pay to show our children and our children's children what America was like before their forefathers tamed the wilderness."

The humor of Mr. Hoppe's piece just about vanishes when one realizes that the national park of his fantasy is very nearly an accurate prediction of what will happen if, through mistaken ideas of progress, we continue to throw the geometric curve of increasing demand at American space and wildness. The best weapon against the unending deprivation that would be the consequence of that unending demand is a revival of man's sense of place. The places that we have roots in, and the flavor of their light and sound and feel when things are right in those places, are the wellsprings of our serenity. There must be something in them as important to us as a home slope is for a Douglas fir, for example, an importance a geneticist has in mind when he says, "Plant local seed stock." Alienation does not come easily to living things; even in migration they contemplate a return. Granted, the affinity for the milestone places in a man's life is an affinity that is largely unstudied, and this is not the place for extensive delving; we simply know that nostalgia has a purpose.

But there are other roots, too, roots that themselves have places in the various and faraway regions they must draw from if they are to endure. Each of them has drawn from wilderness to become what it is, and to overlook this truth is as sensible as saying you don't need air outdoors because you have it in your room. Throughout the course of life on the planet, wildness has flowed from form to form, each, Muir said, more beautiful than the one that went before. Then suddenly, with a speed of attack there is no beginning of precedent for, man undertook to simplify that wildness, foreclose on diversity, dry up springs, and praise himself.

There are better things to do, and Alan Gussow has sought to do them. In the effort to save Storm King Mountain from Consolidated Edison's plans for meeting the demand for a never-ending increase in electrical energy, Mr. Gussow's defense of one of the places most important to him, the Hudson River Valley, was one of the most eloquent statements heard. We learned about the eloquence of his brush soon thereafter. The show he put together for the Peridot Gallery in January 1968, *The American Landscape: A Living Tradition*, led to the Smithsonian Institution's circulating the entire exhibit for a year. It seemed to us by autumn that there should be a book in what Mr. Gussow had assembled, augmented by what he could say so well. The following September he attended the first Aspen conference conducted by the John Muir Institute for Environmental Studies, and the clarity of what he said there about a sense of place required that we move on with the book as part of our series, The Earth's Wild Places. And then Mr. Gussow capped his achievements by persuading Richard Wilbur to add his own eloquence.

We accept Emerson's advice, and we shall go out to walk with these painters, and this poet.

San Francisco, California
August 31, 1971

DAVID R. BROWER, *President*
Friends of the Earth

by ALAN GUSSOW

with an introduction by RICHARD WILBUR

foreword by DAVID R. BROWER

A Sense of Place

THE ARTIST AND THE AMERICAN LAND

FRIENDS OF THE EARTH ◉ SAN FRANCISCO, NEW YORK, LONDON, PARIS

A CONTINUUM BOOK / THE SEABURY PRESS NEW YORK

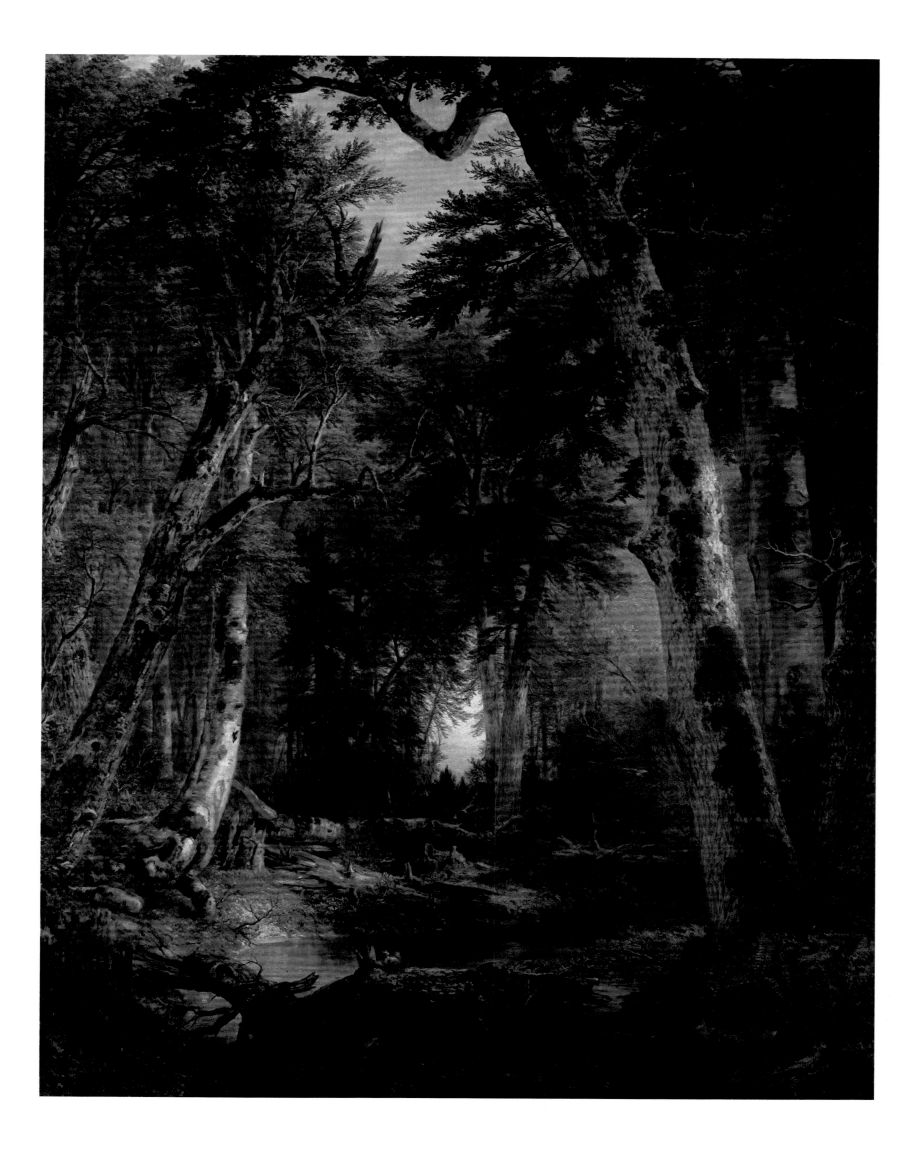

INDEX OF ARTISTS

Copyright in all countries of the International Copyright Union by Friends of the Earth. All rights reserved. Published in New York by Friends of the Earth, Inc., and simultaneously in Paris by Les Amis de la Terre, and in London by Friends of the Earth Ltd.

ISBN 0-913890-07-2

Printed and bound in Italy

This Friends of the Earth/Seabury Press printing contains corrections of minor errors but no substantive changes in text, photographs, or other illustrations. For current information about what is happening in the earth's wild places, write Friends of the Earth, San Francisco.

ASHER BROWN DURAND: IN THE WOODS, 1855
Collection, The Metropolitan Museum of Art, New York, gift in memory of Jonathan Sturges by his children, 1895, o/c, 60¾ x 48.

To Joan
and to Monhegan Island

Contents

Sources of Artists' Statements

Anderson, Lennart, interview, December 1970, Brooklyn, New York.

Audubon, John James, *Ornithological Biography*, Volumes I and II, Edinburgh, Adam & Charles Black, 1834.

Avery, Milton, interview with Sally Avery, June 1970, New York, N.Y.

Benton, Thomas Hart, *An Artist in America*, New York, McBride, 1937.

Bierstadt, Albert, letter dated July 10, 1859, Rocky Mountains, published in *The Crayon*, Volume 6 (September 1859).

Bischoff, Elmer, letter, January 29, 1971, Berkeley, California.

Blaine, Nell, interview, September 1970, New York, N.Y.

Bogart, Richard, interview, October 1970, Monroe, Connecticut.

Bruder, Harold, interview, December 1970, New York, N.Y.

Burchfield, Charles, "Journal, 1916" (Collection, Burchfield Foundation, Buffalo, New York).

Button, John, interview, November 1970, New York, N.Y.

Catlin, George, *The Manners, Customs and Condition of the North American Indians*, Volumes I and II, London, published by George Catlin at Egyptian Hall, Piccadilly, 1841, Letter No. 2, Letter No. 33.

Chase, William Merritt, in Katherine Metcalf Roof, *The Life and Art of William Merritt Chase*, New York, Charles Scribner's & Sons, 1917.

Church, Frederick, Thomas Winthrop, *Life in the Open Air and Other Papers*, Boston, Ticknor & Fields, 1863.

Cole, Thomas, letter quoted in Rev. Charles Rockwell, "The Catskill Mountains and the Region Around, 1867," in Roland Van Zandt, *The Catskill Mountain House*, New Brunswick, Rutgers Univ. Press, 1966.

Cropsey, Jasper Francis, letters 1846, 1892, 1897 (from the Estate of William Steinschneider, Hastings-on-Hudson, New York).

Davies, Arthur B., letters, September, 1890 from Holland Patent, New York (Collection Mrs. Niles M. Davies, Congers, New York).

Dickinson, Edwin, interview, December 1970, New York, N.Y.

Diebenkorn, Richard, letter, October 22, 1970, Santa Monica, California.

Dove, Arthur, undated note (from LaVerne George, Princeton, N.J.).

Durand, Asher Brown, letter from North Conway, New Hampshire to the Editor of *The Crayon*, published in Volume II, No. 9, August 29, 1855.

Eastman, Seth, "Journal, August 11, 1848," San Antonio, Texas (Collection, Marion Koogler McNay Art Institute, San Antonio, Texas).

Gelber, Sam, interview, December 1970, New York, N.Y.

Gifford, Sanford Robinson, letter to his father from Steamer Atlantic, at sea, May 19, 1855 (in the Archives of American Art, Washington, D.C.).

Goodman, Sidney, letter, December 4, 1970, Elkins Park, Pennsylvania.

Hartley, Marsden, letter to Roy Newman, January 17, 1941, Bangor, Maine (in Archives of American Art, Washington, D.C.); poem, "Waterfall," dated October 24, 1937, Georgetown, Maine, in *Selected Poems by Marsden Hartley*, edited and introduction by Henry W. Wells, New York, The Viking Press, 1945.

Harvey, George, *Harvey's Illustrations of Our Country, with an outline of its Social Progress, Political Development and Material Resources, being an epitome of a part of eight lectures which the artist had the honor of delivering before the members of the Royal Institution of Great Britain in 1849, and subsequently before many other literary societies of England and Scotland, entitled the Discovery, Resources and Progress of North America, North of Virginia illustrated by more than 60 views*, Boston, Dutton & Wentworth, 1851.

Heade, Martin Johnson, "Notes of a Floridian Experience," *Forest & Stream Magazine*, May 24, 1883 (under psuedonym "Didymus").

Homer, Winslow, letters to M. O'Brien & Son, from Scarboro, Maine, March 15, 1895 and October 29, 1902, both quoted in William Howe Downes, *The Life and Works of Winslow Homer*, Boston, Houghton, Mifflin Co., 1911. Also quoted in John W. Beatty, *Recollections of an Intimate Friendship, 1923-24*, published in Lloyd Goodrich, *Winslow Homer*, published for the Whitney Museum of American Art by the Macmillan Company, New York, 1945.

Hopper, Edward, interview quoted by Katherine Kuh in *The Artist's Voice*, New York, Harper & Row, 1960; quoted by Brian O'Doherty in *Art in America*, December 1964; *Edward Hopper retrospective Exhibition Catalog*, 1933, The Museum of Modern Art, New York.

Inness, George, article in *Art Journal*, 1879, New York, N.Y.; letter to Ripley Hitchcock, March 23, 1884, Goochland County, Virginia; article in *Harpers New Monthly Magazine*, May 1878, New York, N.Y.

Kahn, Wolf, interview, May 1970, New York, N.Y.; letter, October 3, 1968, New York, N.Y.

Kensett, John, letter to J. R. Kensett, March 19, 1842, Paris (Collection, The New York State Library, Albany, New York).

Kent, Rockwell, *It's Me Oh Lord*, New York, Dodd-Mead & Co., 1955, copyright Rockwell Kent.

Kienbusch, William, letter, November 3, 1970, New York, N.Y.

Laderman, Gabriel, interview, December 1970, New York, N.Y.

La Farge, John, quoted by Royal Cortissoz in *John La Farge, A Memoir and a Study*, Boston and New York, Houghton Mifflin Company, 1911.

Lord, Sheridan, interview, January 1971, New York, N.Y.

Marin, John, letter to Alfred Steiglitz, July 31, 1917, Small Point, Maine, quoted in *Selected Writings of John Marin*, edited with an introduction by Dorothy Norman, New York, Pelligrini and Cudahy, 1949.

Miller, Alfred Jacob, from his "Western Journal, 1837," quoted in Marvin C. Ross, *The West of Alfred Jacob Miller*, 1951, University of Oklahoma Press, Norman, Oklahoma.

Moran, Thomas, article by W. H. Jackson, "With Moran in the Yellowstone . . . ," *Appalachia Magazine*, Volume I, No. 82, December 1936; Ferdinand V. Hayden, *Preliminary Report (for 1871) of the United States Geological Survey of Montana and Ajacent Territories*, 1872, U.S. Government Printing Office, Washington, D.C.; Congressman M. H. Dunnell, letter to C. Delano, Secretary of the Interior, 1872.

Mount, William Sidney, from his Journal, 1843-48; letter to Benjamin Thompson, December 31, 1848, Stony Brook, New York; letter to unknown editor, December 15, 1848, Stony Brook, New York. (All in Collection, Suffolk Museum and Carriage House, Stony Brook, Long Island, New York.)

O'Keeffe, Georgia, interview quoted by Katherine Kuh in *The Artist's Voice*, New York, Harper & Row, 1960; interview with Grace Glueck, October 1970, New York, N.Y.

Perrine, Van Dearing, letter to Carleton Noyes, November 18, 1902, Palisades, New Jersey; undated letter quoted in catalog, *Van Dearing Perrine, Painter of Light and Color*, The Montclair Art Museum, Montclair, New Jersey, 1965; essay in *The Craftsman*, Volume XII, No. 5, August 1907; letter to Carleton Noyes, April 1909.

Poor, Anne, interview, December 1970, New City, New York.

Poor, Henry Varnum, interview, December 1970, New City, New York; Henry Varnum Poor, *An Artist Sees Alaska*, illustrated by the Author, New York, Viking Press, 1945, copyright by Henry Varnum Poor.

Porter, Fairfield, interview, October 1970, New York, N.Y.; letter, October 1, 1968

Resika, Paul, interview, September 1970, New York, N.Y.

Richardson, Constance, catalog statement, Kennedy Galleries, New York, N.Y., January 1960; letter, February 1, 1971.

Schrag, Karl, letter, October 4, 1968, New York, N.Y.

Sheeler, Charles, *The Black Book*, reprinted in Charles Sheeler, published for the National Collection of Fine Arts by the Smithsonian Institution, Washington, D.C., 1968.

Tam, Reuben, letter, October 19, 1968; poems, undated, published here for the first time.

Twachtman, John Henry, letter to J. Alden Weir, December 16, 1891, Greenwich, Conn., from Dorothy Weir Young, *Life and Letters of J. Alden Weir*, New Haven, Yale University Press, 1960.

Wexler, George, interview, December 1970, New Paltz, New York.

White, John, Thomas Hariot, *A Brief and True Report of the New Found Land of Virginia*, London, 1588.

Whittredge, Worthington, "The Autobiography of Worthington Whittredge" (1905), *Brooklyn Museum Journal*, 1942, ed., John I. H. Baur.

Wilson, Jane, interview, October 1970, New York, N.Y.

Yates, Sharon, "Journal, 1970," Baltimore, Maryland.

ACKNOWLEDGMENTS

ROBERT FROST often referred to poetry as "a voyage of discovery"—both for the poet and for the reader of poetry. I hope this book will be a voyage of discovery for the reader and the viewer. It certainly has been one for me. As an artist who painted from the landscape and as a conservationist who tried in a variety of practical ways to save parts of the world still natural, I long hoped it would be possible one day to combine my interests in a single effort. This prospect brightened in the fall of 1969 when Dave Brower asked if I would be willing to participate in an organizing conference of the John Muir Institute for Environmental Studies in Aspen, Colorado, suggesting as my topic, "An Artist and the Sense of Place." The result was an acceptance of the invitation and an excuse to try to pull together a number of ideas that had been in my mind for some time, ideas that I hoped would interest the assorted physicists, government officials, labor organizers, churchmen, and other talented types who were all to become friends of the earth.

The response to my remarks about "places" was emphatic and pleasing. It was obvious that we all did, indeed, have our places. Having earlier organized an exhibit of paintings built around the theme of the American landscape as a living tradition, I suddenly saw a way in which the two ideas—places and paintings—could be united. My "voyage of discovery," therefore, was quietly launched that autumn weekend in Aspen and Dave Brower deserves special thanks for shoving me off.

Since that time a number of people and institutions have come to my rescue. A particular note of gratitude is due John K. Howat, Curator of American Painting and Sculpture at the Metropolitan Museum of Art, who made his library, desk, leather sofa, air-conditioned offices, files, telephone, secretary, as well as his own vast knowledge of nineteenth-century American painting and his notes on John Kensett freely available to me. Also a word of thanks to Natalie Spassky, his assistant at the Met, for her many good suggestions and for generously arranging for me to view many of the Museum's paintings privately. There is an awesome sense of power in having storage walls unrolled while you calmly feast on buried treasure in the Met basement.

A number of excerpts from artists' letters and journals are published here for the first time. My thanks to Mrs. Niles M. Davies for her permission to quote from the early letters of Arthur B. Davies. Brooks Wright, who is preparing his own book on Davies, made available typescripts of this correspondence. Mrs. A. T. Ellsworth, granddaughter of Jasper Cropsey, kindly allowed me to go through Cropsey letters and select material excerpted here. Also, my thanks to Edna M. Lindemann, Curator of the Charles Burchfield Center at Buffalo, who personally assembled excerpts from Burchfield journals. Doris Bry has kindly made available the transparency of the Georgia O'Keeffe painting, and Grace Glueck of the *New York Times* offered me use of her notes from an interview with O'Keeffe. Arthur F. Hewitt, Jr., Acting Superintendent, Hawaii Volcanoes National Park, generously provided a transparency of David Howard Hitchcock's painting, "Halemaumau." The Archives of American Art proved enormously helpful, providing me with an opportunity to read unpublished material by Sanford Robinson Gifford and Marsden Hartley, among many others. Mrs. Nathalie Baum of the Downtown Gallery made available Charles Sheeler's own photograph of his drawing, "Rocks at Steichen's." Mrs. Robin H. Nelson, Archivist of the Suffolk Museum and Carriage House at Stony Brook, Long Island, very kindly researched the William Sidney Mount papers, producing documents with an environmental interest. Richard Slavin, Curator of Olana, the Frederick Church homestead, provided me with the opportunity to view many of Church's drawings and small paintings and to read correspondence relating to the construction of Olana. It was in the attic of Olana that I first read Theodore Winthrop's book,

Life in the Open Air, which is quoted here in connection with Church's painting of Mt. Katadhin. My thanks also to Mary Perrine for making available documents about her father.

Edward H. Dwight, Director, Museum of Art, Munson-Williams-Proctor Institute in Utica, New York, helped in the selection of Worthington Whittredge paintings, and also assisted in the selection of text and plate by John James Audubon. Maria Naylor, Research Historian of the Kennedy Galleries, New York, directed my attention to the existence of George Harvey's lecture notes.

Stuart Feld, Director of Hirschl and Adler Galleries, New York, shared his library, paintings, and insights with me. His scholarly generosity helped provide me with a crash course on nineteenth-century American Art. Of the art dealers—all of whom have been most helpful—two stand out: Antoinette Kraushaar for her abiding, personal interest in the artists and in the progress of this book; and Joan Washburn, newly named Director of my gallery, the Peridot, who, apart from general encouragement, made the spectacular Martin Johnson Heade painting available for reproduction. I regret that Louis Pollack, founding Director of the Peridot Gallery, has not lived to share with me the pleasures of this volume. Thanks to his initiative, we were able to organize the exhibit, first shown at the Peridot in 1968, called "The American Landscape: A Living Tradition," which brought together for the first time many of the artists included in this book. He was particularly pleased that the Smithsonian Institution circulated that show to museums and college galleries all over the United States.

The contemporary artists whom I have interviewed and exchanged correspondence with have been uniformly cooperative. I have had the pleasure of sitting with seventeen of these artists, discussing (and recording) their views on the value of painting from nature. Without their generous cooperation, there would have been no book. I am indebted to the late Rockwell Kent for making available his own transparencies of Monhegan paintings from which we were able to prepare dye-transfer prints.

Reproductions of paintings can be only as good as the transparencies from which they are made. Malcolm Varon, who photographed most of the paintings for this book, proved to be compulsive about quality. He provided services beyond any reasonable expectation and color-corrected each photograph against the original painting.

My thanks also to Perry Knowlton, fellow passenger in glider flight, who, as a vice-president of Friends of the Earth and as my agent, provided continuing answers to my sundry questions.

From my distant years as a student at Middlebury College in Vermont, where I first learned to love the out-of-doors, I recall with pleasure the earth wisdom of two professors, painter Arthur K. D. Healy and Reginald Cook, scholar of American literature. In tandem they set me on a course that led to here.

Finally, a public word of appreciation to my wife Joan, who deserves, at a minimum, to be listed as coauthor. Through long, agonizing days of my discontent, she was calmly reassuring. When the time came for final editing, her sure hand and logical mind combined to make my introductory essay possible. It isn't every author who has a Maxwell Perkins for a wife. Quite simply, without her help and her understanding, this book would never have been completed.

Congers, New York —A.G.
March, 1971

INTRODUCTION

Patrick Kavanagh, the Irish poet, speaks scornfully in one of his poems of bustling, abstract men who sit on committees and cannot perceive "the undying difference in the corner of a field." I have found that phrase a good means of guessing anyone's origins: those who were city bred hear it blankly, but those who grew up on farms often know what it means. Even in fast-changing America, a man can come back after fifty years and find the expression of some angle of land much the same: it may have been plowed, bulldozed or otherwise altered, and there will have been changes in wall, fence, or hedge; yet in some relationship of rocks, perhaps, some degree of slope, some presence of water which makes for greenness, the stubborn peculiarity of the place will be there. It is hard to say why this should matter so much to some people.

A feeling for the lay and character of the land must have been near-universal in the ancient Mediterranean world; for the Greeks, places had their genii, and all the gods, however eclectically fused and generalized by the poets, were local. Japan, to this day, is attentive and imaginatively responsive to every natural scene. But my friend from New York, an excellent abstract artist, walks through our Berkshire woods smoking Gauloises and talking of Berlin. It is too bad that he cannot be where he is, enjoying the glades and closures, the climbs, the descents, the flat stretches strewn with Canada Mayflower and wintergreen; I should like to see him catch the first rumor of a stream up ahead, or notice how we leave the beech-grove behind and enter a stand of hemlock and laurel. These woods have a delectable variety, because there is some overlapping of forests here: the black oak is not found much farther north, and the larch thins out to the south of us. The elaborate arrangement of the hop hornbeam's leaves would engage my friends's exquisite sense of line and pattern, if only he would see it, but he will not. "Forgive me," he says. "To me, this is all a smear of green." And so he walks along in an envelope of smoke and talk.

Cardinal Newman comes to mind, because I happen to have been reading him. The *Apologia* is not an inclusive autobiography, but an effort on Newman's part to describe the development of his religious opinions and to defend the honesty of his progress toward conversion. Nevertheless, Newman's defense does take the form of an autobiographical account, and it consists not merely of the drily doctrinal but also of powerful figures of speech and dramatic effects of tone and timing. In a life-story with so many emotive elements, the reader might expect to encounter evocations of place, but they are not forthcoming. Newman goes on walks, but will not say what he sees; abroad, he tells us that he "went to various coasts of the Mediterranean" and "found pleasure in historical sites and beautiful scenes;" back home again, he finds himself "amid familiar scenes and faces." One could scarcely be less vivid than that. Newman does, in fact, prepare us throughout his first chapter for the starvation of our mind's eye; he tells us that he has had since boyhood a "feeling of separation from the visible world," and a conviction as to "the unreality of material phenomena." The *Apologia* makes frequent use of metaphors (of light and dark, for example), in which things are instantly converted into spiritual meanings, but I can remember only one sustained passage in which Newman's surroundings are acknowledged as such, and thought and feeling attach to specific "material phenomena." It comes when Newman has gone over to Roman Catholicism, and is leaving Oxford after 30 years:

". . . I called on Dr. Ogle, one of my oldest friends, for he was my private Tutor, when I was an Undergraduate. In him I took leave of my first college, Trinity, which was so dear to me . . . Trinity had never been unkind to me. There used to be much snap-dragon growing on the walls opposite my freshman's rooms

there, and I had for years taken it as the emblem of my own perpetual residence even unto death in my University.

"On the morning of the 23rd I left the Observatory. I have never seen Oxford since, excepting its spires, as they are seen from the railway."

The snapdragon and the spires are emblems, as for Newman's sensibility they would have to be; but three decades of Oxford have also impressed them on his mind as beloved *objects*. The passage is deeply affecting, while at the same time it makes us aware of the rarity of such consciousness in the *Apologia*, and points to something missing or avoided in a great and fiery spirit.

For Yeats, the task of the soul was to encompass all the varied or opposing states or stances of which souls are capable; yet first and last his poetry is that of an "antithetical" or subjective man who asserts, as in "Blood and the Moon," that the mind creates the world. For such a poet there can be only a limited sense of place, and even the rocks and moor-hens of the later verse are symbols which seldom threaten to assert a life of their own. The celebrated "Lake Isle of Innisfree" is not an island at all, but a projection in natural images of the state of reverie. We feel this most strongly when Yeats somewhat endangers his tone:

> Nine bean-rows will I have there, a hive for the honeybee,
> And live alone in the bee-loud glade.

Those beans, and the implication of manual exertion, are incongruous, and we are put in mind, by contrast, of Henry David Thoreau, whose beans, whatever else he made of them, were in the first place actual. Reading Yeat's poems, magnificent though they are, I often recall with relief that opposed extremist Robinson Jeffers, for whom

> The beauty of things was born before eyes and sufficient
> to itself; the heart-breaking beauty
> Will remain when there is no heart to break for it. . .

or remember Jorge Guillen's intensely bracing line,

> The landscape imagines me.

Pétrus Borel denounced the trees for producing, year after year, the same tiresome green. There have always been, I suppose, and especially in the last two centuries, natures unresponsive or even hostile to their surroundings; and no doubt it is the most original natures who are most susceptible to deformity and detachment. What bothers me more than Pétrus Borel is my memory of a motel in South Carolina, which my wife and I settled for at the end of a long day's drive on a fast highway. Its rectangular asphalt parking-lot had been hacked out of a stand of trees far from any town, and in the dim light one could not see what trees they were. The usual shoe-box-like structure was surrounded by cars from all over America; between the motel and the road was the usual fenced swimming-pool. Within were an office, a restaurant which did not offer grits on the breakfast menu, and, for the rest, long corridors lined with identical rooms in which hung pictures of the Pont Neuf and the Arc de Triomphe. Walking down my corridor, cardboard bucket in hand, to visit the niche where stood an ice machine, I heard television voices coming through the doors, talking from everywhere else. In bed that night, I imagined that I heard a field crying out from beneath the asphalt, asking to be a place again, a place in Carolina. And I had the bad fancy that we Americans might be becoming a race which, for all its restless motion, moves by preference through a repetitive labyrinth of highway, ramp, lobby, snack-bar, escalator, and concourse—an anaesthetic modular world in which we are at home only because things are everywhere the same.

The Englishwoman, looking up at my lofty and ragged mock orange, said, "You Americans like your nature rather . . . wild, do you not?" I expect that she was making a conventional observation, yet it is still one truth about us that many Americans have a liking for the rough and unpruned—a liking for the wild which goes far beyond that "picturesque" esthetic still visible in so much English parkland. It is a taste with political overtones, having to do with freedom and self-realization, and it also entails an atavistic gesture toward the frontier. We have often comfortably balanced that taste with the advantages of civilized community. So William Cullen Bryant seems to have done. It is interesting that when Bryant, the poet of wild nature and the advocate of the Hudson River painters, was growing up in Cummington, the population was twice its present number and the land mostly cleared and worked. It was a rural place, but scarcely savage. Fortunately, there were thirty acres of virgin timber just downhill from the Bryant homestead, in which a doctor's son with a literary bent could nourish a sense of wilderness.

Asher Durand's painting of Bryant and Thomas Cole, in which the two are dwarfed by the sublime scenery of a Catskill gorge, amuses us because of the formality of the small, gazing figures: Mr. Bryant is dressed as what he was, not the Deerslayer but the editor of the New York *Post*. We are amused by a frock coat in the wilds; but would Bryant truly look more "natural" in buckskin? It is natural for men to live and work in society, and to reflect in their dress and manner whatever fashions and customs are in force. I daresay that Durand's picture does, after all, represent a harmony.

It is not merely gorges and virgin forests in which the feeling of place awakens, and we find ourselves in surroundings which answer to the spirit. A Vermont town sitting well in its valley, or an Italian town on its hill, look no more artificial than a beehive. Seen from a rocky slope by Constance Richardson, the city of Duluth is in key with earth and water. And a great city like Rome, which honors its river and its topography, which is full of parks, fountains, and an endless variety of architecture, could almost suffice us forever. If the Campidoglio is not a place, what is? Cities and suburbs estrange us from the world only when they rape and obliterate their sites (as El Paso is now ingesting its mountains) and spread about so widely and drearily as to lose all focus, character, and congruence with extrahuman nature. From such "material phenomena" the senses retract, to the spirit's cost.

Several years ago, I took part in a panel discussion at a southern university. The topic was, as so often, the relationship of art to society, and it chanced that the panelist who opened the discussion dealt so elegantly with the matter in ten minutes as to leave us with nothing to say. I then begged leave to change the subject, and to ask a question which I thought might be well-answered at the seat of the Agrarian Movement. What was the value to us, I asked, of unspoiled nature, and why should we not exterminate the whooping crane? It had not been my intention to cast a pall on the occasion, but that is what happened: a shyness came over panel and audience, and our symposium did not recover its verve. Undoubtedly there was something like unanimity of feeling about the issue, but we lacked the terms in which to recommend our feelings, or to come to an articulate agreement.

I mentioned my disruptive question, a few days later, to a clever man who had been a writer of presidential speeches. "As for the whooping crane," he said, "I wouldn't have it vanish because that would deprive me of a possible experience." Not the loftiest of answers, perhaps, but a hard, honest one, and better than silence.

In part, at least, all men approach the landscape self-centeredly or self-expressively, looking for what agrees with their temperaments, what seems to embody their emotions, what suits them as décor or theatre of action. Some have the luck to be born, and to remain, in country which is continuous with their personalities; others ramble about until they can say at last, like Brigham Young, "This is the place." Certain affinities are understandable, or can be made so: there is the man of daring philosophic mind, whose chief happiness lies in

mountaineering; and there is W. H. Auden's poem "In Praise of Limestone," which brilliantly shows the correspondence between one kind of scenery and one human disposition. Other affinities are more obscure, though doubtless as profound: a painter writes simply, "I don't like New England . . . I like desert, I like rocks . . ."

In the introduction to a recent anthology of nature poetry, William Cole reports his inability to find any suitable poems about the desert. Painters appear to have done more and better with the subject, and I remember one who told me how long it had taken him to adjust his eye and brush and palette to New Mexico. At first the dunes, mesas, mountains and sky had impressed him as vast, empty, and paralyzing, and he had made out only four or five colors. It was a whole half-year before he apprehended great motions in the landscape, and a granular subtlety of color which called, so he judged, for a species of pointillist attack. Observation, the adaptation of his technique, and the discovery of what in himself the scenery might declare, had at last made it possible for him to paint. He had invented New Mexico: what I like about his account, however, is that it implies no easy affinity, no facile personalization or imposition of mood, but a struggle with something powerfully other. Could one not just as well say that the desert, in requiring of the painter a fresh self, had in its own good time imagined *him*?

Certain ways and means of perceiving nature are fast being lost to us. The small farm is vanishing, and the experience of great solitudes is harder to come by. The common language of rural topography—that vocabulary of *dell, swale, coppice* and *coomb* which Hardy used so well—has fallen into disuse, so that we are relatively speechless before the landscape. In New England, the precise word *intervale* begins to sound consciously old-Yankee, there being less and less practical reason to specify "a low tract of land between hills, especially along a river." Bryant's homiletic woods, Emerson's or Whitman's symbolic streams or grasses, all latter versions and warpings of the old notion that nature is a book of revelations, have lost much credit in this century; the book has grown difficult to read, and when one hears it read in poem or pulpit, it is commonly done with small fidelity or conviction. This is unfortunate for the imagination, which when in best health neither slights the world of fact nor stops with it, but seeks the invisible through the visible.

But shall we not soon be forced to recoup, and to recover a view of nature which is not purely exploitative? Between the last paragraph and this, I sat in our kitchen eating lunch and heard Lord Ritchie-Calder speak on the radio of things which no one can now ignore—the crisis in population growth and food supply, the pollution of Earth's water systems and atmosphere, the finding of DDT in Antarctic fauna, our perilous storing of radioactive wastes in the State of Washington . . . Unless we elect to despair, we are now obliged to make choices which will reconcile us with a natural system of which we are only a part, and I do not doubt that the process will bring not only a fresh sense of how nature may be used, but also of what it is. Scripture asserts that we are worth many sparrows, and that may well be so; we may soon better remember what else scripture says of the sparrow—that it possesses infinite value and meaning in itself. There are many signs that, impelled by the present emergency, people are groping toward a reconciliation with this planet: to mention but one, new editions of Thoreau are appearing, and people of all ages are reading him again. I hope they may reject in him the neurotic opposition of nature and society, while prizing his power of vision and communion.

It is not necessary that everything be major: there are pleasant scenic poems, quite free of grand intuitions, which one would be poorer without, and I see no reason why painters should not enrich us with nostalgic dooryards, optical studies, and blithe cuneiform sketches of gulls and waves. But for landscape painting to attempt its fullest possibilities in any period, there must be some painters who embody the attitude of V. D. Perrine, who said of rocks, trees and rivers that they were "symbols of a great Universal Power . . . which makes and shapes tree and rock and river equally with myself." Provided the holder of such a view can also paint, he may help to redeem us from indifference or subjective deformity by his achievements of place—a place being a fusion of human and natural order, and a peculiar window on the whole.

Cummington, Massachusetts —RICHARD WILBUR

A SENSE OF PLACE

We shall not cease from exploration
And the end of all our exploring
Will be to arrive where we started
And know the place for the first time.
T. S. ELIOT, *"Little Gidding"*

WHEN I WAS A BOY, I used to read maps instead of books. Places then had colors—brown going into very dark brown meaning very high, green going into very light green meaning swamps, the blues going into deeper blues and deeper seas—all kinds of marvelous meaning-filled colors of places. I used to imagine entering Tibet, climbing into the brownest parts of the map, finding some wild, mysterious land.

There were names too, of course. The excitement of words like Natal and Dakar, Tasmania and Borneo—and Antarctica, dotted with features that always seemed (and as it later turned out, were) the names of people, McMurdo and the rest. There were Capes of Good Hope and Fear and Straits of Magellan and Gibraltar. Magellan was my hero.

It wasn't the remote alone that attracted; after all, what is the meaning of 'remote' in the imagination? I memorized the states—all forty-eight—and the shapes of each. New Hampshire was a little like Idaho, but smaller and reversed; Colorado was like Pennsylvania, without the ragged edge on the right. There was the starlike shape of Texas, the banana of Florida; and there was New York, with Long Island blown out taut like a pennant in a strong west wind. Even on world globes I would look first to see if justice had been done to Long Island, where I lived.

Of all the projects we did in grade school, it was the salt maps that I most enjoyed making, and the little villages with houses and streets that we built in social studies. I loved places even before I knew them. And as I grew older and traveled, I never learned to love them less.

This is a book about places. It is not about those dark brown and deep blue spots, or salty hills and valleys on the maps of my childhood. Nor is it about the real spots they stood for on the earth. This is a book about the qualities in certain natural places which certain men and women have responded to with love. Because these men and women were artists, they have left a record of their encounters with the land for others to see, read, and understand. This is really all that sets them apart—that talented connection between eye, mind, and hand. For all of us have our loved places; all of us have laid claim to parts of the earth; and all of us, whether we know it or not, are in some measure the products of our sense of place.

In this country, at this moment, we are very conscious of man as a violator of his environment, a destroyer of the earth's lovely places. The notion that man is also a place maker—and ultimately the product of the places he himself has known, was the genesis of this volume. For in thinking about the conservation of *environment*, I gradually came to realize that an environment was not a place; that the words were not interchangeable; and that the difference was critical. There is a great deal of talk these days about saving the environment. We must, for the environment sustains our bodies. But as humans we also require support for our spirits, and this is what certain kinds of places provide. The catalyst that converts any physical location—any environment if you will—into a place, is the process of experiencing deeply. A place is a piece of the whole environment that has been claimed by feelings. Viewed simply as a life-support system, the earth is an environment. Viewed as a resource that sustains our humanity, the earth is a collection of places. We never speak, for example, of an environment we have known; it is always places we have known—and recall. We are homesick for places, we are

reminded of places, it is the sounds and smells and sights of places which haunt us and against which we often measure our present.

Many places, probably most places, are by their very nature, private. They are the products of an encounter between a single individual and his surroundings. Other places, for one reason or another, become public. Vincent Scully in his book, *The Earth, the Temples and the Gods,* tells how the ancient Greeks took their environment and carved places out of it. Struck by certain qualities in the landscape—the airiness of the sky, the movement of a ridge of mountains, the different ways that spaces looked between the mountains and the seas—open and ample or sharp and confined—the Greeks saw particular landscapes as evoking particular deities. The land itself spoke to them, inviting them to build their temples to specific gods—here a setting suited to the God of War, or there, perhaps, a place to put a temple for the Goddess of Love.

In this country, too, the response of many of the oldest Americans to their land has had a reverential awareness. On the lands around their sacred Blue Lake, the Taos Indians have worshipped for thousands of years at unmarked places, shrines made so holy by nature that they require no temples. We newcomers to the continent are descendants of other less modest peoples. The Europeans who "discovered" America brought to the American land no such native reverence. Enamoured of progress, they scarcely got to know the land before they had begun to alter it beyond recognition. In school we are taught that the history of the American nineteenth century was the history of the frontier, of a process whereby democracy was forged in a continuing conquest of the land. Woven deeply into this historical fabric is the notion that man showed his love of country by farming it, building on it, clearing the woods, and leveling the hills. Yet among all those who viewed the land as a commodity exchangeable for private wealth, there were a few who preserved some places on the land for public gain, taking nothing from them save what Aldo Leopold has called "an aesthetic harvest." Even as the land was being transformed by the ambition of the many, there were some who loved the natural in the land and who limned its features with passion and delight. These were the artists, blessed with the unique ability to make their places visible, and able thus, to share with those of us who have not been there what they have learned from their encounters with the land.

Almost four hundred years ago, John White sailed into the calm unexplored waters off the coast of Virginia. White and his fellow travelers hoped to establish a colony there, to find articles of trade, to initiate an agriculture. Into this wild, wooded, and uncertain land, White came armed with a painter's brush. Though he was supplied, no doubt, with other more conventional defense, his colony did not survive. What endured were the products of his touching curiosity—his beautiful and unaffected watercolor notes about the Indians and their land, images of a time when primitive peoples lived in close harmony with the earth. It is a virtue common to all the artists in this volume, from John White in Virginia in 1585, to Richard Diebenkorn in California in our own time, that they have sought to share the special qualities of the places they have found—to make of them the public places of America, images of what the land has been and ought to be. Gifted with brush and pencil, they have gone out to the earth, loved it, and brought back to the rest of us the products of their love.

What drove these artists to the land? What kind of men have they been who across four centuries looked at the face of America and found it beautiful? Despite the evidence of John White, American landscape painting is not four centuries, but less than two centuries old. In the years between John White and the arrival on the scene of Thomas Cole in 1825, America developed no great landscape painting tradition. Such landscapes as were painted generally served merely as backgrounds to portraits, or as parts of historical scenes dominated by figures and events rather than by the features of the land itself. Authentic responses to nature were buried on the one hand under academic English landscape traditions, and reduced on the other to "decorative elements." Trumbull, Allston, Vanderlyn, and Doughty all ventured into landscape, but it wasn't until Thomas Cole began painting that artists were suddenly able to see the American land as an independent subject matter offering a wide variety of natural forms.

Cole's call to the land was very clear. "Whether [every American] beholds the Hudson mingling waters with the Atlantic—explores the central wilds of the vast continent, or stands on the margin of the distant Oregon, he is still in the midst of American scenery—it is his own land; its beauty, its magnificence, its sublimity— are all his; and how undeserving of such a birthright," Cole wrote, "if he can turn towards it an unobserving eye, an unaffected heart." Urged on by Cole and seconded by Asher Durand who directed, "Go first to Nature!" American artists in the nineteenth century took to the distant hills. The future was in the land, in the vast, all-beckoning western spaces, and the artists scrambled to explore it.

George Catlin decided to give up his career as a lawyer and became an artist. When a delegation of plumed and painted Indians passed through Catlin's city of Philadelphia on their way to Washington, Catlin resolved, almost on the spot, that "the history and customs of such a people . . . are themes worthy of a life-time of one man, and nothing short of the loss of my life shall prevent me from visiting their country, and of becoming their historian." Catlin was true to his word. Leaving in the spring of 1830, he began what would become a lifetime of traveling and documenting, "drawing knowledge from the true source"—unspoiled nature and the Indians who lived on the land.

Albert Bierstadt of New Bedford, Massachusetts (by way of Dusseldorf, Germany) joined Colonel F. W. Lander on a wagon-road expedition to the Rocky Mountains in 1859. Writing to his fellow artists while camping in the Rockies, Bierstadt tells of awakening with dew on his face and seeing "jagged summits covered with snow and mingling with clouds, a scene which every lover of landscape would gaze upon with unqualified delight." Sketching and painting everywhere, Bierstadt would later assemble his ideas into magnificent composites, portraits of the newly seen, profoundly moving western lands.

A short time later, just after the close of the Civil War, Worthington Whittredge traveled on horseback with General Pope more than two thousand miles across the western plains. Whittredge claimed his reason for the trip was a simple desire "to pursue his studies"—the way to do so was to participate in the Great Western Adventure. Impressed with the vastness and silence of the plains, Whittredge would work each day out in the open, setting up his white umbrella in all kinds of territory, whether hostile or not, sketching this innocent, primitive place.

When the American Fur Trading Corporation explored Wyoming in the 1830s, Alfred Jacob Miller, an artist from Baltimore, was with them, seeing wild mountain lakes he doubted that even "twenty white men had ever seen before," lakes "as fresh and as beautiful as if just from the hands of the creator."

Thomas Moran, who had been camping only once before in his life (and then on the shores of a midwestern lake), was included in geologist F. V. Hayden's official party exploring Yellowstone in 1871. Bony and finnicky about food, Moran proved a durable traveler, padding his McClellan saddle when the going got too rough, and painting Yellowstone so convincingly that he is personally credited with moving Congress a year later to set aside Yellowstone as a national park, a fitting sequitur to the action of Congress eight years before in designating Yosemite Valley as a park for the nation's benefit.

Most artists who wanted to see the West teamed up with government surveying expeditions or with traders. An exception was Captain Seth Eastman, West Point graduate and leader of an Army company given the responsibility to sweep through Texas in the mid 1800s. Eastman was both an Army man and an artist— he had once taught drawing at the Military Academy. During his march through the Southwest he made hundreds of sketches and kept a detailed journal. The prospect in our day of an Army captain in Vietnam taking time to sketch the fragile beauty of that vanishing countryside is almost beyond our comprehension. Yet that is equivalent to what Eastman did in his own day.

While the pioneers who moved westward were busy altering the land, the artists were describing the scene before it changed. Some, like John James Audubon, saw change coming. In the early 1800s, Audubon wrote

with a sense of urgency that the time had come to provide "delightful . . . descriptions of the original state of a country that has been so rapidly forced to change her form and attire under the influence of increasing population." The legacy of these wide-roaming painters of the nineteenth century is a vivid recreation of a landscape which, even in their day, was under stress. Looking at the paintings of Bierstadt, Catlin, Whittredge, Cole, Church, Durand, Moran, and others, we can imagine what it must have been like to be there when America's great natural places were discovered for the first time.

When the need for surveying ended, when much of the continent had been seen and recorded, the artists began to view themselves in a different relation to the land. Less awed by its grandeur, perhaps, they became more self-consciously aware of their own presence in nature. They observed themselves as actors in the scene and exulted in their powers. In 1907, Van Dearing Perrine, "The Thoreau of the Palisades," wrote in his journal, "I feel this great power linking me to all the universe, even to the remotest star, and linking all to myself . . . the whole world appears to me as one vast miracle and I am a part of the whole."

Any artist, of course, no matter how objectively he may try to delineate his subject, always paints himself as well. Church and Bierstadt, too, interpreted their landscapes, but by the close of the nineteenth century, artists had become more aware of their own response to the land and saw that response as the source of the painting. "An artist may study anatomy, geology, botany," George Inness wrote, "any science that helps the accuracy of his representations of nature; but the quality and the force of his acquisitions must be subjected to the regulating power of the artistic sentiment that inspires him . . . the greatness of art is . . . in the distinctness with which it conveys the impressions of a personal vital force that acts spontaneously, without fear or hesitation."

To recognize oneself as the force behind the painting is but a step from seeing oneself as the creator of the landscape. Liberated by movements in art itself that encouraged each artist to invent his private forms, many twentieth-century artists responded by creating their own countrysides, domains where only certain kinds of sunlight shone over certain kinds of hills. Think of John Marin, for example, and a specific visual territory comes to mind; it could by Maine or Weehauken or Taos, but whatever its inspiration it comes out Marin-land, a rough-and-tumble country with glints of light, flecks of mountains, hints of clouds—windblown lands and ruffled waters. Think of Marsden Hartley and a bulky, jagged-edged, heavy-handed, strongly colored place emerges.

Arthur Dove is a creator of a playful landscape with rolling forms, bending and twisting like a slinky toy. It is a landscape of stuffed animals, part real thing, part nursery school. Edward Hopper is a painter of empty spaces, finding in cities, down roads, and across tracks an emptiness and quiet—a mute land that stands as metaphor for our time. Rockwell Kent describes a well-shaven landscape, a bald pate of a place, clean, bright, clear, where mountains show their forms in simple dimensions. No wonder Kent found Greenland so much to his liking; it is a country made for him, a place he would have invented if he had not found it. The Charles Sheeler landscape is austere, puritan, with no dust on his tables, no smell from his factories, no auto exhaust on his bridges. Sheeler's selective eye finds profound joy in the form itself, not in how it is used, not in what it is to become. His scenes are landscapes of integrity.

And when one comes to Georgia O'Keeffe, there is the discovery of the sensual in the elemental. It is no surprise that O'Keeffe paints the land near the region where the Taos Indians live. She seems to understand from the inside that the land needs no monuments, that the land itself is its own monument. Her land forms are alive, possessed of an inner pulse which is revealed in her sensitivity to the outer skin. Thus as the world slowly filled with man-made things, some landscape painters—lovers of natural forms—were creating untouched natural landscapes of their own.

How unimaginably and with what an acceleration are we changing the world! "Why was the earth made so

beautiful?" Thomas Cole asked in 1835, and then went on to answer: "It has not been made in vain—the good, the enlightened of all ages and nations have found pleasure and consolation in the beauty of the rural earth."

The ravaged earth we occupy today offers to the enlightened little pleasure and few consolations. How is it that the painters of the land have not simply tossed in the sponge, along with a few brushes? It is easy to assume that since the natural landscape is dying, landscape painting is also dying, or ought to be. Perhaps our polluted landscape, which no longer provides for proper human flowering, no longer deserves memorialization in paint. In the "art world," landscape painting has been presumed moribund—if not since the turn of the century then certainly since its early years, when such artists as Edward Hopper, Charles Burchfield, and Mardsden Hartley were in their painting prime. Yet not only are there notable artists of that generation, Georgia O'Keeffe for one, who are very much alive, but almost half of the artists represented here are still working. For a nation that prides itself on being a "pluralistic democracy," we seem to be curiously myopic with regard to art movements and trends. Since World War II, only one art "movement" at a time—abstract expressionism, then abstract impressionism, followed by pop art, then minimal art, then earthworking, and now anti-illusionism—has been permitted center stage on the critical circuit. Yet all the while artists—a large number of gifted artists—have been quietly looking at, responding to, and creating from the land. Nature and the natural landscape have continued to absorb the creative energies of some of the finest artists at work in this country at this time.

Yet with the natural world shrinking away like water in a sun-baked tide pool, is it not a kind of derrière garde sentimentality that leads artists to turn to the land for inspiration? David C. Huntington says of Church that in his own nineteenth century, "he helped his fellow man to discover himself as the emotional native of a great virgin continent." Today's earth is hardly virginal. The water is corrupted, the air is polluted, our cities have fallen from grace. Nature editor J. B. Jackson describes what we are helping to construct around ourselves as "an existential landscape—without absolutes, without prototypes, devoted to change and mobility." Yet look at these paintings. Where among them is represented an existential landscape? Where is the evidence of the blight man is spreading impatiently over the earth? These paintings are as filled with a love of the natural land as are those of the nineteenth century.

In a world so increasingly unlovely, making paintings such as these must seem at best naïvely unrealistic and at worst irrelevantly retrograde. I hope that it is only a joke to suggest that at the present rate of environmental change, paintings of natural places may soon become nonobjective art; but any serious artist must ask himself today whether such work has any purpose at all—let alone a national purpose. In an increasingly unnatural world what possible value can there be in paintings of unpolluted places? Do any but the hopelessly romantic, the escapist, the reactionary paint them, or demand them? Why should any artist of merit concern himself with these simple, outdated, and increasingly unnatural images?

To begin with, what any artist chooses to paint is what he believes is important to paint, for whatever reason. Any painting is in that sense arbitrary, the product of a private value system. The artists who made these paintings made them for pleasure, usually their own, without regard to style. They paint times and places in the natural world because such places evoke in them strong emotions. Some of them are obsessed with coastlines, some are enamoured of evening shadows, some are transfixed by bark and leaves, wet grass and morning sky. These artists are moved by the sight of nature—and for all the blight on our landscape, the mountains, the trees, and the oceans are still there. A sharp and loving eye can find quality where quality exists, and fixing it in paint can make us feel its presence also.

The artists who paint nature today are also moved, as were their predecessors, by the sheer physical delight of being outdoors. "You sit, I know you do," Thomas Cole once wrote to his friend Asher Durand, "in a close, airtight room, toiling, stagnating and breeding dissatisfaction at all you do when if you had the untainted

breeze to breathe, your body would be invigorated, your spirits buoyant, and your pictures would even charm yourself . . ." Art historians typically look at the art itself and then work back, making esthetic judgments. But for the artist the process is quite the opposite. The artist begins, as Cole knew, with the environment. Responding with mind and body he claims a place, and out of his whole response, at last, produces a work of art. "Painting is like a spider's web," says Nell Blaine. "It comes out of the body of the artist."

Writing to his friend Alfred Steiglitz from Maine, John Marin reminisced: "I went out in my boat and landed on a beach. And there was a great calm and quiet in the fog and the water looked so beautiful and clean and inviting that I stripped without a stitch and went in and felt bully. A great hawk came along, almost up to me before he saw me, then he acted so foolish trying to beat it I wonder if my nakedness shocked him. It might have been a she."

The untainted breezes and the clean and beautiful waters are, perhaps, less easy to find, but they still exist, and artists still succumb to the charm of their physical encounters with nature. "I like the feeling of being by myself with the huge sky, with bare feet in the earth," says contemporary painter Sheridan Lord. "I feel better about myself, more complete. It's a very primitive thing, it's stripping life to the very bare essentials to stand with your feet on either side of a potato furrow with the clothes on that you need and that's all."

Reuben Tam once described the ways in which he conducted his continuing love affair with nature: "I like to explore coastlines and headlands. I study geology and write poems. I go rock-hounding and collect minerals and crystals. I grow vegetables and perennials in a garden by the sea. I wade in tide pools and gather edible seaweed. I photograph sunsets and stormfront clouds. I collect maps and charts of mountains and bays and islands. I'm a horizon watcher. I try to bring to my paintings something about the space and light of places I have known." Tam also brings to his paintings a long history of intimate interaction with a natural world in which he finds the untouched headlands and coastlines and islands and mountains as ecstatically beautiful as his predecessors found the whole continent more than a century ago.

The nineteenth-century artists, lovers of the land, often engaged it close-up, exposing themselves to very real dangers to find the marvelous scenes they sought. Often their subjects left them no choice. The nature they chose to paint was rugged and often remote in time and space from where they were—they needed a kind of ruggedness themselves to get there. In a century that enshrines effortlessness as a virtue, the artists who paint the land must still seek out their chosen subject; nature now is often harder to find, but still worth the effort. "We once drove into Canyonlands," Harold Bruder remembers; "the roads were very rough and my wife and kids were saying, 'You've got to turn back.' You don't see anybody. And you have to drive a long way, and I passed one person who was coming out and I said 'Is it worth it?' and he said 'Yes, it's worth it,' so you keep going. As an urban person that's the closest thing you ever get to being an explorer. Occasionally you pass a ranger and you feel very good about it because you think 'somebody's there just in case.' I was driving an eight-year-old Peugeot and the tires were beginning to wear out, and I never knew what was going to happen. I was running out of gas and I was stubborn—had to keep going; and the kids were getting hungry and everybody was getting annoyed. And finally we reached what is called Island in the Sky and we stepped out. It was like either the end of the world or the beginning of the world."

If it is clear why artists may choose to go on painting nature, it is perhaps less clear why such paintings, once made, are worth looking at in a world grown increasingly "unnatural." I suspect that the importance of paintings of natural places is that such paintings assert the value of things in the environment and in ourselves that we now risk losing. There is tragedy in the fact that we have grayed our skies and clouded our rivers, and that many of us even come to take such a blight for granted, as if nothing serious is being lost so long as we do not actually destroy the life-sustaining capacity of the environment. The even greater tragedy may be our failure to understand that as the nature of our places is being altered we too are being subtly changed. It is not

simply nostalgia for a romantic and rural past that causes us to grieve over the loss of natural open spaces. It is a concern over the loss of human values. For we are not distinct from nature; we are a part of it, and so far as our places are degraded, we too will be degraded.

Moreover, in a world where technology has run amok, these paintings tell us something very old and therefore always very new about knowledge. They tell us that the whole world is still much lovelier than can be explained by everything that's in it, and that however much we learn about the pieces, the whole is still a sum beyond their totaling. These paintings remind us of the human event. In a time that too often confuses data with experience, the sun is still a yellow ball pressing down on us from the sky at midday. Its color and its temperature affect us. It is this hot and vivid sun to which these artists respond.

What is under stress today is the very definition of the natural. What is natural to many people, whether we like it or not, is what they have grown up expecting, and in our man-made world nature is increasingly unexpected. Those of us who believe that *natural* natural places are necessary for the salvation not only of the human race, but also of the human spirit, must insist on pointing up, over and over again, what it is we risk losing.

Nineteenth-century painters went out into the wilderness to bring back reports about a land we did not know; painters now report about a land we risk forgetting. Their gentle paintings direct us earthward; they remind us of seasons, of times of day, of processes outside human factors. They urge upon us a balance. They do not suggest a return to rustic simplicity wholly inappropriate to our times. They are not retreats. These paintings put a value on certain qualities in the environment. Acts of salvage in a desperate time, they can become a model against which we measure our success or failure as restorers of the land.

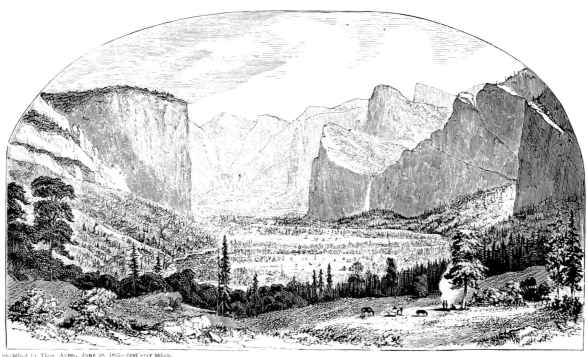

sketched by Thos. Ayres, June 20, 1855—first ever taken.

GENERAL VIEW OF THE YO SEMITE VALLEY.

[From Opeu-etr-noueah, on the Old Indian Trail.]

A SENSE OF PLACE
THE ARTIST AND THE AMERICAN LAND

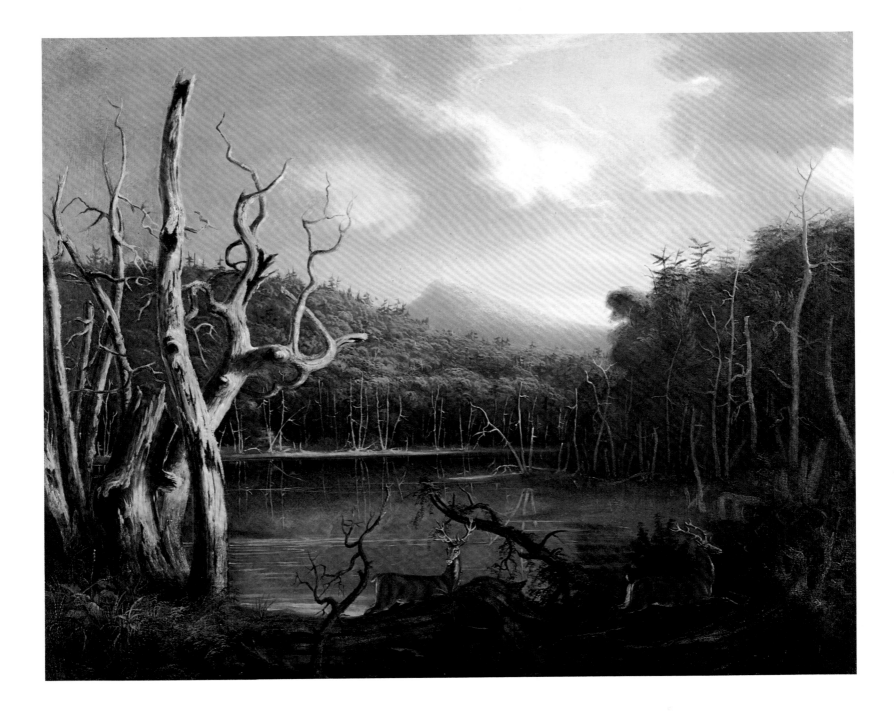

Thomas Cole (1801-1848)

Although he was not the first American landscape painter of quality, because Thomas Doughty and Thomas Birch, among others, were already at work, Thomas Cole enjoys the preëminent reputation as the best known, most widely admired, early nineteenth-century painter of nature. Founder of the Hudson River School, Cole embodied in his life's work a significant duality, revealing on the one hand a Platonic sense of nature as morally, religiously, and philosophically up-lifting, and on the other a remarkable ability to capture the natural fact. This duality, which historian Barbara Novak identifies as "the real and the ideal" was approaching resolution when Cole died. "Landscape with Dead Trees" is clearly a real painting, a very early effort, and one of three pictures which brought immediate success to Cole when first exhibited by a New York frame-maker in 1825. It was the product of the artist's first exploration up the Hudson River in the Catskills. His account of a day on this lake leaves no doubt that the area was a "place" of his own.

I POINTED OUT a view which I once painted, which was, I think, the first picture ever painted of the lake, . . . Several years since I explored its shores for some distance, but thick woods and swampy grounds impeded me. I enriched my sketchbook with studies of fine dead trees, which stand like spectres on the shores. As we made our way to an opening through the woods, which disclosed the lake in a charming manner, we perceived a rude boat among the bushes, which was exactly what we wanted. We pushed off and leaped into it, as the genius of the deep had placed it there for our special use. Before us spread the virgin waters which the prow of the sketcher had never yet curled, enfolded by the green woods, whose venerable masses had never yet figured in annuals, and overlooked by the stern mountain peaks never beheld by Claude or Salvator, nor subjected to the canvas by the innumerable dabblers in paint of all past time. . . .

A little promontory, forming a fine foreground to a charming view down the lake, invited us. We had some fine perspective lines of forest on our right, with many dead trees standing near the shore, as if stripped for the elements. These dead trees are a striking feature in the scenery of this lake, and exceedingly picturesque. Their pale forms rise from the margin of the lake, stretching out their contorted branches, and looking like so many genii set to protect their sacred waters. On the left was another reach of forest of various hues, and in the center of the picture rose the distant Round Top, blue and well defined, and cast its reflection on the lake, out to the point where our boat swung like a thing in air. The headland was picturesque in the extreme. Apart from the dense wood, a few birches and pines were grouped together in a rich mass, and one giant pine rose far above the rest. On the extreme cape a few bushes of light green grew directly from the water. In the midst of their sparkling foliage stood two of the bare spectral trees, with limbs decorated with moss of silvery hue, and waving like gray locks in the wind. We remained here long enough to finish a sketch, and returned to our harbor to refit.

After dinner, we again launched our vessel for a longer voyage of discovery. We now crossed the lake, paddling after the manner of the Indians. Our boat glided beautifully over tranquil waters, and swept aside the yellow water-lilies. In a strait between the mainland and a low islet, where the water was very still, the woods were reflected beautifully. I never saw such depth and brilliancy in the reflections. The dead trees on the margin added by their silvery tints to the harmony of color, and their images in the water, which had a gentle undulation, appeared like immense glittering serpents playing in the deep. At every stroke of the oar some fresh object of beauty would break upon us. We made several sketches, and about sunset turned our prow. As we returned we struck up the "Canadian Boat Song," and though our music was rude, the woods answered in melodious echoes. What a place for music by moonlight!

THOMAS COLE: LANDSCAPE WITH DEAD TREES (Catskill), 1825
Collection, Allen Memorial Art Museum, Oberlin College, Oberlin, Ohio, o/c, 27 x 34.

[37

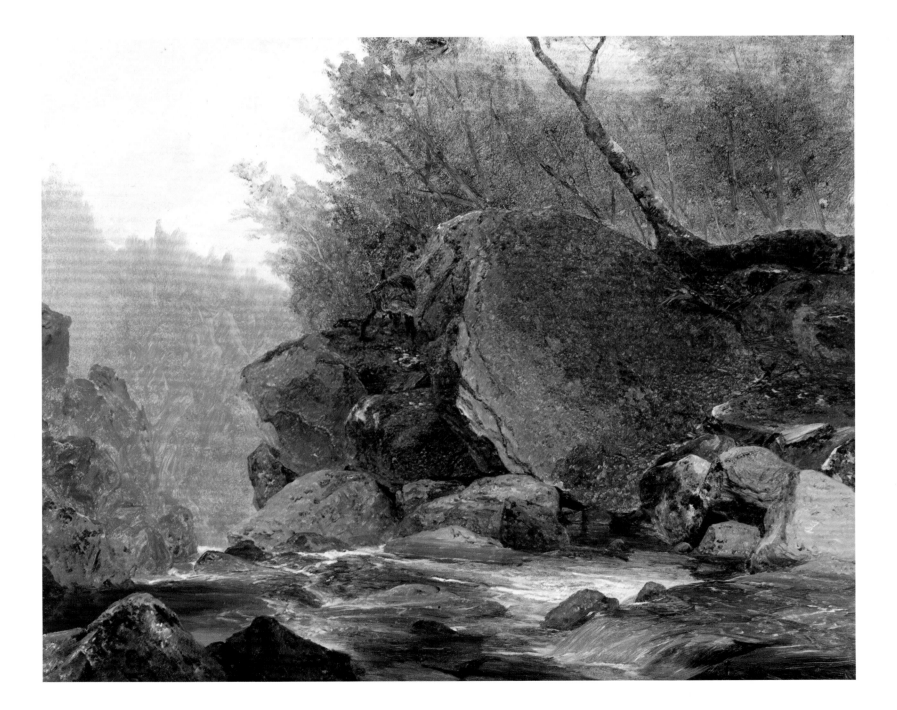

John Kensett (1816-1872)

Trained as an engraver, John Kensett, a central figure in nineteenth-century American landscape painting, enjoyed great popularity among both painters and collectors. Sharing in the broad esthetic concepts of the so-called Hudson River School, Kensett's work is notable for its sensitivity to texture, its firmness of design, and its uncanny feeling for natural light. "Kauterskill Gap" is Kensett's fresh view of a Catskill mountain stream much admired by artists of the period. In 1842, in Paris, he wrote the following letter:

IT IS A beautiful characteristic of genius, that whatever receives its touch is gifted with its immortality.— It is by mixing up intellectual and spiritual associations with *things*, and only so that they have any importance to our minds, *things* are nothing but what the *mind* constitutes them, nothing, but by an infusion with them of the intellectual principle of our nature [tis] thus this humble habitation becomes a shrine of continued worship—which otherwise would be passed by unreguarded & without a thought and thus the most indifferent, and of itself unvalued thing—be it but the fragment of a rock, a broken weapon, a tattered raiment, a decayed branch, or a simple leaf,—receiving a spiritual touch, is rendered an object of intense interest, a relic, priceless as memory itself.

Marsden Hartley (1877-1943)

Rough, blunt, scraggle-edged, Marsden Hartley's paintings have for their subject the pine woods and rockbound coast of Maine. Less primitive than his paintings imply, he is a significant American painter of the twentieth century, one who showed in the historic Armory Show of 1913 and who stood out through the long, lean period of regionalism in the 1930s as original and authentic. He was also a serious (and published) poet. His "Smelt Brook Falls" is in the interior of Maine and is pure Hartley, rough and tumble all the way. His poem, "Waterfall," relates directly to the painting, and his letter to Roy Newman, a composer friend, develops a personal context for both the painting and the poem:

Waterfall

From the breast of the tired horizon
this milk of vague, deserted mornings
tumbles, exudes, evades, expires
at the end in still disasters
coming to a pool-polished face
receiving exits of a thing begun and
never ended.
the woman of the fall spreading
out her creamcoloured hair to let it
preen itself with rivulet commotion
and be frivolous with sacred substances,
the night, the evening, the afternoon, the day—
lavishly laving her brown curves.

Bangor, Maine, January 17th, '41

I'M GLAD you saw the Smelt Brook Falls picture, it is well liked in general, but you will understand that I gave the sense of the condition in the possible freshets which sometimes come after a heavy rain in the fall, in order to symbolize the sense of the thing as an idea. I have hopes at one time or another to have a show of nothing but waterfalls, as I love them so much, and there are some remarkable ones upstate as soon as I can get to them, which is a bit difficult, as one must go up to Katahdin Iron Works, then drive some, then go in a canoe some, then walk some—but I intend to do it all when it works out, and for years have had the falls at Lewiston on my mind which are wonderful and formidable indeed at times during the spring freshets, but there is always the damnable iron bridge and how to cover it up or else just go ahead and put the damn thing in for it *is* there, and up to now I haven't found a view that would give the fall right and yet get rid of the bridge, but the falls themselves are very wonderful and play such a part in my boyish memories.

Jasper Francis Cropsey (1823-1900)

In an American tradition rich with landscape painters only one artist of merit ever focused on one season—Jasper Cropsey, on autumn. He was an emblematic painter of the Hudson River School, and in his later years specialized in scenes with fall coloring, finding in the warm, mellow tones of autumnal foliage a counterpart to his deep, almost religious, feeling in the presence of nature. Trained as an architect, Cropsey was a knowing draftsman as well as a gifted colorist. In the first of the excerpts that follow he writes to his fiancée (later his wife), in the second to a friend, and in the third to a collector.

AFTER GETTING HOME, and tea over, the other little incidents of talk, reading, and the hundred small matters that are passing and repassing; in a great degree having passed away; giving place for the reflective hours of twilight, and myself alone with nature, watching the sun to his resting place, clothed in all his array of purple and gold;—the quietness of the scene brought to my mind a sense of loneliness almost painful. Could you have been with me to have strolled over that green meadow, or to have said one word, how much peace would have flowed into my mind. The beauties of nature had a charm, the voice of God came to me through every motionless leaf—on every blade of grass—the odor of the flower and in every breath of air I drew—seemed only to increase my loneliness . . .

Have you ever reclined upon some gentle slope, some hillside in a beautiful country with your eyes half closed and your mind away from care dreaming of soft and gentle love and the lovely and beautiful in nature and art with a far away and o'er the hills feeling of the chameleon sky, the glowing sunshine and soothing shadows—the distant smokey town—the rich autumnal foliage, bits of green pasturage and nibbling sheep and stately trees, a stream of water winding in and out around some wooded headland . . . [?]

I lived at the Greenwood Lake during the summers for a number of years, and I formed a strong attachment to the place. It has been the origin of many of my pictures—it is a beautiful sheet of water in the northern part of the state of New Jersey with about one half of it extending into New York. In earlier times when it was more of a wilderness than now it was called "Double Pond." The lowland, an island that spreads out in the center of it, divides it and gives it the appearance of two lakes, and now that it has become a fashionable summer resort some people call it "Wundermere." I have represented it in the autumn time when the foliage is all aglow with color and the atmosphere is mellow, and tender, and refreshing.

Martin Johnson Heade (1819-1904)

A compulsive traveler who ranged over the entire world, Martin Johnson Heade painted the most varied body of work by any American artist of the nineteenth century. Portraits, landscapes (often of marshes), enlarged flowers (particularly orchids and roses), hummingbirds and owls—all were transformed into haunting images by his constant obsession, the brooding and exotic silences of the inner place. Settling permanently in St. Augustine, Florida, in 1883, he painted a number of marsh scenes, of which "Great Florida Sunset, 1887" is outstanding. He wrote "letters" for Forest and Stream as "Didymus"; his letter of May 24, 1883, takes a curious anticonservation direction, but the editor's note did not:

I HAVE WANDERED, in an unsatisfactory way, nearly all over the state without finding a spot whence I cared to stop until I reached St. Augustine, and that I did find a fascinating, quaint old place, and is bound to be the winter Newport . . . Everything now is nicely arranged to make [it] by far the most attractive winter resort in Florida, except—the lack of wisdom in her rulers. Nearly half the men who visit Florida have an eye to enjoyment in the way of shooting and fishing, and when they come here and find they are not

JASPER FRANCIS CROPSEY: AUTUMN GREENWOOD LAKE, 1866
Collection, Mrs. John C. Newington, Greenwich, Connecticut, o/c, 22 x 36.

MARTIN JOHNSON HEADE: GREAT FLORIDA SUNSET, 1887
Collection, Flagler Junior College, St. Augustine, Florida. Courtesy Peridot Gallery, o/c, 52 x 96.

[43

permitted to shoot plover or other birds, even on the marshes a mile from the city, they very naturally feel disgusted, and many of them leave for places where they have some liberty; and the city loses thousands a year....

It is astounding—in view of the sensible efforts made by Jacksonville and other towns to attract the travelling crowds—that a set of men can be found who will resolutely shut their eyes to the great advantage they possess of making their city by all odds the most attractive point in the state, and look calmly on while other cities draw the population and the money. But luckily for those who come here to enjoy themselves, these wise men have no control beyond the city limits, and the shooting and fishing is far better than any place where I have been, if it is not "unsurpassed."

[Editor's note] The only reason our correspondent found the birds aplenty about St. Augustine is just because of the much-needed and very proper prohibitory provisions of which he complains. Nowhere in this country has there been a more marked instance of the extermination of birds than that which took place in the vicinity of St. Augustine when the rush of Northern visitors first set in there. The gunners spared nothing that had wings. The prohibitory law was enacted as a last resort. We are glad to learn that it has accomplished its purpose.

Paul Resika (1928-)

A product of the "push-pull" esthetics of Hans Hofmann, with whom he once studied, Paul Resika is a painter's painter. He knows how to use the past, not simply as a source for a superficial manner but rather as an approach to paint handling and pictorial organization. He carries on in the tradition of Corot and Courbet, and is a contemporary master of the "motif," a way of isolating natural forms along lines established through centuries of landscape painting. He is well known as a teacher, particularly of drawing, and has exhibited widely. Although he has painted in a number of places, including Mexico and Italy, he is best known for his brilliantly accurate renderings of the ponds, dunes, and bays of Cape Cod. The following is excerpted from an interview in 1970:

YOU COULDN'T say about this pond that it is a spectacular landscape. It is an intimate corner, but it isn't picturesque. It's very homey. It was pastureland originally. Sheep were there; then it grew over. It is a fresh-water pond, has fish, geese, lilies. The dunes separate it by not more than 200 feet from the ocean. The trees come down to the bank. In the evening they get very dark. It is enclosed, almost like a stage, yet there is no central figure on that stage. It is undramatic, except for this darkness, except for some bit of contrast. The cape that has this dramatic sea is ordinary land. Even when it is clear on the Cape, the light is soft. If you are high up in the tropics everything is different. There is no atmosphere between objects. The Cape has a long twilight and so does the whole temperate world. We have a light of sentiment. To an outdoor painter it's light more than topography.

Outdoor painting is a spot. I don't believe it should be too conscious. That's the whole point. You treat a motif; you just go at it like a machine for an hour, or an hour and three quarters.

I like a picture to dry in a place where it's painted. The good air—there's something about it. It is tough to retouch a picture, to repaint it. A picture should be done *then*. There's a very nice feeling about a painting that's done in the same place. That's the thing about painting outdoors, you don't paint. It paints.

PAUL RESIKA: HORSELEECH POND, 1968
Courtesy Peridot Gallery, New York, o/c, 24 x 36.

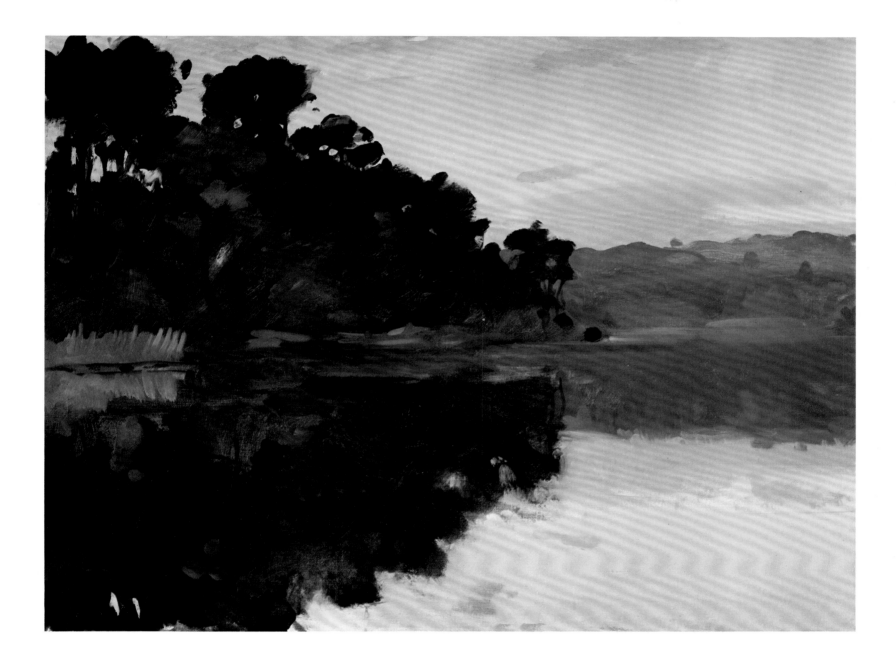

Richard Bogart (1929-)

Richard Bogart is always looking and listening to the sights and sounds of nature. Yet, when the time comes to paint, he turns inward, confident that he will quietly distill what nature is truly about. His paintings are mirror images of states of mind—inner meditations—which find reflection in the natural world. It is a Wordsworthian point of view, mystical rather than sentimental, intuitive rather than rational. Bogart was born in Highland Park, Michigan, went to Cass Tech High School in Detroit, graduated from the Art Institute of Chicago, and studied briefly at the University of Illinois. Although he had his first one-man show in 1958 (Wells Street Gallery in Chicago), it wasn't until ten years later that Richard Bogart had his first solo exhibit in New York, at the prestigious Poindexter Gallery. The art press responded immediately and enthusiastically to his work, creating an audience overnight for this apparently late-blooming artist. Bogart lives the year round at the edge of tame woods in Monroe, Connecticut, for reasons the following interview explains:

I AM ALWAYS fascinated by islands, a clump of island things in water. There are lots of them around here. I like the idea of a ship at sea—something like Lady of the Lake in King Arthur—with a head coming out of the water, only this happens to be trees. It could be a ghost whaler. I have all these kinds of thoughts when I'm doing the thing. I'm a studio painter. I don't know if I could really paint outdoors. I have to be moved and and distill it through a long process of filters, so that I can put what I really want on because I don't really feel that nature's that good in itself. It needs a painter's help. The thing itself is terrific, but I can help it much more, I can make it better. I can exercise discipline where nature can't. All it has to do is go through the cycle.

I'm not particularly fond of the sun. The glare bothers me. I love rain; I like being closed in by the rain . . . the grays, the mist, the mist-drenched feeling, the quietness, it's always been in my mind. It was brain-washed into me when I was in Detroit. There was always something about Connecticut as being a very refined place where you could get solitude. I don't know where that image came from but I always got the feeling from anything I ever read that Connecticut was a sanctuary—that painting is like a sanctuary and there are these sanctuaries in Connecticut where, if you are careful and take out the power lines and the beer cans, you can see a really awe-inspiring kind of a thing. Secretly I have always wanted to live in Connecticut.

RICHARD BOGART: OF ROOKS AND RISING MISTWAVES, 1968
Courtesy Poindexter Gallery, New York, o/c, 47 x 55.

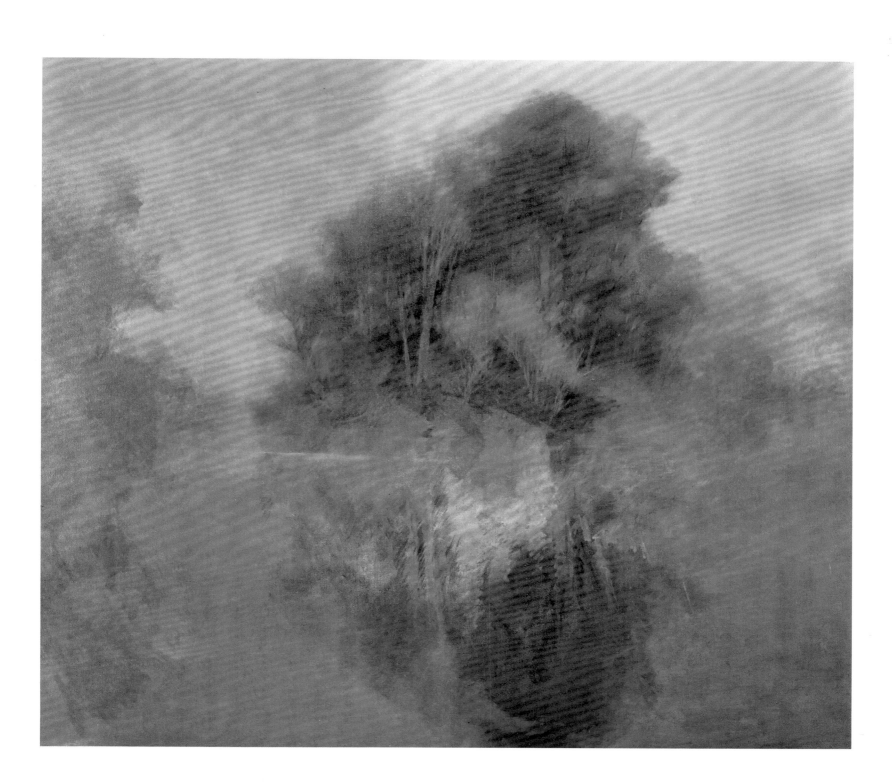

Sharon Yates (1942–)

Sharon Yates is the youngest artist whose work is reproduced in this book. Her paintings exert an almost hypnotic force, so intently has she looked at the land, indeed, into the land. She was born in Rochester, New York, educated at Syracuse University (spending a semester in Florence, Italy, under the University's study abroad program) and at the Newcomb School of Art, Tulane University, New Orleans. In 1970 she received a grant from the America the Beautiful Fund's "Artists for Environmental Conservation" program; this grant enabled her to live during the summer as artist-in-residence at the Fund's estate, "Roland" in Fauquier County, Virginia. Selections from her Roland journal follow:

July 13th–10:45 P.M.

Is the color of the water in that pond a non-color . . . something electric? A silent hazy blue-green gray-like a swamp–but it is not dirty. It glistens with ripples at times and I get dizzy with the optical effect. The reflection in the early morning is crystal clear with the absence of wind and the presence of a friendly rising sun. The green jewel and ochre foliage emerge from the depths of that deep, deep GREEN–that green is the deepest far away green I have ever seen or felt–even the foliage from the trees has not yet had that mysterious depth. The water is another sky. Some days the water and sky color are almost identical–it is that small fraction which I select for all the difference. . . .

July 20th–11:00 P.M.

It is cooling off now–there is a sound out there that persists I have never heard before–like someone breathing very heavily–the rain-soaked leaves give some drops and very old crickets speak SUMMER! Summer time is the most sensual of all for me–it is when all life is at a maximum blossom–even the temperature of air, humidity. It is so still now.

July 22nd–10:15 P.M.

. . . A silence is necessary so I can begin to be familiar to another world of sounds. The frogs in the Pond, the insects, the wind. Every whisper of noise in the grass would cause me to turn–I never thought I could be so sensitive to what was happening behind me as I am now while I paint. I never dreamt of what distractions could persist in painting out of doors. I know I must become more immersed in where I am while painting to enter another world. I need no interruptions of lawnmowers, cars, onlookers, I need truly to be absolutely alone. Endlessly alone. And then it is truly not loneliness because I become aware then of how I belong to this earth–this tree–that sunrise.

July 29th–3:35 afternoon

Nothing is forever–humanity is this. But Nature seems to endure. I wonder how a tree feels losing green leaves to bright hues and then nothing again for a cold stark white or just gloomy gray winter. I look up at those velvet greens, every shade is there like whispers in this hazy hot air–it is just another very deep summer day. In Virginia–rich, sensuous land. . . .

August 1–11:00 P.M.

My paintings have not been of a particular time, or mood of light or color but rather a common denominator for an entire day of change . . .

SHARON YATES: ROLAND POND No. 2, 1970
Collection of the artist, Baltimore, Maryland, o/c, 12 x 15.

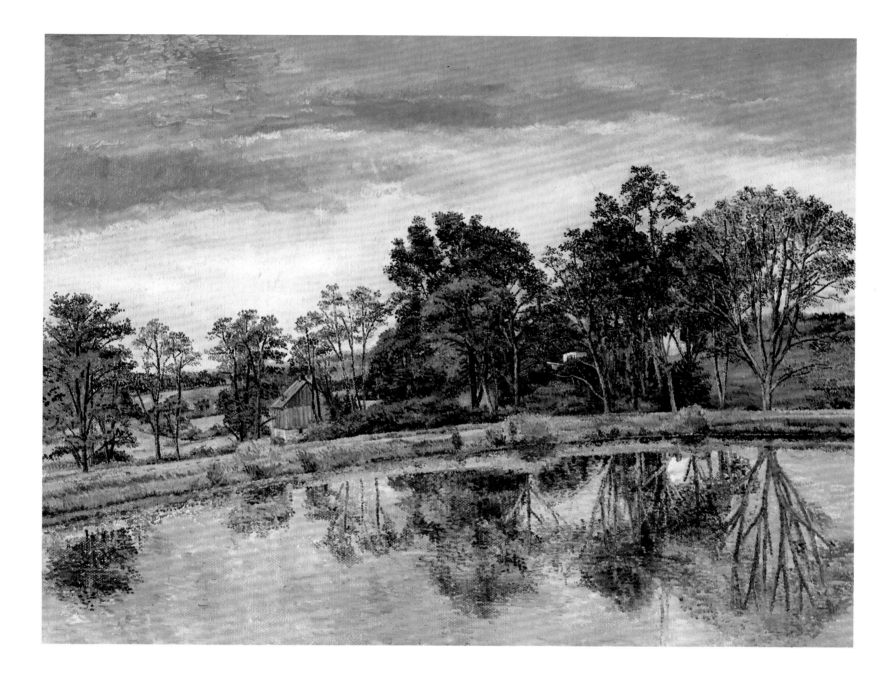

August 14th—11:00 P.M.

I decided to walk through the fields down to the Pond at early afternoon for my rest...I crossed a small creek just before the field where the horses graze at dusk. I enjoy my new site. I despise the June bugs. They notify me of their landings with noise of jet planes—those gray ugly tiny beasts, I hate them...One day I returned at mid-afternoon and found several creeping across the freshly painted reflections in the Pond; I became enraged...

August 22nd—midnight

My canvases take time because I need suspension for drifting—painting slowly allows me to penetrate a space and time without being consciously concerned for technical process....I need time to change me. That is what my work is about if anything.

September 8th—10:15 P.M.

Autumn is infringing upon the epic summer stillness and a new mood prevails now...the suspense of what events will follow this blocked heavy summer, a summer isolated in time and place from all I have ever done before. To live and paint harmoniously uninvolved with institutionalized Art. There has been no structure here at Roland...just sunrise, and sun's zenith and sunset. The humidity, the haze and the heat eliminating definition of color and far off spatial acuity. I have had no responsibilities except for my own sanity....

To submerge myself in a totally remote reality; that dialogue with nature, that struggle to yield instead of fight—the rain is good, the blinding light is good...the changing effects causing my pigments to be misleading hourly. Such frustration is welcomed to heighten my awareness of what actually does exist....

Elmer Bischoff (1916-)

A luscious celebration of the joys of flesh, paint, and the outdoor air infuse the timeless paintings of Elmer Bischoff. If we are to believe the following comments, which he made in a recent letter, then California-bred Bischoff may be unique in this book—a nature painting artist who is put off by some of the elemental aspects of nature.

THIS PAINTING ("Figure in the Cove") is a studio invention. The rock with a tunnel-like opening is similar to one I once saw at the California coast near Mendocino. I've made a number of paintings with ocean and rocks in one form or another viewed close up and nearly at ground level. I've wanted these scenes to appear both voluptuous and ominous. In actuality the ocean repels me. I find it mildly attractive only from a safe distance.

ELMER BISCHOFF: FIGURE IN THE COVE, 1965
Courtesy Staempfli Gallery, New York, o/c, 80 x 80.

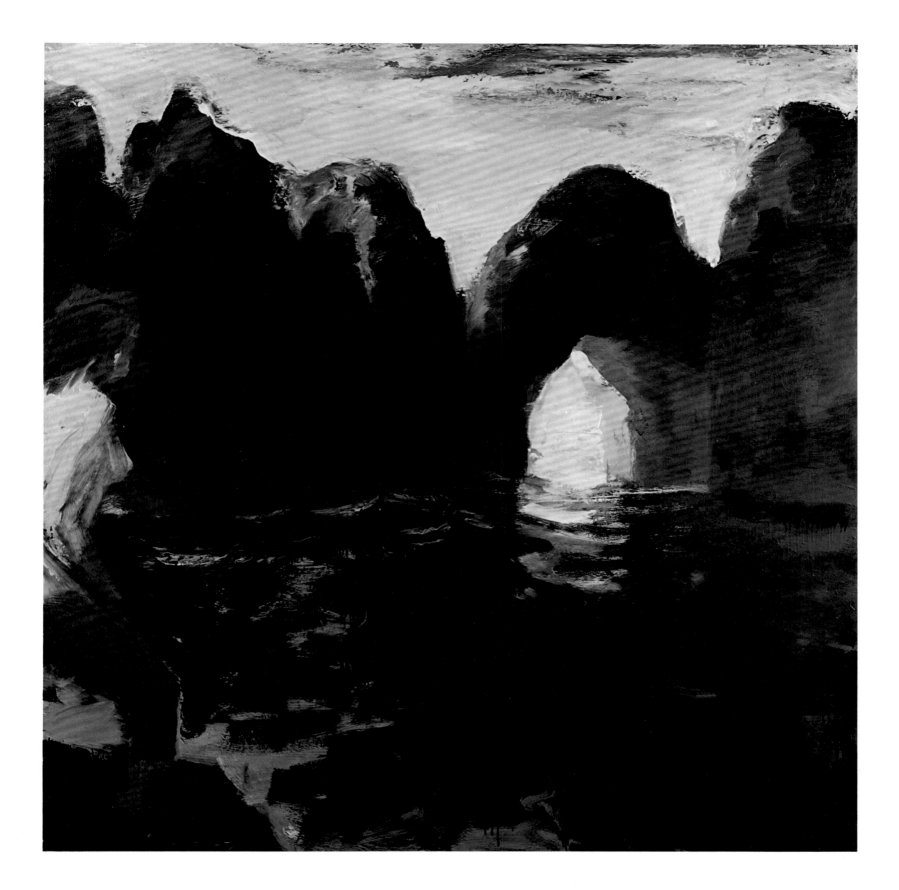

Rockwell Kent (1882-1971)

Vigorous and free thinking, Rockwell Kent carried on an unabashed love affair with the natural world for more than three quarters of a century. He was a prolific writer (eight books) and gifted illustrator, perhaps most familiarly known for his Random House edition of Moby Dick. He once summarized the relationship between his life and his art, saying, "Life always has been first to me; the arts I've practiced have been its by-products—even as I myself am one." The paintings reproduced here, once offered by the artist to a regional museum in Maine (and declined by that institution presumably because of his independent political views), have since been presented to the Russian people. The text is from his book, It's Me Oh Lord, *published in 1955. Monhegan is a small, rock-bound island nine miles off the coast of Maine.*

MONHEGAN! We've reached the harbor's mouth; we've entered it; we've reached the wharf; we're moored; I've jumped ashore. My bag in hand I race up the hill, and . . . like a puppy let out of his pen I'm off at a run to see, to climb, to touch, and feel this wonder island that I've come to.

Hugging the harbor shore I reached the island's south-west end where the surf makes suds around the Washerwoman rock or breaks on Norman's ledge; then on to the gulley of Gull-Rock, and over it to climb the smooth, bald, winter-surf-washed rock itself; and on again to Burnt Head; and then down over a broad waste of boulder-strewn bare granite ledges to climb the head land, White head, and from its one hundred and fifty foot height look far out to sea toward Africa and England. It was so vast, so beautiful that clear blue day, with the green grass and dandelions at my feet and Blackhead, its twin headland seen from there in all its mass and dignity of form. Blackhead, its dark face splotched with gleaming guano! Then on again, over the intervening minor headlands and the gulleys tangled with the debris of fire and storm, and through such tangles, up and over Blackhead; and down again—real climbing now to pass the rocky gorges—to the massive granite cube of Pulpit Rock. And there at last, like a quiet passage in a tumultuous symphony, a sheltered harbor after the storm, the gentle, grassy slopes of Green Point, still thickly starred with the blossoms of strawberries to be. And the seal ledges and their happy denizens—sunning themselves or slithering and diving off the rocks as though in sport, the water dotted with their almost human heads. Then on to Deadman's Cove and its lone fish-house out-post of the settlement. And always inland from the shore there was the dark spruce forest, another world, a deeply solemn world that I should come to know.

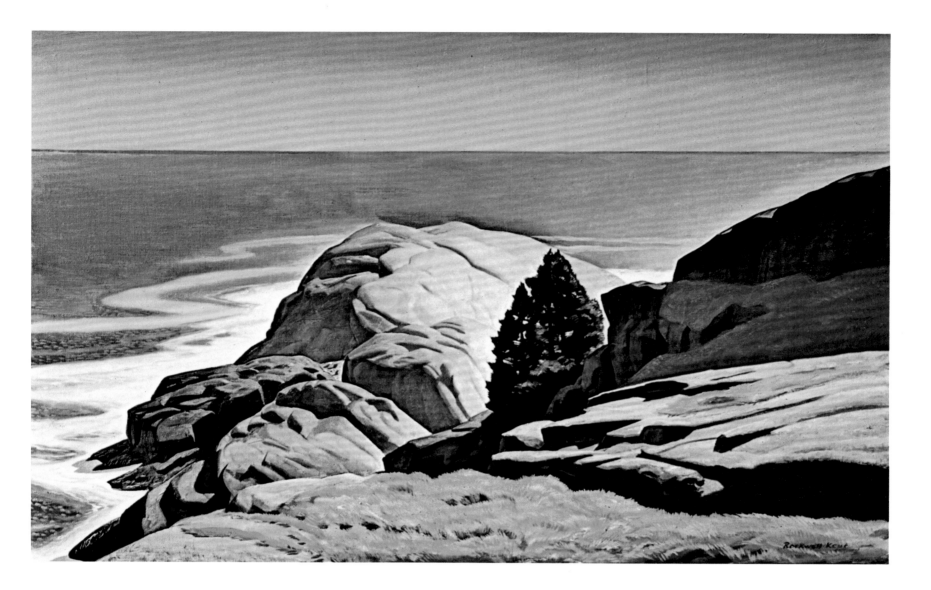

John Marin (1870-1953)

Breezy and bouyant, the watercolors of John Marin were a perfect visual realization of an unbridled, high-spirited artist. Although he painted in New Jersey, his birthplace, and in New Mexico, among other places, it is in Maine that he did his most memorable work. Marin's prose, like his cryptic paintings, is filled with pokes and jabs, exuberant trills and boldly summarizing statements. The following excerpt from a letter to Alfred Stieglitz, Marin's patron and dealer (his first one-man show at the Stieglitz 291 Gallery was in 1909) was written in the summer of 1917 from Small Point, Maine, the summer he made "The Cove," an unusually literal (for Marin) and delightful response to a quiet beach.

I HAVE JUST BEEN in for a swim and feel better. The water delicious, the sands to the touch of the feet. Big shelving rocks, hoary with enormous hanging beards of sea weed, carrying forests of evergreen on their backs. The big tides come in swift, go out swift.

And the winds bring in big waves, they pound the beaches and rocks. Wonderful days. Wonderful sunset closings. Good to have eyes to see, ears to hear the roar of the waters. Nostrils to take in the odors of the salt sea and the firs.

Fresh fish, caught some myself. Berries to pick, picked many delicious strawberries. The blueberries are coming on.

On the verge of the wilderness, big flopping lazy still-flying cranes. . . . The solemn restful beautiful firs. The border of the sea . . . my island looks tantalizingly beautiful.

It's great to sit on a gigantic rock and look at the waters!

JOHN MARIN: THE COVE, 1917
Collection, The Columbus Gallery of Fine Arts, Columbus, Ohio, gift of Ferdinand Howald, watercolor, 16 x 19.

Winslow Homer (1836-1910)

"[Homer] is a genuine painter; that is to see, and to reproduce what he sees is his only care...".—so wrote Henry James in 1875. Homer is perhaps the most dominant figure in nineteenth-century American nature painting, an artist of enormous popular appeal whose achievement and orginality in pictorial terms have not always been recognized by the public at large. Homer was born in Boston, apprenticed to a local lithographer, began contributing to Harper's Weekly *in 1857, and studied briefly at the National Academy of Design night school. After a trip to Paris, Homer returned to his New York City home, leaving it frequently for trips to the White Mountains of New Hampshire, the Adirondacks, Virginia, and Glouster. He made a critically important visit to Tynemouth, England in 1881. Art historian Barbara Novak says of this trip, "There he consummated a marriage to the sea that would last until his death, reinforcing an artistic and personal concern with the obdurate and obstinate, with survival in the face of elemental dangers.... If nature was a source of wonder to the landscapists up to the mid-century, to Homer it was a worthy antagonist to be taken on...." Homer settled in Prout's Neck, Maine, in 1883, maintaining a studio there until his death, twenty-seven years later. He was not a literary man; his letters are quite brief and he did not keep journals or notebooks. His thinking was distinctly visual. The excerpts below come from three sources: two letters written to M. O'Brien and Son, Homer's dealer, and originally quoted by William Howe Downes in his book on Homer; a 1903 memoir of John W. Beatty, Homer's friend, in Lloyd Goodrich's book on Homer.*

Scarboro, Me., March 15, 1902

IT WILL please you that, after waiting a full year, looking out every day for it (when I have been here), on the sea that I wanted; but as it was very cold I had to paint out of my window, and I was a little too far way,—and although making a beautiful thing—it is not good enough yet, and I must have another painting from nature on it.

Scarboro, Me., October 29, 1902

...I will now say the long-looked-for day arrived, and from 6 to 8 o'clock A.M. I painted from nature on this...finishing it, making the fourth painting on this canvas of two hours each. This is the best picture of the sea that I have painted....

...people never see that early morning effect. They don't get up early enough. They only see that duck pond down there... [gestures to quiet sea].

When I have selected the thing carefully, I paint it exactly as it appears.

...the rare thing is to find a painter who knows a good thing when he sees it...you must not paint everything you see. You must wait, and wait patiently, until the exceptional, the wonderful effect or aspect come. Then if you have enough sense to see it—well, that is all there is to that.

...I try to paint truthfully what I see, and make no calculations....I never try to make things stronger than when they are actually in nature....Of course, I go over them in the studio and put them in shape.

I have learned two or three things in my years of experience. One is, never paint a blue sky—Why, because it looks like the devil, that's all. Another thing; a horizon is horrible—that straight line!

It is a gift to be able to see the beauties of nature.

WINSLOW HOMER: Early Morning after a Storm at Sea, 1902
Collection, The Cleveland Museum of Art, gift from J. H. Wade, o/c, 30¼ x 50.

Sanford Robinson Gifford (1823-1880)

In 1855 Sanford Gifford sailed from New York to Great Britain, beginning a two-year sojourn in Europe in search of scenery. "Night on the Hudson River" done in the 1870s, confirms Gifford's lifelong interest in air, light, time, and weather. He kept a journal and wrote detailed letters back to his family, one (to his father) reflecting his reaction to his initial Atlantic crossing from the first evening at sea, revealing a painter's observant eye:

TOWARDS EVENING I went on deck and sat for a long while watching for the sun to come down below the grey cloud which covered the heavens like a dome, and to appear in the narrow strip of clear sky which was along the western horizon. It presently burst brilliantly out through the lower edge of the curtain and, as I hoped from the state of the atmosphere, gave us a fine setting. Besides the rich crimson and gold of the clouds, the sea was lighted with brilliant color, and the crests of the waves, as they broke in the track of the sun, looked as if loaded with myriads of opalescent gems. . . .

Friday 18th—did not feel well after getting up, but managed to eat a boiled egg and half a slice of toast. After getting up on deck, however, in the fresh pure air and brilliant sunshine, I began to feel myself again and to be conscious anew of the blessings of simple existence in the enjoyment of sunlight and air. All day the sky was perfectly cloudless and the air and water sparklingly bright. When I first came on deck, before the sun got very high in its course, and looked westward over breaking "whitecaps," each cap in bursting disclosed in its spray a brilliant rainbow. The effect was as beautiful as it was singular. . . .

The sun went down beautifully from a perfectly clear sky. There is a peculiarity about a clear sun-set at sea that I have never observed on land. When a part of the sun's disc disappears below the sharp horizon line, the corners (so to speak) become rounded and it assumes the form of an ellipse. There was a fine star lit sky at night, and I had the good luck to see the delicate crescent of the *new* moon over my *right shoulder*. . . .

. . . in the fair-weather sea, such as we have had thus far, I find very little of the grandeur and sublimity that we hear so much talked of. The sea as it has been since we left New York is neither grand nor sublime.

SANFORD ROBINSON GIFFORD: NIGHT ON THE HUDSON RIVER, c. 1870
Collection, Douglas B. Collins, Longmeadow, Massachusetts, o/c, 8½ x 15½.

It has very much the appearance of New York Bay during a windy day—the surface I mean. I have experienced far grander emotions in sweeping the great horizon as it is seen from the highlands of Neversink than I have here in mid-ocean. The reason is, I think, that *there* we have objects with which to compare its immensity. The perspective of the shore also gives a much greater appearance of distance to the horizon. Here the circle, of which our steamer is the center, appears very contracted—the more so the clearer the atmosphere.

. . . the weather has been changing since morning. The sky is overcast and misty, and signs of a storm are gathering. "Old oceans grey and melancholy waste" is a line which runs in my mind today, and it is very descriptive of the present aspect of the sea. . . .

. . . the wind rose into a gale, and the sea rose with it. However tame and monotonous the fair weather sea may appear, nothing of any kind can be said of his present majesty. It has given me an entirely new conception of water power. In these mighty masses of water which tower and culminate above us till they threaten to overwhelm us with irresistible weight and mass, and in the fearful valleys which lie between, are genuine elements of the sublime. At sunset, when the sun burst over the heaving sea, the sight was magnificent beyond anything I have ever seen. As the sunlight streamed over the great waves of the distance, suffusing them with a rich golden atmosphere, they looked like distant ranges of mountains bathed in a warm sunset. The nearer waves were vast hillsides of dark blackish green, the thinner crests transparent, and as they were hurled off into spray, glittering and flashing with light and color, the warmer and more brilliant as they contrasted with the foam that rolled pure blue down the shadowed side.

. . . Eleven days at sea are quite enough to satisfy me, and I will gladly exchange its monotony, its discomfort and its majesty, for a firm footing on mother earth.

Reuben Tam (1916-)

Reuben Tam was born in Hawaii, educated at the University of Hawaii and at Columbia, lives in Manhattan, and has summered for many years on Monhegan Island off the coast of Maine. He is the senior painting instructor at the Brooklyn Museum Art School and has shared his insights with students at such widely separated institutions as Oregon State University in Corvallis and Skowhegan in Maine. On Monhegan, his perennial rock garden (which winter storms oblige him perennially to restore each May) is the joy of the island. He was first shown in New York by Edith Gregor Halpert at her Downtown Gallery in 1945 and today his work is included in the permanent collections of almost every major museum in the United States. A painter of the eventful in nature, Tam joins in his art a profound understanding of how nature works with a poet's gift for the lyric impulse. Since he is a poet as well as a painter, two of his poems are published here for the first time, in addition to a brief excerpt from a letter (1968).

TO PUT THOUGHTS of the long years of search into words is difficult, much like trying to explain a mountain with a handful of stones. But let me try.

Always in my life it has been *place*. My work as a painter, my most personal concerns, my obsessions and interests and involvements, all these have their origins and substance in the spirit of place. I was born on Kauai, northernmost of the Hawaiian Islands, an island of towering volcanic mountains, deep canyons, lava headlands, and beaches. The sea was all around, intimate, and vast. I wanted to walk the shores of the world.

Geology was always the most compelling study for me. And geomorphology, especially. To be aware of the origin of land, the revisions of the earth's crust, the imminent changes of the coastline, the cycles and surprises of weather and climate. Later, I was to look upon glaciers and moraines, and to spend summers in a region of fog. The weathers of place—how they surround me in their fullness and their variety!

In most of my paintings there's the plane of land (or sea) and the space of sky. There's always light—sunlight of morning or noon or the daytime, or moonlight, or even starlight or the light of the aurora. In painting land, I usually try to describe the terrain—rock, sand, grass, or faulting, stratification, erosion and the marks of time. I like distance in my depiction of landscape, and I can't imagine land without distance. I paint horizons.

If I say, to begin with, that my painting is a by-product of my enthusiasm for nature, then you'll see that my other activities are as integral a part of my life as my painting is. Here are some things I do. I paint, I write poems, I grow vegetables, I go rock-hounding and collect rocks, I tend a large garden of perennials set among rocks, I grow exotic tropical plants indoors under fluorescent lights, I star-gaze and follow comets, I hike, explore coastlines and read maps, collect sea shells, study the hybridizing of orchids, gather edible seaweeds, photograph sunsets and storm fronts. I'm a moonwatcher and I wade in tide pools.

Poetry is my first love in literature. Certain poets have helped to give me direction, by illuminating those areas of experience that have to do with wonder, time, light, the earth, and the sea. Some of these poets

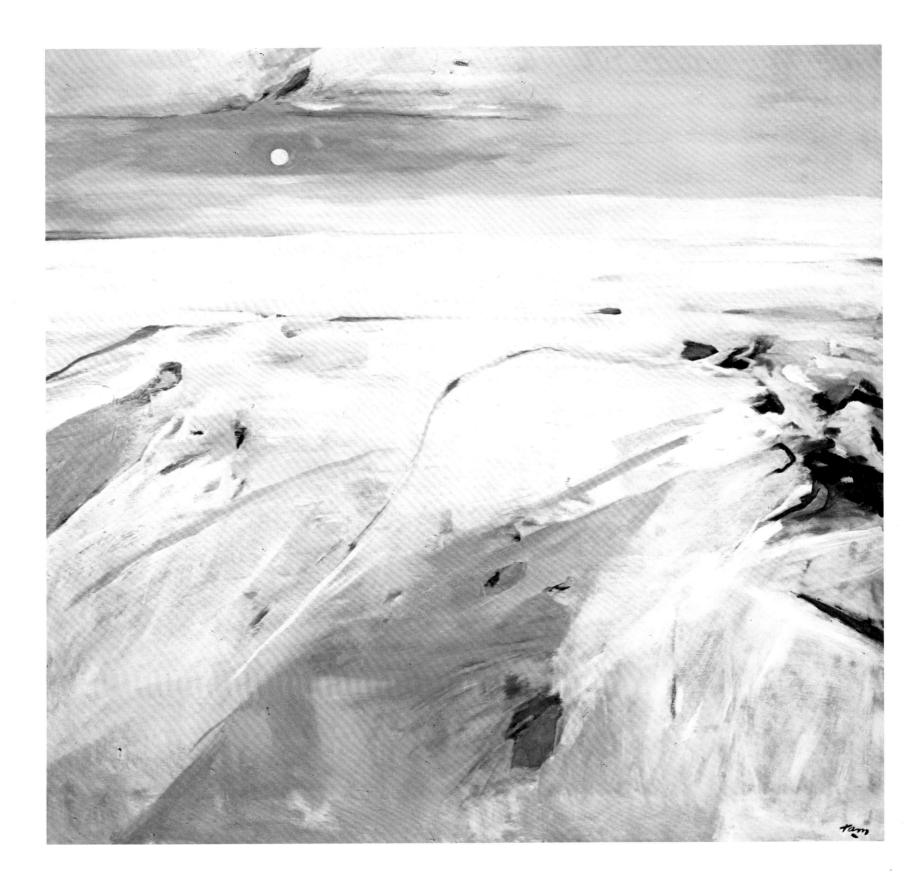

are Aiken, Jeffers, Crane, W. S. Graham. Certain books were very important to me during the early years of my search—W. H. Hudson's *A Hind in Richmond Park*; Rockwell Kent's *Voyaging* and his *N by E*, Bridge's *The Uttermost Part of the Earth*, Haberly's *Pursuit of the Horizon; The Life of George Catlin*. And in addition, certain books on geology, oceanography, and travel.

 I like places where the forces of nature are in active operation. Some of my favorite places are:

 The coast of Alaska—storm-ridden, a place of grey seas and dark cliffs rent with glaciers and hanging valleys.

 The Canadian Rockies—moraines, tarns, screes, towering peaks, ice fields.

 The Oregon coast—a grand display of tides, weathering, and seacliffs.

 The islands of Hawaii—volcanoes, rain forests, red earth, the origins of land in mid-ocean.

 Monhegan Island, Maine—the drowned coast, the region of fog, grandeur and intimacy, the edge of land, and the sea.

 I have also seen other interesting places: Northern California, Yukon Territory, Cape Cod, and the Bay of Fundy.

I'd like very much to visit other places with exciting weather, dramatic terrain, and most important of all, a prevalence of *wilderness*.

Island Night

Walk to the shore to see moonlight.
The low wind skims the rockweed,
Blending the rustle of bay-caught drift
And our singing of a song of islands.

The warm rocks leading to the outland
Are spaced apart it seems for us, firm
As the matrix based in our keep.

There lies the sea, the full moon on us
And the amethyst waves. The current
Leans outward in a vast waste of glint.
The shoals and coves are ashen craters.

Juniper, barnacle, heath aster,
Clinging with us to the outer strata,
Ride the great ellipse this night.

In the cold fading light,
In the glare of sudden meteors,
See the screes fall away,
And the unanchored,
And the mica of our days,
And the moult of our divinity.

REUBEN TAM: WHITE SEA, 1969
Courtesy Coe Kerr Gallery, New York, o/c, 42 x 44.

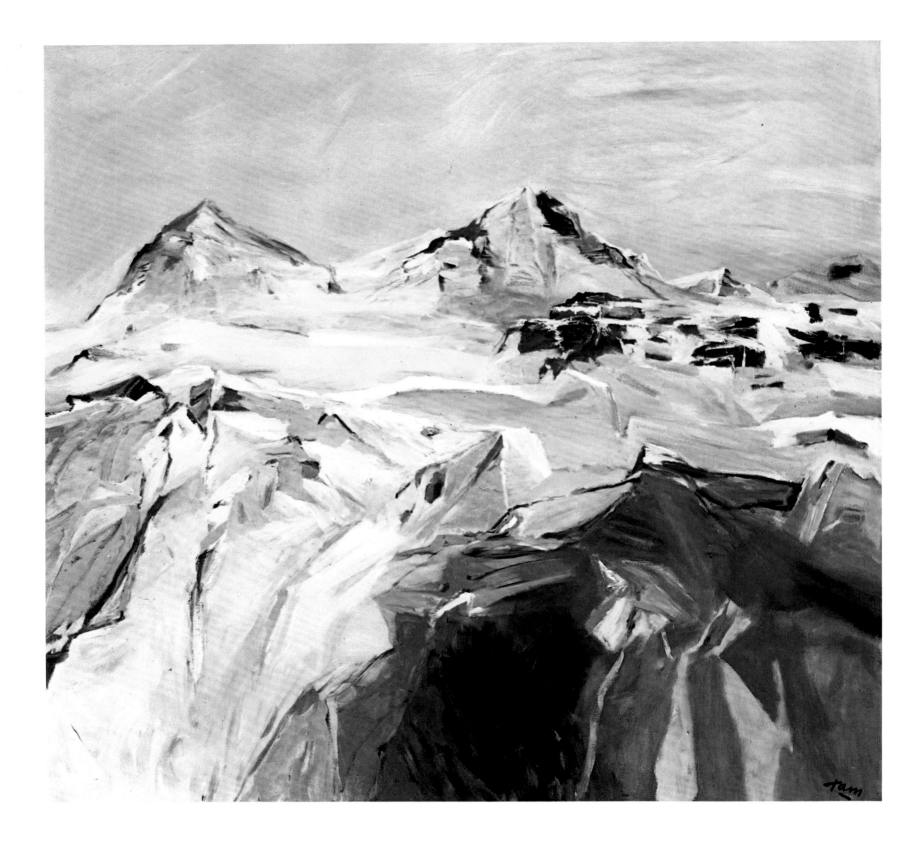

Among Mountains

Ultimate in a serrate sky,
In a balance of ice planes and peaks,
The range of white mountains shone,
Signed in parallels for my landscape.

But place fell into shields, scattering
Contours on an undivided plain.
A glacier turned the ridges around,
Against the heave of a warm time.

And night was ground water seeping
Through labyrinths in rock. Terrain
Was the stay of sediment
After each passing anarchy.

Stones of the moraine, what terminal?
Crack of quartz, facet of which dark?
Taut at my step, the fault
Staggers this day I've walked into.

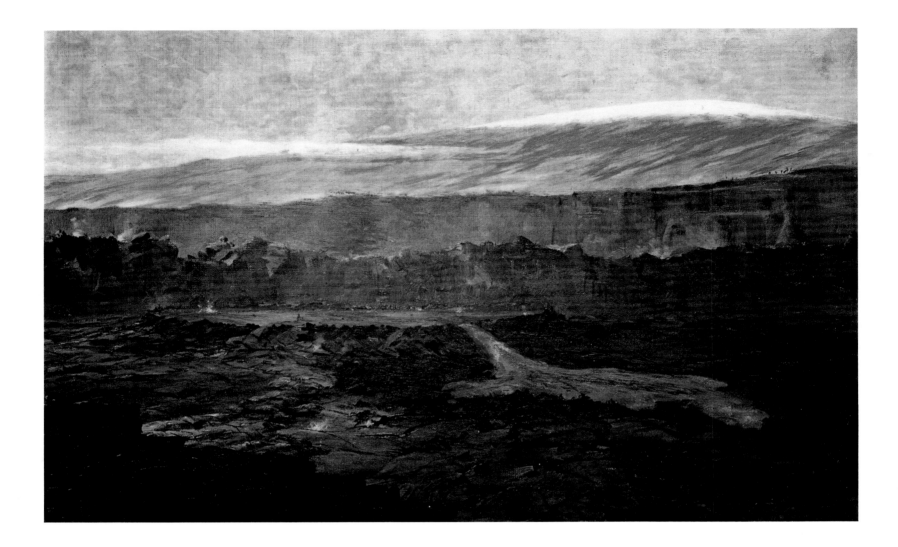

David Howard Hitchcock (1861-1943)

Hawaii claims at least one outstanding nineteenth-century American landscape painter, David Howard Hitchcock, who was born in Hilo and educated at Punahou School and at Oberlin College. He received his art training at the San Francisco Art School (in 1885) and the National Academy of Design in New York, which he followed by a three-year residency at the Julienne Academy in Paris. He exhibited in the Paris Salon of 1893 and won the Gold Medal at the Alaska-Yukon Exhibition in Seattle in 1894. Describing himself as a "conservative impressionist," he painted beaches, mountains, and volcanoes with a disarming directness, typified by "Halemaumau," done in 1894.

DAVID HOWARD HITCHCOCK: HALEMAUMAU, 1894
Collection, Hawaii Volcanoes National Park, Hawaii, o/c, 20 x 36.

[69

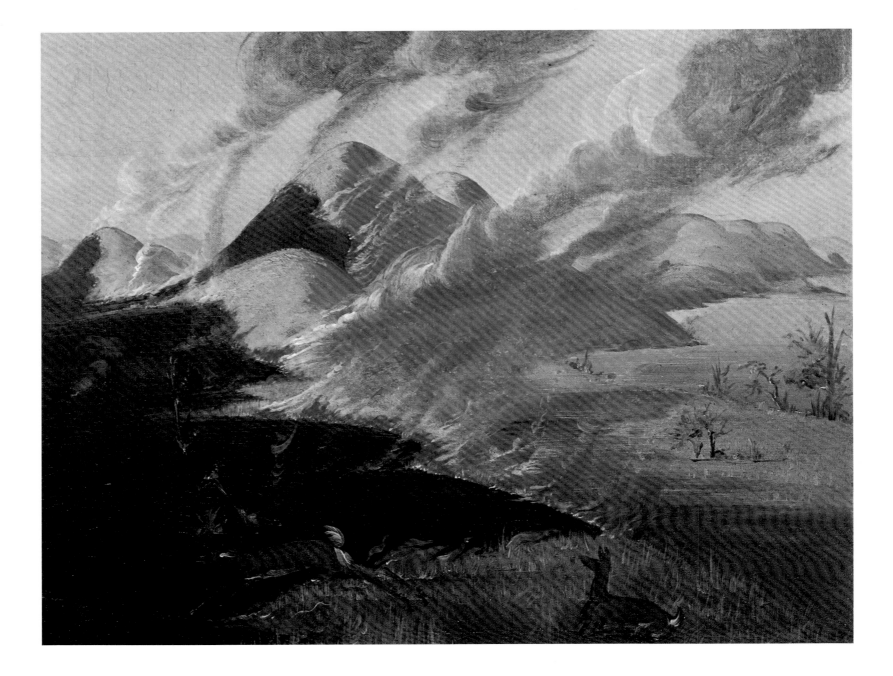

George Catlin (1796-1872)

An early drop-out from a career as a lawyer, George Catlin gave his entire mature life over to the Indians—traveling under the most primitive conditions to see them (not only to the western United States but to South America as well), to paint pictures of chiefs and tribes, their ritual ceremonies and every-day activities, and to describe the beauty and variety of the natural landscape. Single-minded in his devotion to the Indians, Catlin at one time so impressed General William Clark, co-leader of the Lewis and Clark expedition, that he served as an artist-in-residence to the Bureau of Indian Affairs operating out of St. Louis, traveling with Clark to treaty councils with the Sauk and Fox, Iowa, Missouri, Omaha, and Sioux tribes. Catlin was also a showman; he gathered more than five hundred of his paintings and Indian artifacts (collected along the way) into his "Indian Gallery," which he promoted in New York and other east coast cities, later taking the show to Europe, where an amazed and delighted royalty invited him to exhibit. In 1841 Catlin published a detailed two-volume work, The Manners, Customs, and Conditions of the North American Indians. *The first excerpt from it, below, was written in 1832 at the mouth of the Yellowstone on the Upper Missouri River. The second comes from approximately the same period, when Catlin visited Fort Leavenworth, in northeastern Kansas, where he saw members of the Kickapoo, Shawnee, and other woodland tribes who had been removed from their homelands in the east. The two sketches of burning demonstrate that while man may work in harmony with nature, employing even fire for ecological ends, nature always possesses the potential for an abrupt and frightening impact on the landscape.*

MOUTH OF THE YELLOWSTONE, 1832

. . . I am here in the full enthusiasm and practice of my art. That enthusiasm alone has brought me into this remote region, three thousand five hundred miles from my native soil; the last two thousand of which have furnished me with almost unlimited models, both in landscape and the human figure, exactly suited to my feelings. I am now in the full possession and enjoyments of those conditions, on which alone I was induced to pursue the art as a profession; and in anticipation of which alone, my admiration for the art could ever have been kindled into a pure flame. I mean the free use of nature's undisguised models, with the privilege of selecting for myself. If I am here losing the benefit of the fleeting fashions of the day, and neglecting that elegant polish, which the world say an artist should draw from a continual intercourse with the polite world; yet have I this consolation, that in this country, I am entirely divested of those dangerous steps and allurements which beset an artist in fashionable life; and have little to steal my thoughts away from the contemplation of the beautiful models that are about me. If also, I have not here the benefit of that feeling of emulation, which is the life and spur to the arts, where artists are associates together; yet I am surrounded by living models of such elegance and beauty, that I feel an unceasing excitement of a much higher order—the certainty that I am drawing knowledge from the true source.

. . . No man's imagination, with all the aids of description that can be given to it, can ever picture the beauty and wildness of scenes that may be daily witnessed in this romantic country.

FORT LEAVENWORTH, LOWER MISSOURI

The prairies burning form some of the most beautiful scenes that are to witnessed in the country, and also some of the most sublime. Every acre of these vast prairies (being covered for hundreds and hundreds of miles, with a crop of grass, which dies and dries in the fall) burns over during the fall or early in the spring, leaving the ground of black and doleful color.

There are many modes by which the fire is communicated to them, both by white man and by Indians—

GEORGE CATLIN: PRAIRIE MEADOWS BURNING—UPPER MISSOURI, 1830
Collection, National Collection of Fine Arts, Smithsonian Institution, Washington D.C., o/c, 19 x 27.

par accident, and yet many more where it is voluntarily done for the purpose of getting a fresh crop of grass, for the grazing of their horses, and also for easier traveling during the next summer, when there will be no old grass to lie upon the prairies, entangling the feet of man and horse, as they are passing over them.

Over the elevated lands and prairie bluffs, where the grass is thin and short, the fire slowly creeps with a feeble flame, which one can easily step over; where the wild animals often rest in their lairs until the flames almost burn their noses, when they will reluctantly rise and leap over it, and trot off amongst the cinders, where the fire has past and left the ground as black as jet. These scenes at night become indescribably beautiful, when their flames are seen at many miles distance, creeping over the sides and tops of the bluffs, appearing to be sparkling and brilliant chains of liquid fire (the hills being lost to the view), hanging suspended in graceful festoons from the skies.

But there is yet another character of burning prairies that requires another Letter, and a different pen to describe—the war, or hell of fires! where the grass is seven or eight feet high, as is often the case for many miles together, on the Missouri bottoms; and the flames are driven forward by the hurricanes, which often sweep over the vast prairies of this denuded country. There are many of these meadows on the Missouri, the Platte, and the Arkansas, of many miles in breadth, which are perfectly level, with a waving grass, so high, that we are obliged to stand erect in our stirrups, in order to look over its waving tops, as we are riding through it. The fire in these, before such a wind, travels at an immense and frightful rate, and often destroys, on their fleetest horses, parties of Indians, who are so unlucky as to be overtaken by it; not that it travels as fast as a horse at full speed, but that the high grass is filled with wild pea-vines and other impediments, which render it necessary for the rider to guide his horse in the zig-zag paths of the deers and buffaloes, retarding his progress, until he is overtaken by the dense column of smoke that is swept before the fire—alarming the horse, which stops and stands terrified and immutable, till the burning grass which is wafted in the wind, falls about him, kindling up in a moment a thousand new fires, which are instantly wrapped in the swelling flood of smoke that is moving on like a black thunder-cloud, rolling on the earth, with its lightning's glare, and its thunder rumbling as it goes.

GEORGE CATLIN: PRAIRIE MEADOWS BURNING—UPPER MISSOURI, 1830
Collection, National Collection of Fine Arts, Smithsonian Institution, Washington D.C., o/c, 19 x 27.

Alfred Jacob Miller (1810-1874)

In 1837 Captain William Drummond Stewart, Scottish explorer, invited Alfred Jacob Miller to accompany him on a six-month exploration of the Wyoming territory subsidized by The American Fur Trading Company. Miller made more than one hundred on-the-spot sketches, which served as reference material for many oil and watercolor paintings of Indians and the western landscape, completed in his Baltimore studio over a thirty-year period. Miller's remarks are taken from his "Western Journal."

THE TOURIST who journeys to Europe in search of a new sensation, must by this time find that his vocation is nearly gone. Italy and its wonders have been described so often they begin to pale. Egypt, the River Nile, Cairo, and the pyramids have been "done" to death. Greece and her antiquities are as familiar as household words. What will the enterprising traveller do under these untoward circumstances? Well, here is a new field for him. These mountain lakes have been waiting for him for thousands of years, and could afford to wait thousands of years longer, for they are now as fresh and beautiful as if just from the hands of the creator.

In all probability, when we saw them not 20 white men had ever stood on their borders. A single Lake and Mont Blanc are the wonders of Europe, but here are mountains and lakes reaching from Tehuantepec to the Frozen Ocean in the North, or upwards of 50 degrees—nearly one seventh part of the globe—ample room and verge enough, one would think, for a legion of tourists.

From the elevated rock in the foreground, from whence the sketch was taken, a wide expanse of land, declining gently to the margin of the Lake, spreads out before you, broken up with groups of trees. To the left the rocks rise abruptly from the bosom of the Lake, and behind these rocks a junction takes place with the Lake:—to the North of this. The peak covered with snow in the distance to the left of the sketch is the highest of this range,—probably not less than 15,000 feet above the prairie. Silence reigned supreme over this beautiful sheet of water, only at long intervals broken by the descent of an avalanche, crashing through the trees and among the rocks. As we viewed these Lakes a single line of Keats occurred to us wherein he says

A thing of beauty is a joy forever.

And truly it is so!—It would require but a slight stretch of imagination to fancy the myriads of people in the next generation flocking to see these sublime scenes. The whizzing of steam on the "Sweet Water," the whirring of car wheels through the "South Pass" are a foregone conclusion. It is only a question of time.

ALFRED JACOB MILLER: LAKE SCENE (MOUNTAIN OF WINDS), c. 1858-1860, based on sketch, 1837
Collection, The Walters Art Gallery, Baltimore, Maryland, watercolor, 9¾₆ x 13⅞₆.

Thomas Moran (1837-1926)

Nowhere in the brief history of the United States is the connection between an artist's work and governmental action for the preservation of open space more clearly seen than in the case of Thomas Moran's painting, "The Grand Canyon of the Yellowstone," first exhibited in the spring of 1872. Its enthusiastic reception helped promote establishment of Yellowstone National Park and indeed, contributed to the founding of the National Park system. Moran's large painting, and others similar to it, were based on sketches he made while exploring the headwaters of the Yellowstone as part of a survey team headed by F. V. Hayden, a geologist-surgeon. Hayden later described the expedition in detail in a Preliminary Report of the U.S. Geological Survey of Montana and Portions of the Adjacent Territory *published by the Government Printing Office in 1872. The virtuoso watercolors done on the spot were Moran's best, and an excellent example is "Great Blue Spring of the Lower Geyser Basin, Fire Hole River," reproduced here. Also participating in the Yellowstone expedition was photographer W. H. Jackson, whose reminiscences of Moran, published in 1936, lead off these excerpts. The description of the Great Blue Spring is taken from the Hayden report. The final note is from a letter written in 1872 by Congressman M. H. Dunnell to Secretary of the Interior Delano, underscoring the need for prompt public acquisition of Yellowstone. Taken together, these pieces and the Moran watercolor recreate a confluence of events and opinions that marked the beginnings of federal action for land preservation.*

MORAN WAS 34 years old, at this time, of slight and frail physique and did not seem to be of the kind to endure the strenuous life of the wilderness. But he was wiry and active in getting about and keenly enthusiastic about his participation in the work of the expedition. He had never camped out before, except for a night's bivouac on the shore of Lake Superior ten years previous. This was his first experience in Rocky Mountain regions, coming out entirely unacquainted with his associates, or with the country itself and all that related to it. But he made the adventure with fine courage and quickly adapted himself to the new and unfamiliar conditions and, as it turned out later, none was more untiring on the trail, or less mindful of unaccustomed food or hard bed under a little shelter tent, than he was. At home, fastidious and careful of his diet, with a strong aversion to fats, he wrote in one of his letters about camp life, "You should see me bolt the bacon!"

... Moran had never ridden a horse before, and while getting accustomed to this experience, was quite unabashed in using his camp pillow to protect his rather spare anatomy from the hard lines of a McClellan saddle. But, despite his lack of horsemanship, he made a picturesque appearance when mounted. The jaunty tilt of his sombrero, long yellowish beard and portfolio under his arm marked the artistic type....

—W. H. JACKSON

But the most formidable of all (the geysers) is near the margin of the river. It seems to have broken out close by the river, and to have continually enlarged its orifice by the breaking down of its sides. It evidently commenced on the east side, and the continual wear of the under side of the crust on the west side has caused the margin to fall in, until an aperture at least 250 feet in diameter has been formed, with walls or sides 20 to 30 feet high, showing the laminae of deposition perfectly. The water is intensely agitated all the time, boiling like a cauldron, from which a vast column of steam is ever rising, filling the orifice. As the passing breeze sweeps it away for a moment, one looks down into this terrible seething pit with terror. All around the sides

are large masses of the siliceous crust that have fallen from the rim. An immense column of water flows out of this cauldron into the river. As it pours over the marginal slope, it descends by numerous small channels, with a large number of smaller ones spreading over a broad surface, and the marvelous beauty of the strikingly vivid coloring far surpasses anything of the kind we have seen in this land of wonderous beauty; every possible shade of color, from the vivid scarlet to a bright rose, and every shade of yellow to delicate cream, mingled with vivid green from minute vegetation. Some of the channels were lined with a very fine, delicate yellow, silky material, which vibrates at every movement of the waters. Mr. Thomas Moran, the distinguished artist, obtained studies of these beautiful springs and from his well-known reputation as a colorist, we look for a painting that will convey some conception to the mind of the exquisite variety of colors around this spring.

—F. V. HAYDEN

. . . the hot springs and geysers represent the last stages—the vents or escape-pipes—of these remarkable volcanic manifestations of the internal forces. All of these springs are adorned with decorations more beautiful than human art ever conceived, and which have required thousands of years for the cunning hand of nature to form. Persons are now waiting for the spring to open to enter in and take possession of these remarkable curiosities, to make merchandise of these beautiful specimens, to fence in these rare wonders, so as to charge visitors a fee, . . . for the sight of that which ought to be as free as the air or water.

In a few years this region will be a place of resort for all classes of people from all portions of the world. . . . If this bill fails to become a law this session, the vandals who are now waiting to enter into this wonderland will, in a single season, despoil, beyond recovery, these remarkable curiosities!

—M. H. DUNNELL

Worthington Whittredge (1820-1910)

The dilemma of the nineteenth-century American artist who returns to his native land after a long European residency and finds himself in conflict over esthetic goals was happily resolved by Worthington Whittredge. He completely immersed himself in the American landscape, working back from profound and clarifying experiences in nature to a more personal esthetic. Always a sharp observer of natural detail, he accompanied Major General John Pope on an extensive western expedition, making numerous small paintings along the way, including several vivid depictions of the great plains. At the age of eighty-five Whittredge wrote his autobiography, which includes the following account:

AT THE CLOSE of the Civil War, I was invited by General Pope to accompany him on a tour of inspection throughout the department of the Missouri, as it was then called, which embraced all the eastern portions of the Rocky Mountains and New Mexico. I went as a civilian on the staff of the General without connection with any newspaper, but to pursue my studies as I thought best or most to my advantage. There were no completed railroads at that time across the plains. We left Fort Leavenworth, on the first of June 1865, not long after Lee's surrender, with a small detachment of cavalry and about three hundred militia in wagons drawn by mules. The expedition was one of great interest and value to me. I rode that summer over two thousand miles on horseback, passing up the Platte to Denver and along the base of the mountains until we crossed them at the Spanish Peaks and went over to Santa Fe and Albuquerque, on the Rio Grande, returning over the old Cimarron trail about the end of September.

I had never seen the plains or anything like them. They impressed me deeply. I cared more for them than for the mountains, and very few of my western pictures have been produced from sketches made in the mountains, but rather from those made on the plains with the mountains in the distance. Whoever crossed the plains at that period, notwithstanding its herds of buffalo and flocks of antelope, its wild horses, deer and fleet rabbits, could hardly fail to be impressed with its vastness and silence and the appearance everywhere of an innocent, primitive existence. There was the nomad and the rattlesnake to be taken into consideration, and they both occasionally made some noise. We usually made a march of thirty-three miles a day, which was performed between daybreak and one o'clock in the afternoon. On arriving in camp I gave my horse to an orderly and went at once to the wagon for my sketch box which was usually covered deep with camp furniture, but I always got it out, and while the officers were lounging in their tents and awaiting their dinners, I went out to make a sketch, seldom returning before sundown. Then I had to partake of a cold dinner, if there was anything left for me at all.

Denver was our first stopping place of more than a day or two. There we arrived at an early hour and encamped one mile from the American House, the best hotel in the place. It was a small two-storied building taken up chiefly on the first floor by a bar and a billiard room. Some brick had been used in the structure of this building; the rest of the town consisted of wooden buildings, and they were scattered about without regularity of streets. There were a great many drinking saloons and invariably they had billiard tables attached. One wondered how so many billaird tables ever got to Denver when everything from the east had to be transported across the plains by ox teams, which was very expensive. A ham was worth eight dollars, flour was twenty dollars a barrel, a single copy of the daily paper twenty-five cents. I paid ten dollars for a bushel of onions and then had the indiscretion to leave them standing in my tent. When I came from sketching at night I found General Pope and his officers had eaten them all up. But after our long march we were all famished for fresh vegetables, and I could excuse them, especially as they were clever fellows and did much to make me happy.

Denver had the appearance of a spruced up mining camp. It had not lost the look of its "Pike's Peak" mining days. Parts of costly mining machinery lay abandoned by the roadside all along the route to Denver

and some pieces of this machinery were still to be seen in Denver. But the war was over and the inhabitants were growing bold and predicting great things for their town.

After stopping a few days, we took up the line of march towards New Mexico. The trail led along over foothills at the base of the mountains which were always to the west of us; often on reaching an elevation we had a remarkable view of the great plains. Due to the curvature of the earth, no definite horizon was visible, the whole line melting away, even in that clear atmosphere, into mere air. I had never seen any effect like it, and it was another proof of the vastness and impressiveness of the plains. Nothing could be more like an Arcadian landscape than was here presented to our view. On elevations of long sloping lines, we looked out eastward from undergrowths of large pines with scarcely any underbrush or debris of any sort, the earth covered with soft grass waving in the wind, with innumerable flowers often covering acres with a single color as if they had been planted there. . . .

. . . At that time the Indians were none too civil; the tribe abounding in the region were the Utes. We seldom saw any of them, but an Indian can hide where a white man cannot, and we had met all along our route plenty of ghastly evidences of murders, burning of ranches, and stealings innumerable, until I had frequently been ordered to come back to camp when the General saw my white umbrella perched on an eminence in one of the most innocent looking landscapes on earth, and not an Indian having been seen for days. With the usual slight reminder from the General that the Indians might be about, and an order that I was not to go out of sight of the ambulance, I set out alone long before sunrise to find some elevation from which I could view the scene I desired. I left the ambulance in a sort of valley hidden by trees and commenced my tramp over hills of no great magnitude covered with grass without any shrubbery whatever or hiding place for even a rabbit. Distances in Colorado are very deceptive. I pursued my way along from one eminence to another, and as is often the case for a sketcher, with less and less satisfaction with the view, until finally I wandered fully four miles from our last night's camp or from sight of any human being, good or bad, and there on quite a hill I stuck up my umbrella and went to work, a very conspicuous object in such a place. . . . I took occasion . . . to set down my sketch box and carefully examine my revolver and buckle up my straps generally, then I sat down and resumed my work. I always regarded my umbrella pike as quite as good a weapon at close range as any revolver ever made, but I concluded to leave the umbrella standing and assume the attitude of one indifferent to what might happen. . . .

. . . approaching the end of our round-trip march [we found] the Southern Pacific Railroad has been built nearly to Fort Riley. Here we were to disband and leave our troops behind, while all the rest of us soon scattered and went our different ways. It was pleasant to see something like home again, and yet there was a dread monster in the way. The cholera had broken out and had gotten this far on its march westward. The soldiers of the Fort had been moved out upon the prairie. Still many died. On arriving in St. Louis a few days later, Dr. McDonald, who had been with us during our whole journey, was attacked by the disease and died in a few hours. We were not permitted to see him buried. As we began to approach the Missouri River, we caught glimpses of Indians and of immense herds of buffalo. On crossing the river and gaining a considerable elevation, looking back over a gently rolling country, we had a fine view of what seemed to be endless chains of the latter. They darkened the entire prairie as far as the eye could reach with a most singular effect upon the landscape. Long, crooked, black, wavering, living lines approaching the river coming down to drink. We had been more or less near the herd for several days, and every day were allowed to kill two or three, but General Pope gave the strictest orders that no more could be killed than would furnish the soldiers with a little fresh meat.

On leaving our troops behind, I sought out my orderly and gave him a dollar, not for himself but to buy a few oats for the faithful old cavalry horse which I had ridden over two thousand miles. I hardly expected the horse would ever see the oats, but I thought some recognition of his services was due from me.

John James Audubon (1785-1851)

Audubon was more than a painter of birds. He was a man of extraordinary intelligence, gifted with a scientist's curiosity for the explanatory detail; he was also a writer capable of evoking, with lyric ease, a landscape that even in his own day was fast fading from existence. He was born in Haiti of a Creole mother and French father. He dedicated much of his life to production of the portfolio The Birds of America, *for which he wrote an* Ornithological Biography, *first published in 1834. "The Pinnated Grous" watercolor is noteworthy not only for its excellent treatment of the once-common bird but also for the unusually complete description of the landscape, most probably the barrens of Kentucky. Although landscape details in many "Audubon" watercolors were done by other artists, this watercolor is totally Audubon's. The following excerpts are from* Ornithological Biography. *The second was inspired by a trip down the Ohio River and is remarkable for its observations on problems of population growth and industrialization.*

THE PINNATED GROUS

It has been my good fortune to study the habits of this species of Grous, at a period when, in the district in which I resided, few other birds of any kind were more abundant. I allude to the lower parts of the States of Kentucky, Indiana, Illinois, and Missouri. . . .

The Barrens of Kentucky are by no means so sterile as they have sometimes been represented. Their local appellation, however, had so much deceived me, before I traveled over them, that I expected to find nothing but an undulated extent of rocky ground, destitute of vegetation, and perforated by numberless caverns. My ideas were soon corrected. I saw the Barrens for the first time in the early days of June, and as I entered them from the skirts of an immense forest, I was surprised at the beauty of the prospect before me. Flowers without number, and vying with each other in their beautiful tints, sprung up amidst the luxuriant grass; the fields, the orchards, and the gardens of the settlers, presented an appearance of plenty, scarcely any where exceeded; the wild fruit-trees, having their branches interlaced with grape-vines, promised a rich harvest; and at every step I trod on ripe and fragrant strawberries. When I looked around, an oak knob rose here and there before me, a charming grove embellished a valley, gently sloping hills stretched out into the distance, while at hand the dark entrance of some cavern attracted my notice, or a bubbling spring gushing forth at my feet seemed to invite me to rest and refresh myself with its cooling waters. The timid deer snuffed the air, as it gracefully bounded off, the Wild Turkey led her young ones in silence among the tall herbage, and the bees bounded from flower to blossom. If I struck the stiff foliage of a black-jack oak, or rustled among the sumachs and brambles, perchance there fluttered before me in dismay the frightened Grous and her cowering brood. The weather was extremely beautiful, and I thought that the Barrens must have been the parts from which Kentucky derived her name of the "Garden of the West!"

There it was, that, year after year, and each successive season, I studied the habits of the Pinnated Grous. It was there that, before sunrise, or at the close of day, I heard its curious boomings, witnessed its obstinate battles, watched it during the progress of its courtships, noted its nest and eggs, and followed its young until, fully grown, they betook themselves to winter quarters.

[As for] the tiger lily, this beautiful plant, which grows in swamps and moist copses, in the Northern and Eastern States, as far as Virginia, as well as in the western prairies, attains a height for four or five feet, and

makes a splendid appearance with its numerous large drooping flowers, which sometimes amount to twenty or even thirty on a single stem. . . . The flowers are orange-yellow, spotted with black on their upper surface, the petals revolute. I was forced to reduce the stem, in order to introduce it into my drawing, the back ground of which is an attempt to represent our original western meadows.

THE OHIO

When my wife, my eldest son (then an infant), and myself were returning from Pennsylvania to Kentucky, we found it expedient, the waters being unusually low, to provide ourselves with a skiff, to enable us to proceed to our abode at Henderson. . . .

It was in the month of October. The autumnal tints already decorated the shores of the queen of rivers, the Ohio. Every tree was hung with long and flowing festoons of different species of vines, many loaded with clustered fruits of varied brilliancy, their rich bronzed carmine mingling beautifully with the yellow foliage, which now predominated over the yet green leaves, reflecting more lively tints from the clear stream than ever landscape painter portrayed or poet imagined.

The days were yet warm. The sun had assumed the rich and glowing hue which at that season produces the singular phenomenon called there the "Indian Summer." . . . We glided down the river, meeting no other ripple of water than that formed by the propulsion of our boat. Leisurely we moved along, gazing all day on the grandeur and beauty of the wild scenery around us. . . .

When I think of these times, and call back to my mind the grandeur and beauty of those almost uninhabited shores; when I picture to myself the dense and lofty summits of the forest, that everywhere spread along the hills, and overhung the margins of the stream, unmolested by the axe of the settler; when I know how dearly purchased the safe navigation of that river has been by the blood of many worthy Virginians; when I see that no longer any Aborigines are to be found there, and that the vast herds of elks, deer and buffaloes which once pastured on these hills and in these valleys, making for themselves great roads to the several salt-springs, have ceased to exist; when I reflect that all this grand portion of our Union, instead of being in a state of nature, is now more or less covered with villages, farms, and towns, where the din of hammers and machinery is constantly heard; that the woods are fast disappearing under the axe by day, and the fire by night; that hundreds of steam-boats are gliding to and fro, over the whole length of the majestic river, forcing commerce to take root and to prosper at every spot; when I see the . . . destruction of the forest, and . . . civilization [transplanted] into its darkest recesses; when I remember that these extraordinary changes have all taken place in the short period of twenty years, I pause, wonder, and, although I know all to be fact, can scarcely believe its reality.

Whether these changes are for the better or for the worse, I shall not incline to say. . . .

JOHN JAMES AUDUBON: THE PINNATED GROUS, n.d.
Collection, The New-York Historical Society, watercolor, 25 x 36.

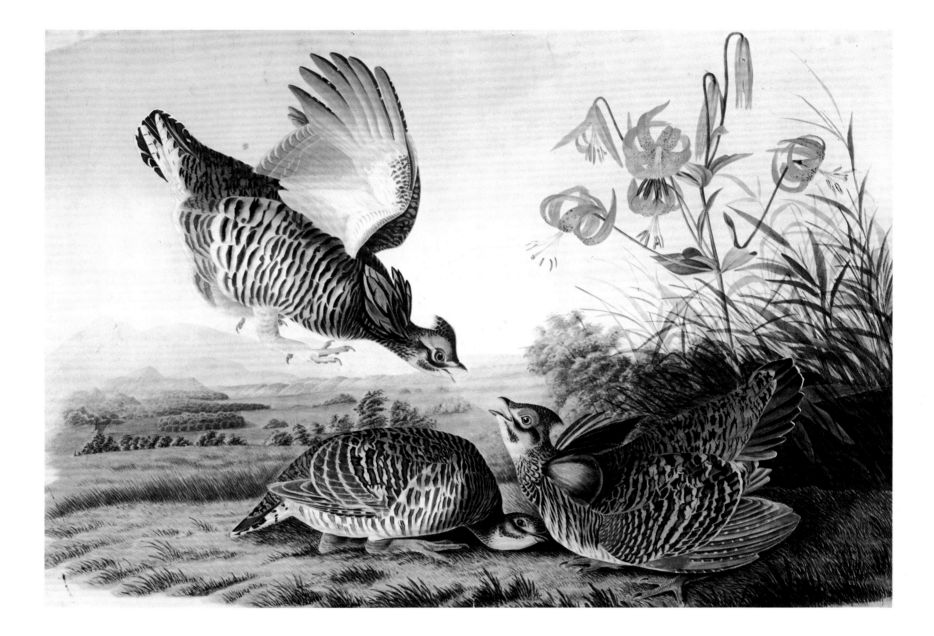

Thomas Hart Benton (1889-)

In the 1930s America in depression looked inward, taking modest satisfaction in the songs and myths of the middle country. Regionalism in art—a turning away from the rampant modernism of Paris—was ascendant, led by a now familiar trio, John Stewart Curry, Grant Wood, and Thomas Hart Benton. Their paintings, when seen in retrospect, remind us first of attitudes not so much about art as about the life and social values of the period, much the way an Andy Warhol image may some twenty-five years hence. Benton, who has outlived the others, stands as the quintessential regional artist. Born in Missouri, Benton has been a newspaper cartoonist, a set designer for Fox films, a muralist, a teacher, a painter, and an impassioned advocate of the rural life. In 1937 he wrote a lively account of his life entitled, An Artist in America, *from which the excerpt below comes. "Lewis and Clark at Eagle Bridge" was completed when he was seventy-nine.*

WHERE DOES THE WEST BEGIN?

Strung in a zigzag pattern up and down the ninety-eight degree line, there is a marked change of country which is observable wherever you journey westward, whether in the North, the Middle country, or the South. About this line, though the exact distance from it is highly variable, the air becomes clearer, the sky bluer, and the world immensely bigger. There are great flat stretches of land in Louisiana, there are prairies in Illinois, Iowa, Missouri, but the experienced traveler in the United States does not confuse these with the West. Even though these more eastern prairies may present the same great vistas which are connected in our thoughts with the West, they lack the character of infinitude which one gets past the 98° line.

In the prairie lands, coming between the old forest country of the Middle West and the plains, one is able at times to see for great distances, but it is as if one were set down in the center of a big plate with elevated edges. There are definite ends to the horizon, which acts as an enclosure and sets a limit to things. In the West proper there are no limits. The world goes on indefinitely. The horizon is not seen as the end of a scene. It carries you on beyond itself into farther and farther spaces. Even the tremendous obstructions of the Rocky Mountains do not affect the sense of infinite expansion which comes over the traveler as he crosses the plains. Unless you are actually in a pocket or a canyon the Rocky Mountains rise in such a way, tier behind tier, that they carry your vision on and on, so that the forward strain of the eyes is communicated to all the muscles of the body and you feel that you can keep moving forever without coming to any end. This is the physical effect of the West.

THOMAS HART BENTON: Lewis & Clark at Eagle Creek, 1968
Collection, the artist, Kansas City, Missouri, o/c.

Harold Bruder (1930-)

Harold Bruder is an Easterner with a passion for the West. Born in Brooklyn, educated at Cooper Union, he lives now in Flushing, New York, with his wife and children. It is in the West, however, where Bruder comes fully alive. Admitting that he is certainly not the first to see Bryce, Zion, and the rest, Bruder nevertheless brings to his experiences an innocent delight in finding what are, for him at least, new lands and new sites. "Colorado National Monument" is a beautifully wrought, deceptively simple view of the scene right back of the visitors' center, a vantage point described in an interview:

WHY DO PEOPLE paint pictures of landscapes? They paint landscapes, number one, because its a tradition . . . number two, because you love Poussin—he painted great landscapes and you want to [create] that feeling of great space with a fugue-like repetition of many things in that space; thirdly you have a life experience. You've experienced something by being there and its vitally important to you. I couldn't paint any subject unless I felt it was . . . important to paint.

I don't like New England. I don't like green mountains. I don't feel like painting them and I don't respond to green landscapes. I like desert, I like rocks, and I like the sense of the West. I can smell the air, feel the vast open sky.

There are two kinds of things you see there. There are things you look up at, like Zion (you drive in), and there are things you've got to go to the edge of—an abyss—and look in, and the thing opens up. What I try to get in the paintings is a quality of discovery. . . .

The thing about the "Colorado National Monument" painting is it kind of says this is in front of that which is in front of that. You look at the space and it has a very definite color feeling, color weight, the color weights come at you very rapidly because of the aerial perspective. The space in back gets grayer, loses its intensity of color . . . you begin to read that very rapidly. Another thing I like is that . . . swinging action on the left, the big boulder on the right and then you start going into this space. The space recedes in a series of layers and you can see it; it's there. . . .

This Colorado National Monument—its a very civilized landscape—it's very well organized by the Park Service in Colorado. You travel on a road that will take you around—this view is right in back of the visitors' center, and you could sit there quite calmly, do your watercolor, and if you had the time even set up and paint there. In some places you couldn't do that because you would be burned out by the sun, starved, nobody would find you—you would be discovered as a skeleton next to a canvas one day. I'm urban. I need those visitors' centers to sit in and look and have slides put in front of me and tell me what it is that I am going to be looking at, how old the rocks are. . . .

Yet it was exciting for me to do the Canyonlands before anybody else had got there.

HAROLD BRUDER: COLORADO NATIONAL MONUMENT, 1967
Collection, Mr. and Mrs. S. Robert Furst, White Plains, o/c, 18 x 18.

William Kienbusch (1914-)

William Kienbusch arrived at painting the hard way (ironically by way of Hotchkiss Academy and Princeton—magna cum laude from the latter), after long years of apprenticeship and search, wandering across the United States and Europe, studying with a startlingly diverse stable of teachers—Eliot O'Hara, Henry Poor, Robert Osborn, Abraham Rattner, and Stuart Davis. He was discharged from the Army in 1946—he was a camouflage instructor in an engineer battalion—and gave himself one year to see if he could be an artist. Two events made the answer positive; first, he found his subject— Maine—where he spent that first summer as a civilian, and second, he discovered casein paint, a medium he has worked in from that time. He has been a nature painter ever since, evolving his own landscapes in highly abstract terms. His forms and colors are evocations of landscape, not renderings of it. He recently traveled far from his familiar Maine, to Colorado. The resulting image has the unmistakable Kienbusch imprint—visual clarity, confident design, color impact, and a pure response to the natural landscape. In the following letter he discusses "The Prairie."

"THE PRAIRIE" was painted as the result of a visit in February 1970 to the ranch of an old friend who lives near Estes Park, Colorado.

Most of my life I have painted landscape pertaining to the coast of Maine and Penobscot Bay. This landscape is, indeed, rugged, but it is also intimate,—spruce trees, bayberries, wild roses, little beaches, rocks and ocean.

Flying west, beyond the Mississippi River, I looked down from the plane, and there were the neat geometric-patterned wheat fields and, later, the vast prairie. Everything was yellow ochre and warm brown, and above was that incredible blue, blue, sky.

Driving around Colorado, outside of Denver, I realized I was always looking straight out (the prairie) or straight up (the mountains). This was very different from the coastal Maine landscape, except perhaps, the sense of unlimited ocean. Indeed, the prairie seemed like an ocean.

I made many sketches for "The Prairie." The difficulty was to arrive at that sense of immenseness, the way out horizon. There was also the problem of getting a feeling of neatness, everything moving away from the eye in a nice order. And finally that impossible blue sky. I've never seen anything like it, except in Greece.

WILLIAM KIENBUSCH: THE PRAIRIE—COLORADO No. 2, 1970
Courtesy Kraushaar Galleries, New York, casein on paper, 31¾ x 41¾.

Anne Poor (1918-)

Anne Poor is the Emily Dickinson of American painting, an artist of quiet intensity who finds whole worlds of feeling revealed in the simplest of flowers. She was born in New York City, and worked in Art Students League classes with Alexander Brook, William Zorach, and Yasuo Kuniyoshi before she had finished high school. She assisted her stepfather Henry Varnum Poor in painting true fresco murals in Washington, D.C., and completed several post office murals on her own. Enlisting in the Women's Army Corps in 1943, she worked as army artist-correspondent in the Air Force until 1945, traveling throughout the Pacific Theater of Operations. She joined the permanent faculty and became one of the directors of the Skowhegan (Maine) School of Painting and Sculpture in 1947. She has won numerous prizes and grants and her Greece, a book of drawings with text by Henry Miller, was published in 1964. For many years she has divided her time between Maine and New York, finding beauty and poetry wherever she walks. I interviewed her in Rockland.

WE PLANT a few flowers when we get up there [in Maine] . . . just a few little flowers, not many, it's not a big garden. I used to use those only, but then I found going for a walk, just to pick a bouquet and the curious thing was I developed a kind of superstition about them almost. I picked them in a certain way, in my hand, and I even thought about painting my hand holding some flowers.

There's a friend nearby and she only grows a few flowers but every year I go and get those few flowers and every year they are magic. I saw some roses that were growing in a yard and I went to this man and said, "Can I have some?" I struggled for a week with them and they were impossible.

In this one [reproduced here] I'm just looking right into the flowers like under a microscope, looking down on them to see them. This painting I could never do in the summer. This is done in the late autumn. Those are Gertrude's flowers, they are the most particular, sharp little daisy-like flowers, after the frost, and they have this wonderful rich color and then the light after the leaves have fallen, suddenly gets this clear marvelous iridescence. It doesn't happen in the summer. Its like a landscape, its like a beautiful day, a reflection in flowers. They are a reflection of the day and my feelings about everything.

ANNE POOR: GERTRUDE'S BOUQUET, 1970
Courtesy Graham Gallery, New York, o/c, 17½ x 15.

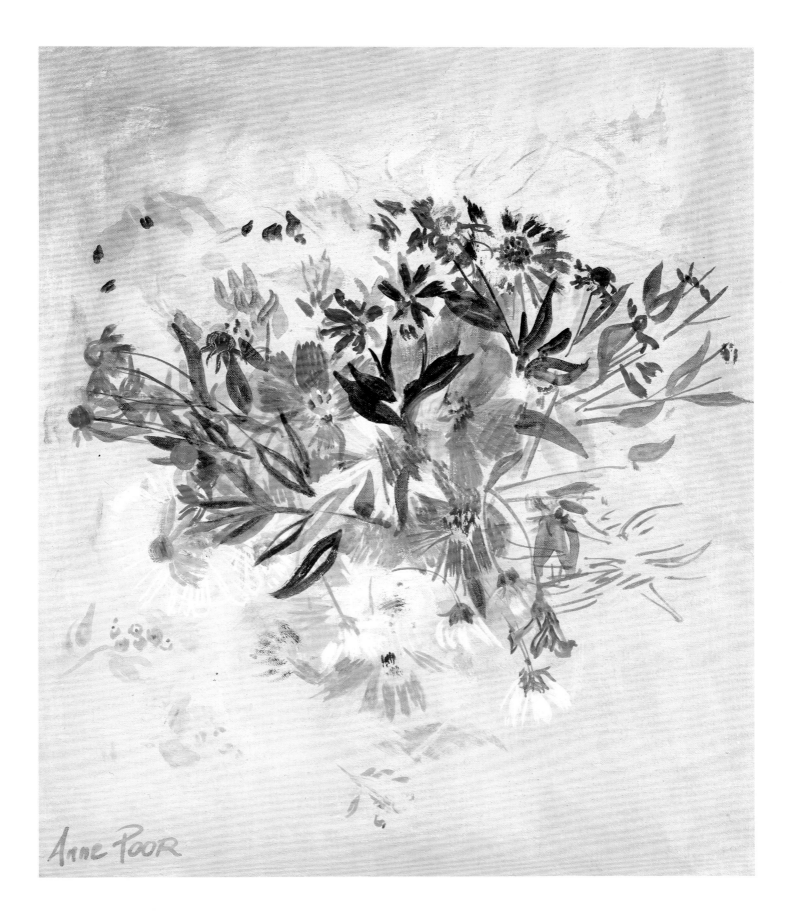

Anne Poor

George Inness (1825-1894)

A major painter of the American nineteenth century, George Inness added the dimensions of memory and feeling to descriptions of the landscape. Abandoning an early reliance on well-handled but conventional documentation, he more and more created his own landscape, a territory seen through glints of light, through silhouetted trees, across pastoral hills brooded over by approaching storms. The statement that follows comes from three sources, the Art Journal *of 1879, a letter to Ripley Hitchcock (art critic for the* New York Times*) written in 1884, and finally an article in* Harper's New Monthly Magazine *(May 1878). "Sunrise, 1889," is Inness' response to Hackensack Meadows, New Jersey.*

AN ARTIST may study anatomy, geology, botany—any science that helps the accuracy of his representations of Nature; but the quality and the force of his aquisitions must be subjected to the regulating power of the artistic sentiment that inspires him. Otherwise his pictures will be anatomical platitudes, scientific diagrams, geographical maps, instead of . . . significant landscapes.

The greatness of Art is not in the display of knowledge, or in material accuracy, but in the distinctness with which it conveys the impressions of a personal vital force, that acts spontaneously, without fear or hesitation.

. . . several years before I went to Europe however I had begun to see that elaborateness in detail did not gain me meaning. A part carefully finished, my forces were exhausted. I could not sustain it everywhere and produce the sense of spaces and distances and with them that subjective mystery of nature with which wherever I went I was filled. . . .

Whoever has been without sight and has sight given sees only surfaces. Shall we therefore ignore these experiences of vision which induce thought and try to paint as though we had never seen? Eden was, it will not be again. We must work our way to Paradise. . . .

. . . no man's motive can be absolutely pure and simple. His environment affects him. The true artistic impulse is divine. The reality of every artistic vision lies in the thought animating the artists mind. This is proven by the fact that every artist who attempts only to imitate what he sees fails to represent that something which comes home to him as a satisfaction—fails to make a representation corresponding in the satisfaction felt in his first perception.

. . . the highest art is where has been most perfectly breathed the sentiment of humanity. Rivers, streams, the rippling brook, the hillside, the sky, the clouds—all things that we see—can convey that sentiment if we are in the love of God and the desire of truth.

GEORGE INNESS: Sunrise, 1887
Collection, The Metropolitan Museum of Art, New York, anonymous gift in memory of Emil Thiele, 1954, o/c, 30 x 45¼.

John Twachtman (1853–1902)

John Twachtman was born in Cincinnati and was exposed first to the esthetic principles of Munich and later of Paris when Whistler and Japanese prints were the rage. He dedicated himself exclusively to landscape painting. He slowly built up images that seem to accept impressionism but more likely imply that he sought the true spirit of nature. His painting "February" catches the sensual essence of New England woods in winter. He wrote in 1891 to J. Alden Weir:

TONIGHT IS A full moon, a cloudy sky to make it mysterious and a fog to increase its mystery. . . . I feel more and more contented with the isolation of country life. To be isolated is a fine thing and we are nearer then to nature. I can see how necessary it is to live always in the country—at all seasons of the year. We must have snow and lots of it. Never is nature more lovely than when it is snowing. Everything is so quiet and the whole earth seems wrapped in a mantle . . . all nature is hushed to silence.

JOHN HENRY TWACHTMAN: FEBRUARY, n.d.
Collection, Museum of Fine Arts, Boston, Charles Henry Hayden Fund, o/c, 36⅛ x 48⅛.

Charles Sheeler (1883-1965)

Charles Sheeler had a single-minded devotion to orderliness. His paintings are lean, pruned to the formal bone, having no trace of the romantic or impulsive. The emphasis is always on selection, distillation, and balance. Although not thought of as a nature painter, he was attentive to the revelation of order in nature, believing that each artist had the responsibility to choose for himself what it was in nature that could be used. He was born in Philadelphia and decided in his teens that he wanted to be a painter more than anything else. He was an outstanding student of William Merritt Chase at the Pennsylvania Academy of Fine Arts and visited Europe for the first time on one of Chase's tours. Sheeler was introduced to European avant-garde painting in 1905 and was profoundly affected. In 1911 he added photography to his creative skills, bringing to that medium a discerning eye and almost classic vision. On a number of occasions his paintings and photographs were shown jointly. Widely exhibited and universally admired, he unblushingly undertook a number of commercial assignments in his mature years, working on location for the Ford Motor Company and for Life and Fortune magazines, describing the industrial environment in epic terms, both in photographs and paintings. His fascination with city forms, factories and bridges, carried over to natural settings. "Rocks at Steichen's," done in 1937, is a tour de force—a small, conte crayon drawing in which the hand and mind of the artist are hardly to be seen. What is omnipresent, however, is that Sheeler eye, discovering timeless order in nature. The following text comes from "The Black Book," a bound notebook in which the artist, late in life, set down with characteristic economy his distilled ideas.

THE MIRACLE of Spring—the first leaf buds and with them the reassurance of the life making a new beginning. The trees in mid-summer with their opulence of celebration. The unbelievable swan-song of Autumn—the fragrance of burning leaves in the air. The man-made architecture inlaid in these environments to serve its several purposes. The look on the faces of human beings in accord with circumstance.

These are among the experiences of artists from which their work derives.

Somewhere near the beginning of my career it was a practice to make excursions into the countryside, with a sketch-box, to record in the paint the thing seen. On one of these excursions, seated by the roadside before my subject, I was accosted by a man who, with permission asked, seated himself beside me. Some would designate him as a tramp, a convenient word for the dismissal of further consideration of him.

His occupation was that of an umbrella mender, a drop of solder on the pot of the farmer's wife, in exchange for a bit of food and lodging for the night in the hayloft. As our conversation developed he quoted passages from Pope's "Essay on Man." Within my knowledge only the author understood it as well. He also informed me in case I didn't know, and I didn't, that it was an especial experience to sleep among the cattle in an open field and to witness the arrival of a new day. Food must enter into the life of everyone. He had a basket on his arm, bread, tomatoes, scallions, and salt. All with the caress of the sun upon them. He invited me to share with him. It was a privilege. I do not have a name for him but I like to think of him as Adam. I also like to think of him, as well as the oak, as having come out of the earth, and that is reassuring.

My work has continuously been based on a clue seen in Nature from which the subject of a picture may be projected. Nature, with its profound order, is an inexhaustible source of supply. Its many facets lend themselves freely to all who would help themselves for the particular needs. Each one may filter out for himself that which is essential to him. Our chief objective is to increase our capacity for perception. The degree of accomplishment determines the calibre of the Artist.

It is known that the amoeba is indispensable to the welfare of man. It is a hope that man is indispensable to the welfare of the amoeba.

Old Zen Saying: To a man who knows nothing, Mountains are Mountains, Waters are Waters, and Trees are Trees. But when he has studied and knows a little, Mountains are no longer Mountains, Waters no longer Waters, and Trees no longer Trees. But when he has thoroughly understood, Mountains are again Mountains, Waters are Waters, and Trees are Trees.

CHARLES SHEELER: Rocks at Steichen's, 1937
Collection, Sheeler Estate, courtesy Downtown Gallery, New York, conte crayon, 10½ x 8¾.

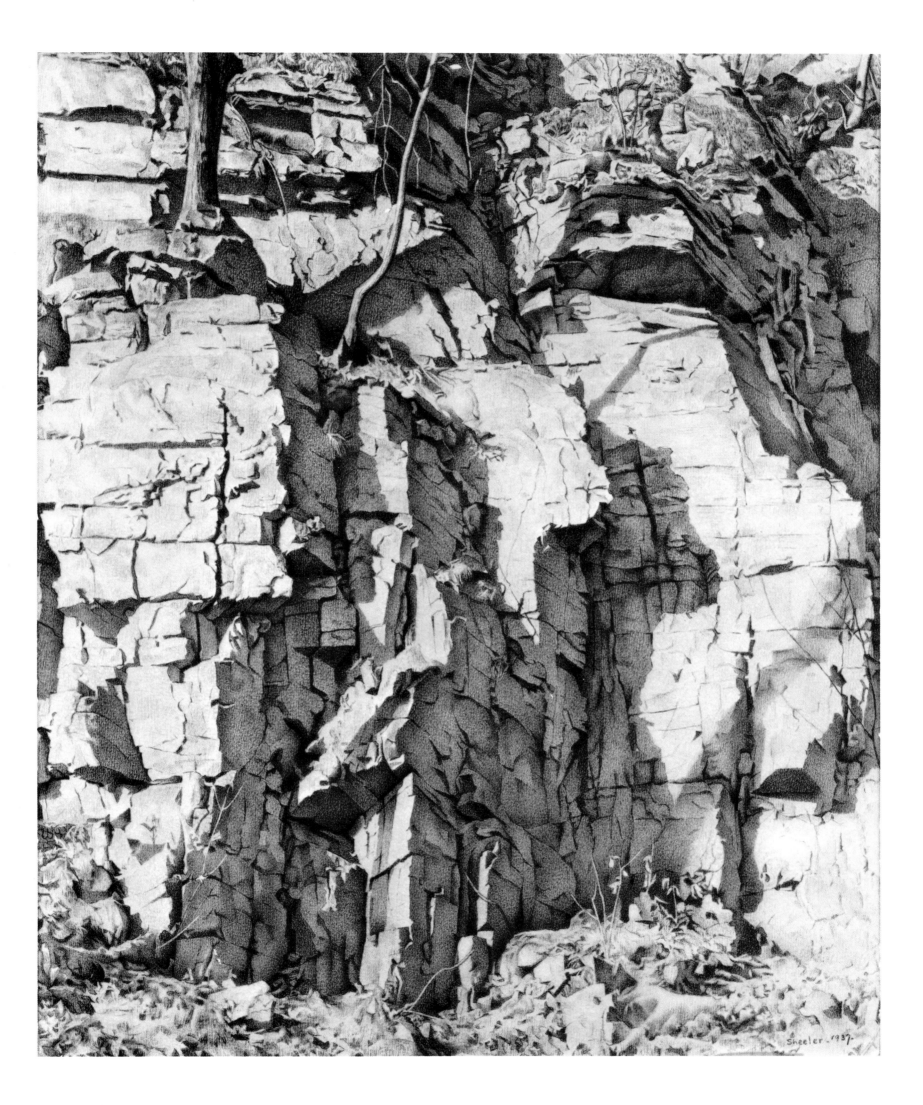

Karl Schrag (1912-)

As a boy Karl Schrag spent summer days and nights walking in Germany's Black Forest. Deeply moved by the earth's nocturnal rhythms, Schrag combines in his mature work, inspired primarily by the Maine coast, an expressionistic vigor for color and brushwork with an almost lyrical, calligraphic response to nature's poetry—touched on in a 1968 letter.

THE GREAT FORCES of the sun, moon and winds and rain—the vastness of the sea and of the sky in ever changing light and weather—the sensation of growth and mystery in the forests have a haunting quality—a spell I wish to find again in my paintings. There seem to be no "big" or "small" themes—a few seagrass in the wind and the stars written into the immense sky above the ocean have equal importance for me. The landscape at the Maine-coast is a landscape of big contrasts—the darkest forest and the most luminous distances—the lightest and the darkest trees (birch trees and pines)—and of hours of brilliant sunshine and dense mist on the same day. All this contrast and change I see as a mirror of my life.

. . . I have a special liking for parts of the forests and shores which one has difficulty in getting to—for clearings in the woods and points at the shore where probably nobody has ever been. It is no accident that our home on Deer Isle—a very old farmhouse—is located in great loneliness at the end of a dead-end road.

KARL SCHRAG: MOON AND APPLE TREE, 1962
Courtesy Kraushaar Galleries, New York, o/c, 38⅛ x 31⅛.

Sam Gelber (1929-)

Sam Gelber was born in Brooklyn, went to public schools there, then to Brooklyn College to study art and now to teach. Gelber first became aware of the art world when abstract-expressionism was the rage and it wasn't until his Army days in Germany (1952-53) that he painted his first landscape. In 1965 Gelber went to the Penobscot Bay region, Maine; he bought a seventy-one-acre farm with a small orchard, and spends his summers in a pastoral paradise, happily painting the trees he loves with a deference to landscape that an interview explains:

I PAINT what the landscape dictates. . . . There may be an occurence between some of the branches or in the sky or in the land that catches my eye and that's where I go. I paint that, catch that response.

"Orchard II" took three months. The tree is growing, the light is changing, the consistency is in the life cycle itself. The process of growth is the process of change in time.

I feel that I am a naturalist and I love painting landscapes more than anything else. Trees are very exciting. They have all the variations that I can adjust to life. I trust myself, my eye, my nerves to look out at the landscape and say, "I'm struck by something and I'm struck by it strongly enough that I paint it." And I don't say, "Well, how does it look in relation to something else?"

I never second-guess the landscape. I've never moved a tree. I've never changed position. I set up in the field. I work on an enamel top table, set it out, and keep it there all summer. I keep a set of paints in the drawer. I only carry the painting in and out. [In the summer of 1970] I was working on three different areas . . . a different table for different areas. I have to start painting [as soon as] I get out there. I can't wait around setting things up; that bothers me. The first response is very important.

I trust the landscape; it tells me what to paint each day, and I believe it. I go out and set up and look at the landscape. I don't wait around pondering or looking at it. It speaks to me and I paint. I feel that in my pursuit . . . I am ordering structures, leaf-relationships, branch relationships.

I once saw a book on trees and I responded to it. So I picked it up and thumbed through it and someone says on a page, "Elm Trees," and in the book they show you exactly how the elm trees grow and how the branches separate and how the clumps are. That's intellectual and that's analytic, but that's not the way the tree is. Some branches look like that but other branches come together, are absolutely alien to that kind of representation. If you investigate a tree and find its structure and you imprint that on your mind . . . you've got to accept the fact that there are ways that trees grow. Elm trees do have long trunks; they tend to grow these sprouting branches, and they don't begin to grow them until twenty or thirty feet off the ground, but you can't predict that there is a certain way that the tree is going to grow. It's like saying each person is like every other person. You can't say that. It's a damaging thing to do to another person, to presume when you meet him that he is like someone else you know.

SAM GELBER: ORCHARD II, 1969
Collection of the artist, New York, oil and lucite on canvas, 40 x 40.

John La Farge (1835-1910)

Perhaps best known for his stained-glass windows, John La Farge was a landscape, still-life, and mural painter who also traveled widely, wrote, and lectured. His response to rising industrialism was actively to promote cooperative efforts of American artists and craftsmen modeled after similar English alliances. His few landscapes are notable for a curious mixture of romantic painterly attitudes and rather straightforward observation. Royal Cortissoz in his memoir quotes the following analysis by La Farge of his approach to painting landscape, which although it relates more directly to such a painting as "Paradise Valley," is not inconsistent with the development of "Bishop Berkeley's Rock, Newport," a painting inspired by a Rhode Island setting chosen by the English philosopher for his meditations.

I FEEL in every part of each second that Nature is almost too beautiful—all of it, every millionth part of it, light and color and shapes. . . . Each little or big blade of grass in front of me, and there are millions, has its shape and composition. The colors are exquisite. . . .

It is Rousseau who said, for painting out of doors in study, "You can paint a chestnut well from an oak if you are in the mood to feel nature call on you."

I undertook a combination of a large variety of problems which were not in the line of my fellow artists here, nor did I know of anyone in Europe who at that time undertook them. My programme was to paint from nature a portrait, and yet to make distinctly a work of art which should remain as a type of the sort of subject I undertook, a subject both novel and absolutely "everydayish."—I therefore had to choose a special moment of the day and a special kind of weather at a special time of the year, when I could count upon the same effect being repeated. I chose a number of difficulties in combination so as to test my acquaintance with them both in theory of color and light and in the practice of painting itself. I chose a time of day when the shadows falling away from me would not help me to model or draw, or make ready arrangements for me, as in the concoction of pictures usually; and also I took a fairly covered day, which would still increase the absence of shadows, that would be throughly commonplace, as we see it all the time, like most of "out-of-doors." I modelled these surfaces of plain and sky upon certain theories of the opposition of horizontals and perpendiculars in respect to color and I carried this general programme into as many small points of detail as possible. I also took as a problem the question of the actual size of my painting as covering the surface which I really saw at a distance, which would be represented by the first appearance of the picture. A student of optics will understand.

The main difficulty was to do all this from nature and to keep steadily at the same time to these theories without having them stick out, if I may say so, as some of my intelligent foreign friends managed to do. In nature nothing sticks out. My foreign friends also have since worked out similar problems but they have not always insisted upon that main one, that the problems are not visible in nature.

Nature, meaning in this case, the landscape we look at, looks as if it had done itself and had not been done by an artist.

Arthur Dove (1880-1946)

In the long history of artistic firsts, Arthur Dove, some claim, was the first painter to make an abstraction from nature. Of more importance here, he painted intriguing and inventive works inspired by natural forms, works that revealed an authentic response to observed phenomena and a profound understanding of earth rhythms. He had his first one-man show at Steiglitz's 291 Gallery in New York in 1912. For much of his life, Dove painted in Connecticut and Long Island studios, though for a while he lived on a boat at the Hudson River's edge. "Snow on Ice" is archetypeal Dove, outwardly simple and abstract, inwardly sophisticated and descriptive; and so is his brief, undated note.

IT IS HARD for a flat thing to understand a round one.

Once the earth was flat, but now it is round. Even yet there are a few who insist.

[James] Joyce is making a great attempt to feel completely round it, but almost free from audience. Perhaps that is the way the world began—with no one looking on.

ARTHUR DOVE: SNOW ON ICE, 1930
Collection, Edith Gregor Halpert Estate, The Downtown Gallery, New York, o/c, 18 x 21.

[107

Frederick Church (1826-1900)

Frederick Church was forever seeking out new territory. Guilty of almost every artistic excess imaginable—flamboyance, theatricality, and the use of lurid color—this restless vagabond nevertheless succeeded in producing some of the most durable and persuasive depictions of nature at its grandest ever painted by an American artist. From Niagara Falls to the heart of the Andes, his spellbinding technique left thousands clamoring for more. He engaged in a thirty-year struggle to construct a perfect paradise, and his home Olana, on the Hudson, stands today as eloquent testimony to his consistent eclecticism. In 1856 he traveled with his friend, novelist Theodore Winthrop, into the interior of Maine. Winthrop, in his book Life in the Open Air, *tells of the morning he and Church, sailing across Moosehead Lake, saw Mount Katahdin the first time.*

YES, THERE WAS a dim point, the object of our pilgrimage. . . . We sat upon the deck and let Katahdin grow,—and sitting talked of mountains. . . .

Mountains are the best things to be seen. Within the keen outline of a great peak is packed more of distance, of detail, of light and shade, of color, of all the qualities of space, than vision can get in any other way. No one who has not seen mountains knows how far the eye can reach. Level horizons are within cannonshot. Mountain horizons not only may be a hundred miles away, but they lift up a hundred miles at length, to be seen at a look. Mountains make a background against which blue sky can be seen; between them and the eye are so many miles of visible atmosphere, domesticated, brought down to the regions of the earth, not resting overhead, a vagueness and a void. . . .

Air, blue in full daylight, rose and violet at sunset, gray like powdered starlight by night, is collected and isolated by a mountain, so that the eye can comprehend it in nearer acquaintance. There is nothing so refined as the outline of a mountain: even a rose-leaf is stiff-edged and harsh in comparison. Nothing else has that definite indefiniteness, that melting permanence, that evanescing changelessness. Clouds in vain strive to imitate it; they are made of slighter stuff; they can be blunt or ragged, but they cannot have that solid positiveness. . . .

Many men need the wilderness and the mountain. Katahdin is the best mountain in the wildest wild to be had on this side of the continent.

FREDERICK CHURCH: SUNSET, 1856
Collection, Munson-Williams-Proctor Institute, Utica, New York, o/c, 24 x 36.

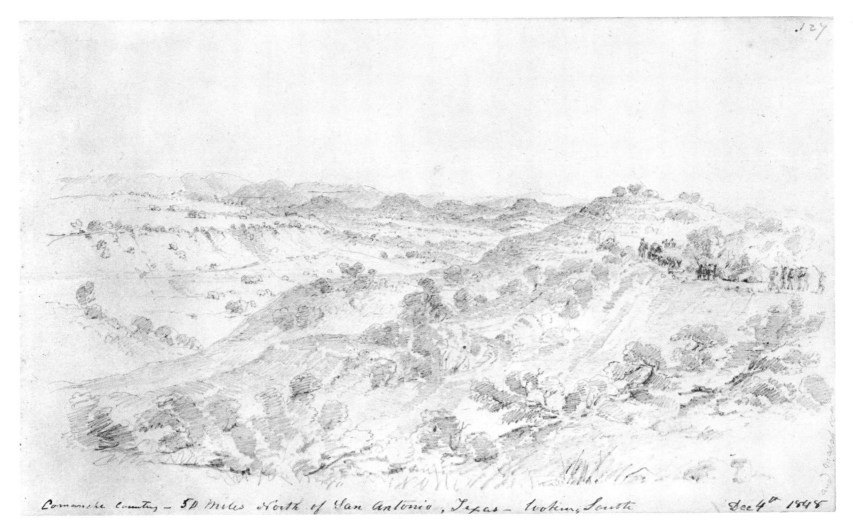

SETH EASTMAN: COMMANCHE COUNTRY—50 MILES NORTH OF SAN ANTONIO, TEXAS—LOOKING SOUTH, Dec. 4th, 1848
Collection, Marian Koogler McNay Art Institute, San Antonio, Texas.

Seth Eastman (1808-1875)

Nineteenth-century painters who explored the western frontier usually did so in the company of colonels and generals, or at a minimum with government geologists. One outstanding exception was Seth Eastman, an artist/illustrator of uncommon quality, who himself was a West Point graduate, captain in the 1st Infantry, commanding a company that explored the River Leona to San Antonio and Laredo. He was finally made brigadier general, ending his days doing Indian scenes and western forts in the national capitol. He kept a journal (with much dash in it) of his march through Texas in 1849; we juxtapose an entry with two graphic drawings, of the city and of surrounding Comanche country.

San Antonio, August 11, 1848

SAN ANTONIO is a Mexican town but rapidly becoming yankeeized—Flat roofs are giving away to the old-fashioned shingled yankee-roofs . . . many of them are built of stone cemented with lime—others of Adobie which are square or rectangular blocks of clay—baked by the sun—These make very handsome walls, but cannot be very strong—If the outside be not coated with a thin coat of lime, the Adobie will be liable to be washed to pieces by rain—The poorer class of Mexicans build their houses of posts stuck upright in the earth—having an opening for a door and window—A thatched roof is then put on, and the crevices stopped up with mud—and behold a Mexican home—Sometimes a mud chimney is made—no floor excepting the hard clay—one room only—Generally cook out of doors—To bake they build a semi dome of mud twenty or thirty feet from the house—when dry they build a fire inside until sufficiently heated, then put in the bread, and stop up

the door—San Antonio contains from 5 to 6 thousand inhabitants—formerly, I am told, it contained 15 thousand—It is very compact, very narrow streets—It has no farms, cottages or retreats around it as is usually found around the towns and cities of the U.S. When you get to the end of one of the streets, you are at the end of town—nothing beyond it but a wild prairie over which the Indian roams as free and wild as the ground that he treads— . . . Before the Americans took possession of this country, the Indians were very insolent to the Mexicans and considered them no better than their slaves—A party of Indians would ride into the city, stop at a Mexican house, order the owner to hold his horse, and then walk in, help himself to what he wants, throw himself on the bed to take a nap and most likely compel the wife or daughter of the one outside holding his horse to go to bed with him—On leaving town they would take any thing they wanted, and never failing of carrying off some female prisoners. . . . The Mexicans fear the Indians greatly and the latter hold the former with the utmost contempt—Not so with the Americans—The Indians have been treated so ruffly by the white man that he dread[s] him—he does not take any liberties with him and will never molest him unless he had clearly the advantage.

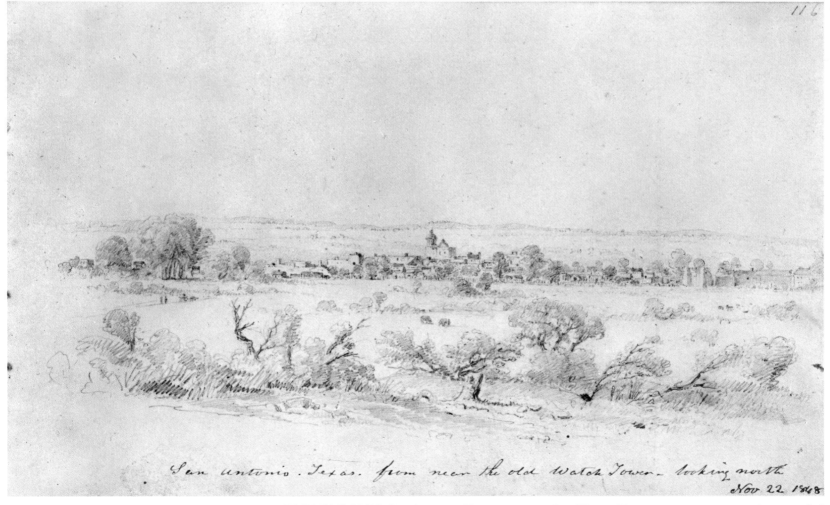

SETH EASTMAN: SAN ANTONIO, TEXAS FROM THE OLD WATCH TOWER—LOOKING NORTH, Nov. 22, 1848
Collection, Marian Koogler McNay Art Institute, San Antonio, Texas

Lennart Anderson (1928-)

Lennart Anderson is a master of composition. His well-poised paintings suggest an air of cool detachment not confirmed by fact, for Anderson is a highly charged artist who exerts enormous self-discipline. Nudes, groups of figures, still-lifes and landscapes—Anderson focuses his analytical eye on all of them, creating images of great durability. He is a graduate of the Art Institute of Chicago and of Cranbrook Academy in Michigan; he also studied with painter Edwin Dickinson. He has won a Rome Prize Fellowship as well as grants from the Tiffany Foundation and the American Academy of Arts and Letters. Much respected as a teacher, Anderson is one of the most widely exhibited, widely collected artists of his generation. Anderson's summer forays into natural places are engineered by his wife, who feels that a change of setting from their Brooklyn environment does them all good—including the children and their artist-father.

THIS PAINTING is so green it's hard to take. It's a very considered picture. It sums up the place very well. Vermont is really nineteenth century in the sense that one road went to one house and another road went to another house and it was like a contained world in this valley. I'm drawn to the nineteenth-century motif. I mean by that, a motif that doesn't give away its twentieth-century accouterments, like telephone poles. But at the same time I feel that it is a little bit of a lie because the world isn't that way.

I paint landscapes because I'm out in the country. I have no choice. I'm taken to the country every summer. I would never paint a landscape otherwise. I didn't say I didn't like landscapes. I said I didn't like to do them. I love landscapes. The landscapes that I love, I love. My pictorial needs are not often answered in the landscapes—whether I like the place or not is something else.

I am tied to what I see. I don't often transpose. I try to paint the way I perceive it . . . the relationships that I see; so I am always struggling against the scene to try to make it work as a picture. A certain scene is great on a gray day and lousy on a sunny day. I have to have a consistent setting. If the light changes, if the day is changing a lot, that's when it's bad because when it changes I have to change too. Then if it changes back again, it's rough.

Finding the right place is the hardest part. When I find a great place I'm confident then. What's bad is when you haven't found a good place and the day is going and you'd rather paint than not paint and you're painting something you really don't want to paint. That happens often. But if you really get a good place, that's most of the job because you know that if you hit it then, its only up to you, and if you feel confident that you can do it then you're bound to get a good picture. I know pretty much whether I've got the right spot and I know where the weaknesses are. I don't often find it *that* perfectly, but I don't change it either. That's my problem. It's the cross of the thing . . . I can't change it and yet I don't find it perfect.

I am very cold-blooded when I go out. I'm cold-blooded about the problem, but, on the other hand, the impressions you get have got to be put down and I try to paint with feeling. At the same time your painting is done with response to the scene. You've got to have your mind kind of clean when you look at the thing or else you're not going to get anywhere; you're going to get a routine picture. You go out with all of your art history behind you and the scene in front of you and you are in the middle; you are a mediator between the two things.

Do you want to know why people don't buy landscapes? People want to touch things. They don't want space. They want something tactile. Landscape [painting] is really just a box of air, with little marks in it telling you how far back in that air things are. In general [people] don't want landscapes, and that's the reason. They can't put their fingers on it, they don't want air, they don't want to buy a box of air.

LENNART ANDERSON: VERMONT II, 1970
Courtesy Graham Gallery, New York, o/c, 19 x 24.

Gabriel Laderman (1929-)

Theoretician (some would say, polemicist), teacher, critic, and painter, Gabriel Laderman is perhaps the most articulate contemporary spokesman for neoclassic ideals. Claiming dispassion as an attitude and past traditions as a guide, he is, nevertheless, a passionate advocate of a point of view that is gaining new currency. He was born in Brooklyn, attended Brooklyn College, Brooklyn Museum Art School, Atelier 17 (graphic workshop), and Cornell University. He studied with Hans Hofmann and Mark Rothko, among others, and has been the recipient of Tiffany, Fulbright, and Yaddo grants. His articles on art appear with increasing frequency in major art magazines. He is a member of the Pratt Institute faculty, and was a visiting professor of art at Louisiana State University in 1966. The following is from an interview.

IT'S VERY IMPORTANT to be able to see what's in the glance of the eye as opposed to what's inside the movement of your foot. A landscape painter is not a mountain climber. Mountain climbing is a physical activity and everything is inside the grasp of the mountain climber. A landscape painter is an eye and he can do everything a mountain climber can do but he can do it in a series of separate takes, not as a continuous activity. You have to begin to realize what is a grouping, what out there groups, what out there is a motif. A motif is a place where there is enough to make a painting ... enough interest for you in what's near and what's farther away to add up to a painting. What makes a motif isn't any one set of structural possibilities. It is that I feel that in [the] particular location all of the elements—the foreground, the middle ground, and the distance—have their own interest, which is second to the interest they make as a group.

The small painting is called "Haystack Mountain from Stowe Road." Near the end of the summer, late August, early September—I was living in West Dover (Vermont) that summer, and I'd been casing the stretch of road from West Dover to Wilmington every day and finally I drove up this road, quite a way out. At the side of the road there was a place where a car could go in and there was an empty field. At the foot of the field there was a riding circle which you can see, where a girl was giving riding lessons, then a whole batch of hills leading up to this distant, high Vermont mountain.

That was a motif, there was no question about it. There is this beautiful little plane leading up, a clump at the left, some little houses and a great big hill, and before you hit the big hill, very beautiful batches of trees. On the day that I painted, it was a rather windy day and there were little bits of clouds flying over which was great, a lovely accident that added something necessary in a place where you have no control. In the sky there may or may not be clouds. Clouds may look wonderful one day and terrible the next.

It had this combination; it had the quality of Vermont. It epitomized the quality of that place—high green hills, farms—and it also had the quality of classical landscape composition with a group of screens, of trees, at various distances, all leading your eye in, light, dark, light. I didn't have to make it up. There it was with an entry into the painting that came out of the classical tradition and then the rest of it was Vermont. It was just perfect. I don't look at landscape without a model in my mind of what painting should be like.

This is a little past midday, about three o'clock. Most of my painting tends to be from three o'clock on. A lot of my paintings are late afternoon with fine light, raking light, neoclassical light giving you sharp, clear, precise shapes.

The good painter is the man who makes the stuff alive in his own mind, his own feeling, his own response to what's in front of him. There is no other way of doing it. You never understand an earlier model except through your own terms, which is personal and therefore never the way that model went. One of the things I am very involved with is an intensity of emotion. I am not at all involved in reportage. I am involved in the emotion that is carried on those tones about that form. I am intensely interested in making a landscape which is ennobling, which is intensely ennobling, which has a sense of grandeur, of expansion, the sense of expansiveness, making the scale of the painting such that you feel enlarged by the whole experience.

GABRIEL LADERMAN: HAYSTACK MOUNTAIN FROM STOWE ROAD, 1968
Courtesy Robert Schoelkopf Gallery, New York, o/c, 16 x 18.

George Wexler (1925–)

George Wexler is a city boy who has become a country man, country he likes as much for its fishing potential as for its beauty. He lives in a modest modern home in the middle of the woods at the base of a cliff north of New Paltz, New York. He is an energetic teacher at the State College there, a man who insists on a maximum degree of comfort while enjoying the qualities of nature. His painting is a quick oil sketch. Excerpts from a 1970 interview follow:

THIS LITTLE SKETCH was done from the top of the Shawangunks, looking north from a high point all the way across the valley. It was a clear day and you could see the Catskills. I went there with the idea of working with the panoramic vista. I reacted to what I saw and tried to do a straight painting.

I like being outdoors. I like fishing. During the season my car is loaded with my painting supplies and I go out. I'll paint, then I may take a break. If I'm near water I'll do a little fishing and then, come back to painting. The whole idea of being outdoors, in good weather for the most part, at least not cold enough that my fingers will bother me, is something that intrigues me. I have rigged up a very effective system of working outdoors. I have one of these aluminum knapsack carriers and a French box easel, which is wonderful and will hold a good size painting, and a chair and bug spray. I put it on my back and I could go anywhere. I spray the canvas to keep the bugs from landing on the paint and I spray the seat and myself and I have no bug problem. I don't see how Cézanne ever did it without the bug spray.

[Not long ago] I became very much aware . . . of nineteenth-century American painting. My whole background, Cooper Union and all, had always oriented me to despise this work. As I got older I started to look at things a little more freshly. The Hudson River School painters!—that's where I live; they were working with the same things I'm working with; there's an affinity here, which I now feel through nature.

George Harvey (c. 1800–1878)

While many artists admired and painted the American landscape, few carried this enthusiasm as far as George Harvey did. More than one hundred years ago, Harvey became so enraptured by American scenery that he prepared lantern slides based on his own watercolors, which he took to his native England in 1849 and began giving slide lectures before a variety of groups extolling the beauties of this virgin land. He came to the United States when he was twenty, traveled to Ohio, Michigan, and Upper Canada, settled briefly in Brooklyn, lived in Boston for a while, painting miniatures, and in 1833 built a home near Hasting-on-Hudson. He attempted, with great effort but little success, to find financial backing for a printed edition of his atmospheric views of American scenery. The title of the slim book from which the following excerpts are taken tells its own story—Harvey's Illustrations of Our Country, with an outline of its Social Progress, Political Development and Material Resources, being an epitome of a part of eight lectures which the artist had the honor of delivering before the members of the Royal Institution of Great Britain in 1849, and subsequently before many other literary societies of England and Scotland, entitled the Discovery, Resources and Progress of North America, North of Virginia illustrated by more than 60 views.

THE HILL on which these beacons are erected lies within the jurisdiction of New Jersey, and at the entrance of the Hudson River. The hill does not exceed 350 feet in height, but nevertheless it is the highest ground from Maine to Vera Cruz. The City of New York can be seen from the Lighthouses, and the splendid bay, which has been thought equal to the celebrated Bay of Naples, is here seen in all its extended and varied beauty. The number of lighthouses claiming attention of Congress already amount to near 500.

Since Jersey City has been admitted to a port of entry, the authorities have claimed the right to grant licenses to pilots, so that the competition with those of New York, produces an activity very beneficial to

GEORGE WEXLER: VIEW FROM MOHONK—CATSKILLS No. 1, 1966
Collection, Dr. and Mrs. Arthur Quart, Poughkeepsie, New York, oil on paper, 11 x 16.

GEORGE HARVEY: LIGHTHOUSES ON THE HIGHLANDS OF NEVERSINK, c. 1830-1840
Collection, The New-York Historical Society, watercolor, 8⅜ x 13⅝.

ship owners. Those pilots who venture furthest to sea, and are the most diligent in quest of approaching vessels, obtain the greatest share of employment. . . .

Every large town in the U.S. has now its cemetery; and from a spirit of pride, as well as just a tribute of respect to the memory of those entombed in these grounds, they are kept in most excellent order, and will compare with the most celebrated in Europe for the good taste with which they are laid out. The present view is a sunrise, typical of our Christian hopes, for the sunrise of the soul is at the boundary of life.

The grounds of this cemetery embrace nearly 500 acres of land and lie within the corporation limits of the City of Brooklyn. They were laid out most judiciously by the late Major Douglas, with wide carriage roads, their limited length measuring more than fifteen miles. The number of elegant and tasteful monuments are multiplying in all parts of the ground; these, combined with the beauties of nature, consisting of picturesque copses of trees, winding avenues through woody groves, shady dells where small natural lakes, reflect in their mirror-like surface the objects near their banks; the gradual slopes of the hills, from one of which the present view is taken, all conspire to make it a place much resorted to by those who have carriages, especially when visitors from distant parts make sight-seeing an object. In fact this place is one of the "lions" of the City of New York and Brooklyn.

The plains in the distance are called Flatlands, and the village, Flatbush,—beyond these is the Atlantic.

John Button (1929-)

John Button is an artist who finds beauty wherever he happens to be and he has been in most of the United States and a good part of the rest of the world. He has painted poetic evocations of pollution-clouded Lake Erie and finds city façades as interesting as the architecture of oceans. In his view, New York City is a grandiose form of nature. He was born in San Francisco, studied at the University of California, Berkeley, and at the California School of Fine Arts. He has taught at Skowhegan, Cornell, and Swarthmore. His first one-man show (at Tibor de Nagy in 1957) was followed by seven more by 1971, most of them at New York's Kornblee Gallery. He is an ardent conservationist, and for the last several years has been a regular midwinter visitor to the all-too-frequently imperiled Everglades.

I WAS JUST overwhelmed by the Everglades; it was more than I expected. It was like being in Africa. I couldn't believe the wildlife or the landscape. I didn't know that anything as lushly tropical and exotic and striking as the Everglades existed in America. When someone would say the word Everglades I thought "cypress trees hanging with moss." Of course, the Everglades is a vast sea of grass which goes gradually from salt to brackish to fresh water. It's flat and you have a simple dividing line at the horizon between the flat sea of grass and the sky, and in the grass are all these exotic creatures.

If you had agoraphobia it would be a nightmare because it's the most open place I have ever been, save for the ocean. It was vast-seeming with endless stretches, quiet, but very alive, including the sky, which had soft tufts of cumulus clouds in constant motion—a damp, moist, living feeling.

This painting describes a scene at the southern tip, almost at the very southern tip of Florida, at the very fringe, right in the ocean's edge. Mind you, the coast of Florida at the southern tip is very vague. It's hard to say which is coast and which is ocean because the hammocks continue out into the water, but instead of this grass, there is mangrove and it breaks up into islands, thousands of islands. The visual thing is very strong. There aren't many places in the world where you get a landscape like this . . . an absolutely dead flat landscape. It's almost like hard edge painting.

The Everglades are miles and miles big . . . and my painting is only eighty-four inches wide. Because I reduce the scale, I am mediating. Now, whether people are going to respond and say This is a beautiful landscape, or whether they are going to say, What a boring landscape; it's just flat and has nothing on it, I don't know. But if they did think it was a boring landscape, I still think they would like my painting.

GEORGE HARVEY: SUN RISE—FLATBUSH AND THE OCEAN FROM GREENWOOD CEMETERY, L.I., c. 1830-1840
Collection, The New-York Historical Society, watercolor, 8⁷⁄₁₆ x 13¾.

JOHN BUTTON: EVERGLADES, 1967
Collection, Helen Weaver, New York, o/c, 52 x 84.

Wolf Kahn (1927-)

Wolf Kahn is a painter who loves paint. Confident of both his vision and his skills, Kahn paints intuitively, weaving his pictures—at first loosely, then tightly—often almost destroying the image before finally retrieving it. He was born in Stuttgart, Germany, left in 1939 to live in England for a year, and came to the United States to attend the famous High School of Music and Art in New York City. He later studied with Hans Hofmann and at the University of Chicago. Returning to New York in 1952, he began devoting himself to painting full time. Over the years, he has experienced a wide range of environments—Louisiana, Mexico, Venice, Cape Cod, Maine, Rome, and Milan. He has won both a Fulbright grant and a Guggenheim fellowship, and has exhibited widely. His paintings are included in many museum collections. The barn in his painting is on a Vermont farm, an environment into which Kahn and his family settle each summer. He discussed the barn in an interview and nostalgia vs. actuality in a letter:

MY PAINTINGS are of a barn that I own, pay taxes on, that I paint inside of, that I've seen in every kind of weather. Barns become as much nature as an orchard is. The essence of the problem is to give [barns]—volume and weight in a measure that corresponds to their physical reality;—also to give them enough airiness and dissolution that they become part of the surface, . . . become part of the texture of nature.

The more I know it, the easier it gets to paint, not in the sense that the more I know it, the less new things I discover, rather the more possibilities constantly unveil themselves. I am aware that an image is some sort of an archetype. The more specific you make a thing and the more securely you place it in a setting, the more archetypal it tends to become. The closer you get to the local quality, the closer you get to the universal. I'm after fidelity to the small context.

It is familiarity that finally renews my barn image. The image is the anchor. It's really what your painting finally wants to be. It's not a picture of a barn . . . the barn is the focus of the picture. The barn is a pretext but nature isn't.

These barns look like stranded whales to me.

What really gets me is the encounter between two contrasting elements like sky and land at the horizon, sea and land at the shore, field and woods, house and foliage—also, being a very mild type who hates conflict I tend to soften the harshness of these encounters. That's why I like fog, haze, and the light of early morning or of dusk.

I believe that nostalgia in its best sense, i.e., a yearning after a Golden Age, informs most of the best landscape painting. . . . It's most clearly evident in Poussin and Lorrain, in Turner and Constable in a more homely key, and very strong in 19th century American landscape painting—Ryder, Blakelock, Inness. There are two generally discernible types of nostalgia—the one for antiquity, and the one for some kind of pastoral past. We in America don't have any antiquity, so for us there is only 18th and 19th century rural nostalgia. It was then we had our heroic age, and a New England barn is to us as a Greek temple was to Poussin, a symbol of a whole tradition, laden with all kinds of good associations. . . .

The environment in which my paintings grow best is at Broadway and 12th Street. I can see nature most clearly in my studio, undistracted by trees and skies. Art being emotion recollected in tranquillity I constantly find Nature too emotional, and Broadway very tranquil.

WOLF KAHN: THE UNDERSIDE OF THE BARN, 1970
Collection, Mr. and Mrs. Robert Redford, New York. Courtesy Grace Borgenicht Gallery, New York, o/c, 52 x 60.

William Sidney Mount (1807-1868)

William Sidney Mount was born in the Long Island village of Setauket and apprenticed at his brother's sign-making shop in New York City. A genre painter of enormous skill, he spent most of his life painting in Stony Brook, and to judge from the voluminous materials which remain, scribbling endless notes and letters, including the letter to the editor (among other items which follow) commenting in 1848 on the garbage situation in New York City. Two other excerpts from his folio are presented here—some observations on nature and art from his private journal, and a letter describing his successful foraging for "wild colors" along the Long Island shore. "Long Island Farmhouses" is a masterful evocation of the nineteenth-century American rural landscape.

THE SKYS as seen from Stony Brook, Long Island, away from the City are remarkable for clearness—also the water in the harbor and Sound are clear and transparent—The sky around large City's is made up partly of coal smoke—The East river and North river about the City is not clear but murky— . . . The water in the Sound is much more blue and clear than the waters about the bay and harbors of New York City—a critic should weigh these matters on looking at a picture, not judge too hastily . . .

My best pictures are those which I painted out of doors . . . one true picture from nature is worth a dozen from the imagination . . . an artist moving about from place to place will see things that will be suggestive—will stimulate him *to paint*— . . . the canopy of heaven is the most perfect paint room for an artist. . . .

How glorious it is to paint in the open fields—to hear the birds singing around you—to draw in the fresh air. How thankful it makes one— . . . why should we strive to work against nature when she beckons us one and all at once to be great.

Stony Brook, December 31st, 1848

. . . it affords me great pleasure to make known to you the colors found on this part of Long Island—a proof that we have the materials for good pictures if they have not yet been painted.

As long ago as 1836 when I was painting The Farmers Nooning—my late brother H. L. Mount, handed me a piece of native umber as found in the banks near this place and desired me to make use of it in my pictures—I did so—and found it as he had represented, transparent, and a good dryer—I have used it more or less ever since and find it a valuable pigment. It looks lighter and makes a cooler tint when burnt—directly opposite to Turkey Umber.—In the gradations of flesh, with white it is truly delightful. It unites harmoniously with all colors. It should be ground in nut—in raw linseed oil.—In Jan. 13th 1843, my brother S. A. Mount proposed that we should explore the high banks bordering on the Sound, for the sake of exercise, and to see what we could find in the way of native pigments—the weather was fine and warm—as we strolled along the bank we picked up pieces of brown, yellow, and red,—we thought the rich "placer" must be somewhere near.—Shepard struck his hoe a few feet up the bank and we were astonished to see a lot of bright red running down the bank & mingling with the sand—It was a rich day for us—we worked with the spirit of golddiggers, and were well paid—The red found in balls was in tint like Indian red, and Venetian red—some of these sand stone balls contained purple, some yellow and some *red*, like orange vermillion. While digging in another part of the bank about seventy feet above the tide water we dug out a white powder encased in a covering so slight that it would not hold its own weight, so we were obliged to take the powder out with a spoon. I have found that

WILLIAM SIDNEY MOUNT: LONG ISLAND FARMHOUSES, c. 1854-1859
Collection, The Metropolitan Museum of Art, New York, gift of Louise F. Wickham, in memory of her father, William H. Wickham, o/c, 21⅞ x 29⅞.

the action of fire will not change it—It has the power of cleaning silver at the moment of application—I have used it in painting—I think Titian must have used something like it, in toning the flesh of his pictures. The Yellow we found in broken lumps resembles naples yellow, but richer in tone. I found that the steel palette knife would change its tint—accordingly I used a bone knife instead. Some of the yellows resembled raw sienna. The browns had the nature of vandyke brown [,] Cologne earth and Cappah brown. We also discovered *pure black*. What interested us very much was the finding of several brimstone balls of a sea-green color, with lines radiating from the center—smelling strong of sulphur, evidently showing this part of the Island to be volcanic. Here we paused and turned around expecting to encounter old Capt. Kidd behind him—after the smell had passed away, we resumed our investigations. We found large bodies of stone and sand bound together with sort of a brownish paste, giving a varnished appearance and forming into solid rock as the pieces separated with difficulty. Along the shore we walked over large blocks of red & yellow sand—also black sand such as used in sanding letters.—Most of the reds, & yellows, and some of the browns require washing before using—I have painted several pictures with colors found in old Suffolk Co.—Mr. Frothingham, our fine colorist was delighted with the number I presented to him—he said his old Master Gilbert Stuart used a native umber—and he had been a long time wishing to obtain some of it. He gave me some choice color in exchange—

—These balls must have been in great estimation by the Indians, not only for the color they contained, but as instruments of music—they served as whistles—very shrill and piercing—

. . . speaking of colors, I found some native tints above Newburgh on the North River, also large quantities of brown—Umber and round about the village of Catskill—but not the quantity of Stony Brook Colors—I questioned Mr. Thomas Cole about the colors—I found these he said he used the umber in his pictures.

Stony Brook, December 15, 1848

"Strike while the iron is hot"—I am pleased to say that there are a few mortals living (and you are one of them) who go in for cleanliness and health, in spite of the demoniacal grin of the monster Cholera, as he looks upon the dirty City as so much capital to commence business upon.

In the year 1825, it was the law and the daily practice in the City of New York for every man to sweep and scrape the dirt from his own door into the centre of the street, early every morning.—at nine o'clock The Corporation Carts would remove the dirt—Every nuisance thrown into the streets was fineable. Then the laws were maintained, and the citizens, & strangers walked erect without fear of having their feet soiled, and their noses drawn out of character by villainous smells. Then man, moved as a man—but not as a hog moveth—Those pleasant days were not to last long—some designing politicians whispered to the people that it was burdensom to clean before ones own door and if the folks would give them their notes, they might set aside the hoe & shovel—The good deluded public smiled, the deed was done—and the great and growing City of New York has stunk ever since.

HENRY VARNUM POOR: IGLOO AT PT. HOPE, 1943
Collection, Mrs. Henry Varnum Poor, New City, New York, ink on paper, 8 x 12.

Henry Varnum Poor (1888-1970)

*A complete country man, Henry Varnum Poor was an architect, a draftsman, and a potter—he said he taught himself
potting to make a living. He was born in Chapman, Kansas, and graduated Phi Beta Kappa from Stanford, where he
was a four-letter man. He served in both World Wars and was Chief of the Army's Art Unit for the Alaskan Theater,
with a rank of Major. He helped found the California School of Fine Arts on the West Coast and later the Skowhegan
School of Painting in Maine. He painted twelve murals for the Department of Justice buildings in Washington and a
large mural, "Conservation of American Wildlife," for the Department of Interior. His paintings are included in
permanent collections of many of the nation's principal museums. In 1943, he went to Alaska as part of the Artists-for-
Victory effort and two years later wrote, An Artist Sees Alaska, for which he supplied both drawings and text. In the
fall of 1970, just four days before he died, I interviewed him in his Rockland County (New York) studio. Brief excerpts
from the Alaska book follow the interview:*

I SELECTED going to Alaska when this first business of the Artists for Victory came up...partly because
as a kid I had gone up along the coast there...and more at this moment thinking that if I went to Alaska—
this was a period early during the war—I would have a chance to get over into Russia. When I got there I
found that the Russians were not at all agreeable to anybody's going on over to Russia. They picked up the
planes at Anchorage and flew them over themselves.

It was partly wanderlust but it was partly a feeling that there were going to be some important war
developments there and this whole war artists thing started with the expectation of the artists being where the
action was and recording it.

Going up to Alaska was the fulfillment of a kid's dream. The Eskimos, I really fell in love with. They are
lighthearted and gay. They were terrifically interested [in me as an artist] and the kids always gathered around
and watched me when I was drawing. That evening in Point Hope was really...one of the most beautiful
things I've ever seen. The dance was symbolic of hunting and of being lost on the ice. Wonderful people...

they were so open-hearted and childlike in the most beautiful way. I had plans to go back and try to bear some part in improving the lot of the Eskimos, because under government supervision what was being done for them, destroying their way of life—just from my interest in buildings, I so much deplored the half-hearted, civilizing influence of building in little wooden shacks and letting them abandon the beautiful old igloos. I thought it was tragic what was happening to them . . . in their own environment they had so much happiness and dignity and lived in such a dignified way.

POINT HOPE (1943)

Up along the rounded top shoulder of Alaska, Point Hope stretches out like a finger pointing, and the village here is called Tigara—the Forefinger. It points into the gray wastes of the Arctic Ocean and is as lost and remote a spot as there is along the whole coast. But it lies in the line of travel for the polar bear and the whale and the walrus; and this line of travel has not varied for centuries, since here at Tigara is the most unbroken continuity of life to be found in all the Arctic. Sunk into the gravelly tundra of this low wind-swept point are the records of a life stretching back beyond the Christian Era, and rising from it now are the well-built sod and whalebone igloos of the vigorous descendants of that ancient highly cultured Asiatic people.

On the morning of July 24, toward midday, we came along the low somber coast before a fair wind from the southwest. A heavy swell was running, so we rounded the whalebone markers at the point to drop anchor on its northern sheltered shore, close in at the base of the finger. A shy and reticent group of Eskimos gathered to welcome us, not a white face among them . . . [Shortly] I went out to see the village. Aside from the schoolhouse and two small tarpaper covered houses which I found to be warehouses of the community trading post, there was not a frame structure in sight. Low rounded igloos of brownish sod lay in a wide double row on each side of a long open grassy stretch, running along the center of the point out to its tip. On the clean, level, sparsely-grassy tundra the igloos made only low mounds, with not an opening on the sides— only the entrance doors at the mouths of the long tunnel storeroom entrances facing south. These entrances were marked with great whalebones, set in sort of an arbor leading to the door. They were curved ribs, set with the big end up, sometimes as many as five or six in a row, and here at last was Eskimo architecture! The effect of these great bleached bones, set with formal exactness before the doorway and the brown walls of sod, was a strange combination of hominess and austerity—like a New England cottage gate with a rose arbor; or like Stonehenge in bone. The whole village was a village of bones—clean, bleached, gleaming bones— shining now in the misty sun that played over the point and over the gray water on each side. The big uprights of the drying racks by each home were bone. The stakes to which the dogs were tied were bone. Down below the village was a big ragged stockade of bones set so closely that no fox or wolf could enter. It was the cemetery. Up and down the village the gleaming white of these great bones shone out from the soft gray and green and brown of the tundra. I didn't know that any creatures of the earth or sea had bones of such size— some of the ribs with their big clubbed tops were easily eight feet above the ground.

Since I'm not a great lover of bones myself, and they gave such a strange unearthly air to the place, I began to see all this in terms of Dali and the surrealist painters and of all the other artists back through the centuries who had been in love with bones. Whether it's love of death or excessive fear of death that induces this love of bones, I don't know; but there is now, and I think always has been, almost a school of bone lovers among the artists. Bones are handsome objects, with their rounded and their concave surfaces, and as you look

at a skull you are seeing a head reduced to its simplest terms, and you are staring death in the face to boot. The combination is exciting, so the cult of bones is understandable, but it's not my world. I saw these bones in terms of other people's paintings, not my own.

But the sod igloos engaged all my interest, and as I stood sketching a large and well-built one, an old woman, returning from the school, drew me in to look at her collection of "old things." The entryway was framed with bones and surfaced with thick solid blocks of sod laid like cut stone with broken joints, making a fine tight wall, with not a chink of light coming through. This arched passageway was roofed with the huge flat bones of the whale, from cheek and head, I suppose, and over it the sod was continuous, the upper overlapping the lower ones to make a tight roof. The entryway was full of meats, skins of seal oil, pans of salmon heads and eggs and various offal of recent killing, but no unpleasant stench. The room we crawled into at the end was suprisingly large and light and clean; scrubbed and sweet smelling, lighted through a skylight of transparent walrus stomach membrane. The floor was of wide scrubbed boards, the walls of boards, and the roof held with heavy poles. This was entirely encased, as the entry was, in thick blocks of turf, and the roof was turfed over, too. With the help of a few big patches of walrus skin around the skylight and the ventilating shaft, it shed water perfectly. What a snug and windproof refuge from the storms that swept over this barren land!

HENRY VARNUM POOR: Pt. Hope July 24, '43
Collection, Mrs. Henry Varnum Poor, New City, New York, ink on paper, 8 x 12.

Arthur B. Davies (1862-1928)

Each artist's landscape of dreams has a physical departure point, a place that exists somewhere, a place that enters memory and becomes transformed into an interior stage set. Arthur B. Davies is best known for his Arcadian idylls populated with doll-like sylphs, acting out some vaguely sexual charade. The landscape of these silent dances is often undulating, horizontal in motif, broken occasionally by a cluster of trees, a landscape not unlike the one surrounding Utica, New York, where he was born. In 1890 he traveled up the Hudson to Holland Patent, a small town near Utica, and wrote tender letters to his fiancée, Lucy, describing his adventures and, of great interest here, the mystical merging of his desire for affection with his feeling about the natural landscape. These letters, published here for the first time, find their logical accompaniment in Davies' pastoral painting, "Along the Erie Canal." The first was dated "Tuesday."

I HAVE ARRIVED, and had a very enjoyable passage all the way from New York. . . . All the way up through the Narrows on the river, back of the schooners, beautiful Selene gracefully moved with a feathered breast, and when the train stopped at Rotterdam on the Mohawk R. I saw . . . moonlight over a high hill that was covered with pines. . . . I got to bed about 1 o'clock in a little old fashioned hotel in New Hartford, and this morning came down into town. The greater part of the time before my train started for H. Patent I spent along the banks of the Mohawk—made three sketches. . . . The day (today) started bright and hopeful—a little rain at noon and tonight the sad sweetness of a dying season spreads over and through the trees.

Friday

Yesterday was *such* a day. I went to a township fair and today—now am up on high hill under some big trees and the sounds sweep over me on the strong wind—have just finished my seventh apple since dinner . . . the leaves say—Lucy: Lucy, Lucy, Lucy, Lucy, the wind feels like her embrace. . . . Last night I witnessed an effect of moonlight, in which the color of objects could be distinctly seen. I watched it from a hammock until I fell asleep and then woke up again and got saturated with the dream. . . . The moonrise was one of those cheese like colors in a lavender sky, with very warm color in ground. Night before last I went up at sunset on a high hill and saw both eastern and western skies. . . .

At the fair yesterday, which in the company of Cousin Willie was reached by a walk of 4 miles through a heavy thunderstorm—part of the time we waited in a barn but we were caught by the heaviest of it—we were rather wet and afterwards the sun came out hot as a summer sun and we were soon dry again. . . . in the afternoon the usual horse-racing and balloon ascensions, a walk home in the twilight with some fresh country lassies . . . how beautiful is the magic sunlight in this air and hurrying leaves—the misty distances.

Saturday

. . . I am sitting now on an eastern slope of a large hill and the warm sunlight comes down on my back, off to the east is a wide valley, in the shadows a smoky purple waits and in the lights the orange of an hour before sunset. The hills seem to flow like waves and the different farm yards send forth the calls of cattle that wait for their rations of green corn. I have not heard any katydids—the crickets keep up a chorus continually. If I could create the emotions on paper that I feel in this golden simplicity and liken it to our affection for each other . . .

ARTHUR B. DAVIES: ALONG THE ERIE CANAL, 1890
Collection, The Phillips Collection, Washington, D.C., o/c, 18 x 40.

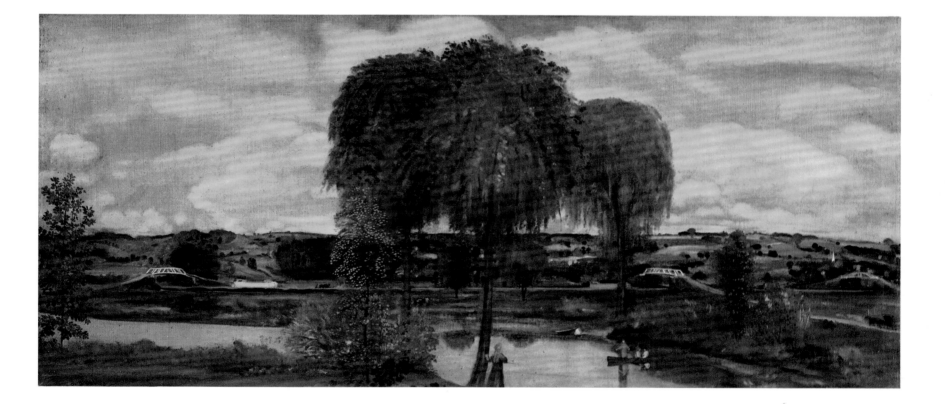

Edward Hopper (1882-1967)

The spare and lucid paintings of Edward Hopper are among the most enduring, hypnotic, and unsentimental images of American places ever made. Contrasting with the archetypal, often more generalized oil paintings, Hopper's watercolors such as "Cobb's House" (in South Truro on Cape Cod) were consistently based on direct observation. First-person statements on art and nature by Hopper are few. The following comments are drawn from three sources: the first paragraph from Katherine Kuh's interview in her book, The Artist's Voice; *the second and fourth from an interview with Brian O'Doherty published in* Art in America; *and the third from Hopper's own catalog statement, made in 1933.*

I CHOSE TO LIVE [on Cape Cod] because it has a longer summer season. I like Maine very much, but it gets so cold in the fall. There is something soft about Cape Cod that doesn't appeal to me too much. But there's a beautiful light there—very luminous—perhaps because its so far out to sea; an island almost. . . . I'm a realist and I react to natural phenomena.

It's like sunsets. The people around here keep telling me about beautiful sunsets. It's what you *add* that makes it beautiful. . . . the unsophisticated think there's something inherent in [the subject] . . . a pond with lilies or something. There isn't, of course.

My aim in painting has always been the most exact transcription possible of my most intimate impressions of nature. I have tried to present my sensations in what is the most congenial and impressive form possible to me.

The thing that makes me so mad is the American Scene business. I never tried to do the American Scene as Benton and Curry and the midwestern painters did. I think the American Scene painters caricatured America. I always wanted to do myself. The French painters didn't talk about the "French Scene" or the English painters about the "English Scene." It always gets a rise out of me. The American quality is *in* a painter—he doesn't have to strive for it.

EDWARD HOPPER: COBB'S HOUSE (SOUTH TRURO), 1942
Collection, Worcester Art Museum, gift of Stephen C. Clark, watercolor, 21½ x 29½.

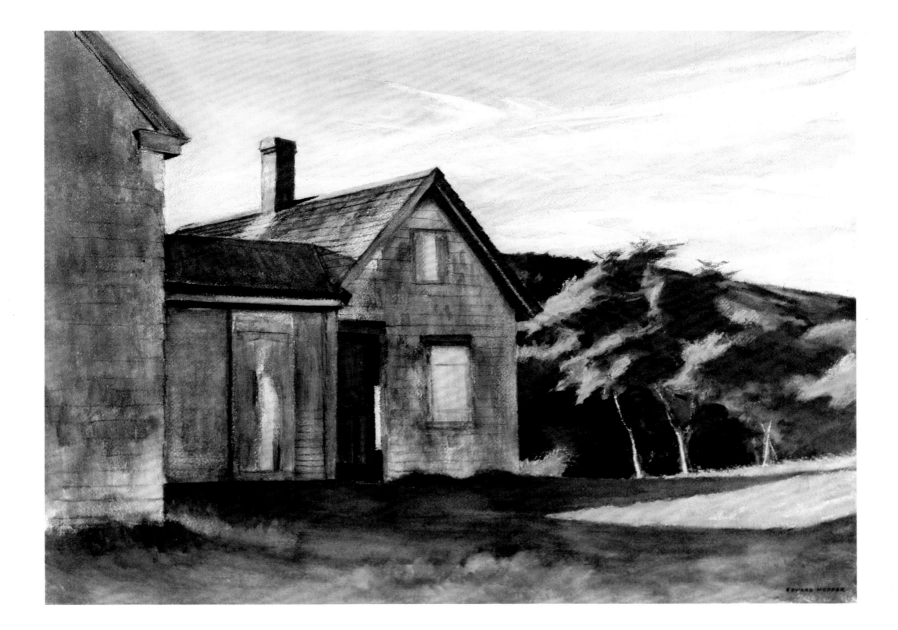

Charles Burchfield (1893-1967)

A fitting evaluation of Charles Burchfield was written by fellow painter, Edward Hopper, many years ago: "He has extracted a quality that we may call poetic, romantic, lyric, or what you will. By sympathy with the particular, he has made it epic and universal." Burchfield was born in Ashtabula, Ohio, the fifth of six children. His father died when he was five and he was taken to Salem, Ohio, his mother's birthplace. He was a lonely, friendless child whose moments of happiness were prompted either by reading or by walking alone in the countryside. He entered the Cleveland Institute of Art in 1912 but dropped out after two unproductive years. His esthetic taste at that time turned toward the exotic, the decorative, and the romantic—Chinese painting, Japanese prints, and illustrations by Arthur Rackham. In the fall of the year 1916, after Burchfield painted "Late Afternoon," he went to New York for what would be an abortive enrollment at the National Academy of Design. He designed wallpaper for a Buffalo company from 1921 to 1929, then devoted himself full time to painting. He describes the "supremely happy moment" when he stood again in the woods and listened to the Ohio wind. His early watercolors are remarkable for the fresh, creative statement of themes which would characterize his lifetime's work in which all forms—trees, birds, clouds, houses—vibrate to a life force, a power that is deeded them by an artist who, as his journal reveals, felt nature's impulse stirring within himself:

July 11, 1916: When I am attracted to a scene, if I do not sketch it . . . I have a feeling of having lost something.

July 21: I long for a period of seclusion—There is nothing in a half-way mode of living—yet I force myself on, matching what little I may from nature, only enough to realize what wonderful poetry I am missing—

July 31: And so I have arrived at this point, and have no more possessions than the love of nature and life—The true poet needs no more.

August 5: While sitting in the flat meadow along the Beaver Creek, I listened to rain roaring on the mill to the east, though there was none where I sat—

All week long I have been getting glimpses of the strange dream-world that is always far beyond my reach.

August 19: In painting, as much idea of the immensity of the sky can be given by showing a very small area as by showing a huge amount.

August 25: I heard thunder booming from unknown depths to the South tonight, and going out saw a sudden vision of clouds planted against the lightning lit sky, while on all sides from the black earth arose the incessant cricket chorus . . .

August 26: This evening at dusk as a storm from the Southwest swept out of the orange sky; as the huge misshapen trees, thinned by the wind waved against the afterglow; as the wind's course was marked in waving corn and levelled sunflowers; as I saw lighted windows in the puny houses; as I saw the fearful immensity of the storm, I felt how small, how futile my attempts so far have been. A great discouragement came over me.

I dream of immense storms in mountain valleys on seas which war with mountainous shores; of boiling rivers curling down mountain sides; of sudden flashes of sunlight at the heights of such storms and wonder if it will ever be my joy to paint such scenes—I must—I will.

At midnight a strange phenomenon—streaks of pale light radiating from zenith west of them extending over the north half of the sky—great nervous waves of light flutter upwards from the north.

August 27: I saw a sketch this evening that gave me the same savage thrill that I felt when as a boy I sighted a new butterfly or moth.

August 28: Morning clings to the fleeing season as in late February the mornings are Winter and the evenings Spring, so now at this new midseason are the sunrises Summer and the sunsets Autumn.

In a cornfield as the sun set—brilliant yellow sunlight . . . with the bright afterglow came the first autumn chill. The smell of corn added to it. My hands grew numb—I came home in the electric air intoxicated with the new feelings. . . .

CHARLES BURCHFIELD: Late Afternoon, 1916
Courtesy Bernard Danenberg Galleries, New York, watercolor, 14 x 20.

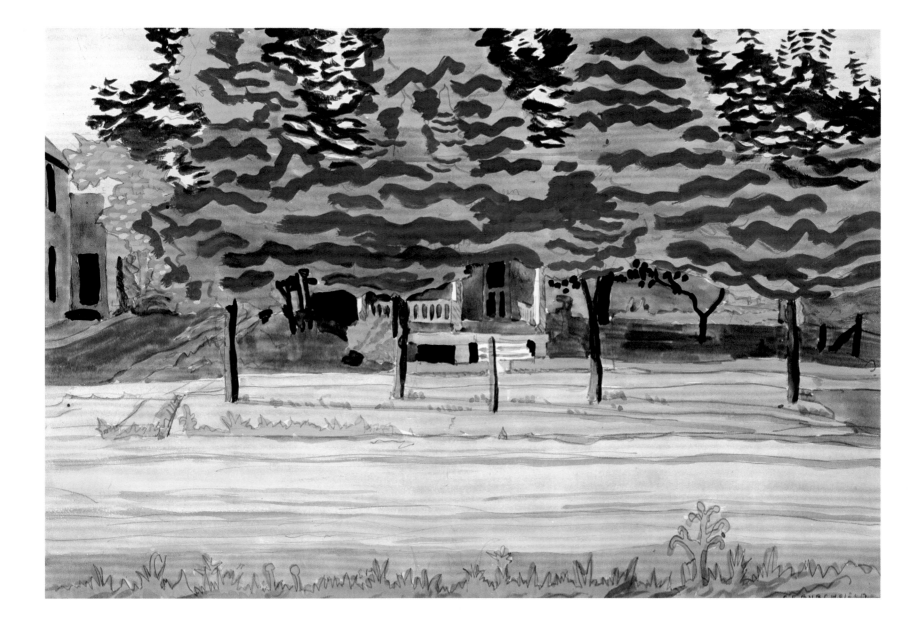

Nell Blaine (1922-)

Not only does Nell Blaine paint unpolluted places, but also she is the Queen of Unpolluted Color. Whether it be gay flowers, the exotic foliage of Caribbean islands, or the pastoral landscape of New York and New England, Nell Blaine brings to every subject an uncorrupted, absolutely fresh sense of life and color. She was born in Richmond, Virginia, studied in the South, and then came to New York, where she joined other gifted artists who were working under Hans Hofmann. Her work at that time was abstract, changing in the early 1950s to more figurative themes. She has had twenty-two one-woman shows since the first in 1945 at the Jane Street Gallery in Manhattan, and has been in more than sixty important group exhibitions in the United States and abroad. She is represented in the permanent collections of many major museums. Continuing her prolific ways, she scatters joy-filled paintings like wildflower seeds on the receptive earth. Her exuberance shows in the interview:

IT WAS A FARM, piece of property, about fifty acres owned by a neighbor of mine. It's near Brewster, only an hour and three quarters from New York. That particular painting just sort of came. I had been staying there for several months, and I have stayed there for two summers one right after the other and I was familiar with the area and that particular spot. At times I was very interested in the way the tops of trees met the sky, or the way that light came in through the trees or some sort of depth that penetrated into the woods. It's mysterious, where you have a long range of color that can be used. Also it's fun to take something that seems clichéd—a view—and see if you can do it in a fresh way.

I hunt for rhythms in nature, whether it be small or large measures, intimate or grand, but internal rhythm it is primarily. I am attracted to the vista as well as to the intimate.

There are all sorts of technical problems outdoors that I find so difficult aside from the painting itself. The light comes from so many directions. I've painted outdoors for more than fifteen years. I had sunstroke once from it, passed out, but then I learned how to shade my eyes because if you stare at a white canvas you can really pass out. When I set up to do a painting, it's really elaborate. I have two people bring out about twenty

NELL BLAINE: SUMMER AFTERNOON, 1969
Courtesy Poindexter Gallery, New York, o/c, 24 x 36.

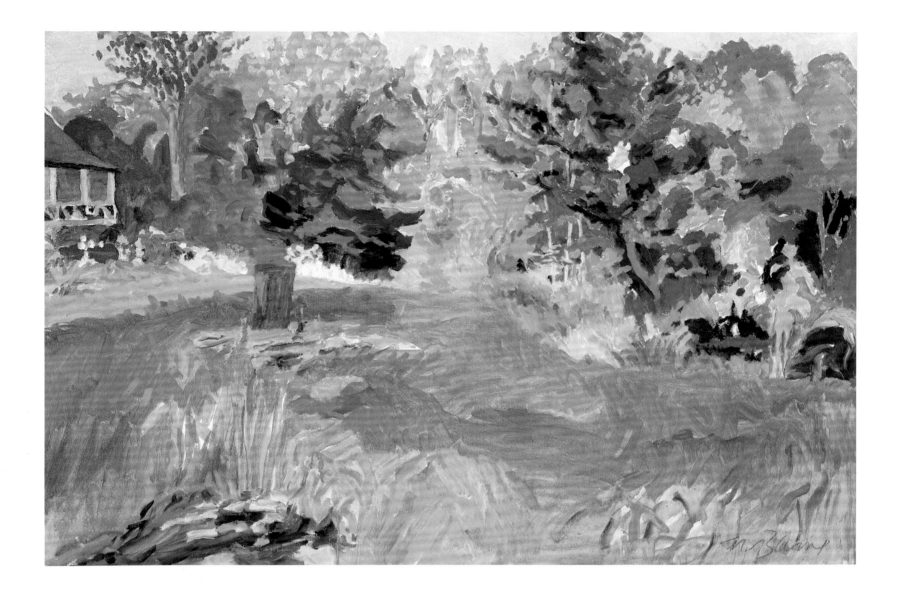

items, a little table, and I have to prop everything to make it level. And on a little rocky road in the woods you can imagine what is involved anyhow. And then I have a huge umbrella and in front of that are attached little pieces of cloth and paper to keep the light from shifting. It's comical.

[Your mood] can be shattered too, very easily sometimes, even though you are very intent. There is a sort of privacy that I try to achieve in relation to nature and something outside can shatter this kind of concentration. An event along the road, some interruption, because the thing is so private. That is one of the major difficulties. On the other hand, things that happen in and around nature sound very romantic, like birds and snakes. I find that very stimulating, so you can see that I must be a romantic without realizing it. Words are the worst intrusion.

The moment of the dying of the light is my favorite moment to paint landscape. For me this time is a great flaring up of life and illumination and excitement and revelation. I become more alive too. I paint more then than any other time. It's a time when I gather my energy. I'm physically more alert to my surroundings... the main reason, I believe, is the excitement that the color takes on—it illuminates everything. In the middle of the day I never feel even the urge to paint—a brilliant light seems to bleach out the forms. But... in the late afternoon I find the rosy color.... It's not the sweetness of it all (I'm sure people think my painting is sweet) but a blast of color coming over and saturating everything, illuminating the actual color out-of-doors. There's a drama that takes place at this time when the light is strong. It's as if everything is unfolded suddenly ... each tree seems to have more life to it and there is some flaring up of its own inner self and the whole unified by some sort of drama in the light. It does a lot of your work I guess. The light mutes some things and illuminates others. I try to paint very fast to accommodate this early image but sometimes a new thing happens that's more exciting than when I first saw it. I try to see the whole area as intensely as possible and I try to work toward that, but I don't adhere rigidly to that because its not organic enough—it's too much of a limitation.

At one point when I was studying I felt that I had made some sort of contact with something in myself—something like a physical force that would come out through my fingertips. Some years ago I read that painting is like a spider's web. It comes out of the body of the artist, is pulled out of the body. From that point I felt I could judge whether it was true or contrived, synthetic or really felt. You know when your whole person is coming together to do this act. You learn to make it come, how to spring open the door.

Constance Richardson (1905-)

Mahonri Sharp Young wrote in a catalog introduction to a ten-year retrospective exhibit (Kennedy Galleries, New York, March 1970), "Constance Richardson has painted everything west of Vermont and north of the Mason-Dixon line." She has been an indefatigable summer traveler and has managed to see beneath appearances and, avoiding the artist-tourist trap, to find the heart of a landscape. She is known particularly for her fresh, buoyant, light-filled Wyoming paintings. She traveled on the Upper Mississippi in the mid-1950s, going into Minnesota, a trip that inspired her extraordinary Duluth paintings. To a contemporary viewer, her "Duluth Hillside, 1956" has a haunting air of the past, when cities seemed more natural. A catalog statement (1960) and an excerpt from a letter (1971) by Constance Richardson follow.

IN 1625 CAHOW BIRDS were believed extinct. Some doubts arose in 1906. In 1951 about a hundred of them were discovered and there was great rejoicing by a very small number of interested persons.

There are some things that just go on. Landscape painters and cahow birds are not apt to be analytical, which rather prevents them from explaining why. But what I imagine to be the inner excitements of the explorer who discovers rivers and mountains and plains, or maybe only a tree or a rock that no one saw before him, and of the hunter who lives a day intensely with each quickened sense alert, and what I know to be the absorbing problems of the painter—all come together in the painting of a landscape.

. . . surely no one supposes that a landscape painter puts down exactly what is before him. First there is the trained eye that selects; the emphasis that *this* is what is wonderful here; *this*, the austere lonely quality, or *this*, the early freshness in a dry world; and always, always the light. Surely no one supposes that a realistic novelist, or playwright, writes exactly what he hears? There are years of experience, of observation before, and days of working the things out, transposing afterward.

The city of Duluth is a long narrow strip along the water, but above it is a steep hillside of grass and splendid black rocks. From there one can see the whole of Lake Superior, the curve of the earth and the ships coming over it to go through the Lift Bridge. From there they go either to Superior, Wisconsin across the bay where the grain elevators loom up like White Castles, or to the ore docks beneath, where they seem to nurse, as little locomotives bring down the red ore from the mines farther north. All day a person can watch these complicated manuevers.

Now, I suppose, the engines are diesel and there is certainly less ore. I hope the ships still come, and that somebody likes to climb up the hill over the great black rock, and look at them.

CONSTANCE RICHARDSON: DULUTH HILLSIDE, 1956
Collection, Mr. and Mrs. Edmund C. Bray, St. Paul, Minnesota, oil on board, 17 x 30.

Richard Diebenkorn (1922-)

Asked once what it was about some locations that made them right for him, Richard Diebenkorn replied, "clarity of light, space, spareness, expansiveness, contrast," which fits his California environment perfectly. He was born in Oregon, and since the mid 1940s has been an exemplar of a west coast school of painting that let in the fresh air of feelings as a motivation for art. His own work over the years has embraced on-the-ground landscape and figurative subjects as well as more airborne abstractions. Its consistent quality, regardless of subject, has been marked by an unusually high degree of painterly elegance and draftsmanlike skill combined with an unmistakable feeling for color. A letter of his speculates on sources:

INGLESIDE IS A residential area west of Twin Peaks in San Francisco, where I lived as a boy. Visiting there thirty years later provided me with a peculiarly concentrated subject matter, one which represented much that I had rejected in intervening years but which at the same time referred largely to what I am. A sense of place was built into my use of this material. I made on-the-spot sketches that were very brief, finding that when I painted from them in my Berkeley studio the relevant detail filled in easily. The pictures that came out of this don't refer to specific streets and houses but I believe are very much about the place, Ingleside.

My sense of place is involved with particular pictures and subjects whereas my present environment has to do in a more general way with light, coloring, and configuration. I painted the Ingleside series in a very different environment (although it was at most fifteen miles distant) from Berkeley's. Could I have painted Ingleside while working in Albuquerque or Los Angeles? We can probably agree that the sources for painting are incredibly tangled and we had better hope they stay that way.

RICHARD DIEBENKORN: INGLESIDE II, 1963
Courtesy Poindexter Gallery, New York, o/c, 30 x 71.

[143

Fairfield Porter (1907-)

Fairfield Porter is an American Vuillard, a master of intricately composed, beautifully colored, light-filled canvases. He was born in Winnetka, Illinois, graduated from Harvard and has had a long, distinguished career as art critic as well as painter. He is author of a book on Thomas Eakins, wrote award-winning articles on art for The Nation, *and has also lectured widely on esthetics at universities. It is as an artist, however, that Porter has achieved his preëminent reputation. During the long post-World War II period when abstract-expressionism dominated American art, Porter was one of the few painters of landscape to enjoy critical approval. He lives in Southampton, Long Island, but summers regularly in Maine. Reasons for inclusion of "Interior with Pattern" in a book devoted to landscapes are implicit from the interview:*

I LIKE MAINE very much but I don't always paint my best landscapes there, because if something is beautiful in itself, that takes you away from making a painting. It makes you think of reproducing it. The painting . . . should be beautiful, not what the painting refers to. Light is what sets me off, the quality of light in nature. It's the light that's in the painting, finally, which counts.

There is one painting of mine where I feel the question of place is happily resolved. It's a picture of a living room in a house my father built on Great Spruce Head Island in Penobscot Bay, Maine. My brothers and sisters built houses for themselves, so I inherited this one. I've painted that room very often, and it's Maine to me. I don't know if its an ugly room or not but it has a very strong personality.

I don't look for places to paint. A place means a lot to me not because I decided that it did. It just does; I can't help it. The most important thing is the quality of love. Love means paying very close attention to something and you can only pay close attention to something because you can't help doing so.

Of all the books and poems I have read about places, those that meant most to me in this respect have been Russian novels and poems by Pasternak, Paustovsky, Tolstoy (in translation; I don't know Russian). These are recent. I can't remember so well earlier ones—except Beatrix Potter. On the whole, of books and poems in English, it is those by Americans that mean most to me in regard to the evocation of place: Sarah Orne Jewett, Hawthorne. The "places" in English literature are not nearly so real to me as those in Russian books, or in Hawthorne, or Jane Bowles (Two Serious Ladies) or Elizabeth Bishop. In Jane Bowles' novel, I feel I know exactly where on Staten Island a part of the book takes place. It isn't that she directly describes it, either. It is, as in Russian books, very much the reality of the people for me that makes the place real. A Russian novel, at its best is like one's own life: an English novel is literary. A poem of Pasternak's about a rain storm and his prose descriptions of Siberia make me feel that I was there. Paustovsky and Elizabeth Bishop are directly visual: the writer was there, or is there, and I am helplessly drawn in. It does not follow that there is not other prose and poetry that does not move me just as much, only not in the visual sense, which is what I believe you are asking about.

I think the quality common to the places I would most like to go to but have never visited is that I can imagine in those places the relation between the place and its human inhabitants so that it would be a place whose strangeness and interest came from my being able to feel that I have already lived there, different as it may be from what I have known.

FAIRFIELD PORTER: INTERIOR WITH PATTERN, 1969
Anonymous collection, New York, o/c, 60 x 44.

William Merritt Chase (1849-1916)

The tradition of the artist-teacher continues strong in the United States as some of the most talented devote part of their energies to assisting young art students. No substitute has been found for the personal exchange or the careful criticism. On the basis of numbers alone an excellent case could be made for William Merritt Chase as the artist who personally guided more students than any other art teacher in America. Autocratic, eclectic, a dazzling master of brushwork, Chase lived a full, prosperous and well-traveled life. For eleven years he maintained a summer school near his home and studio in the Shinnecock Hills at the easterly tip of Long Island. The following vignette, from K. A. Roof's book on the artist, is pure, vintage Chase, the master speaking to the struggling student. The painting "Shinnecock Hills" represents Chase at his artistic best—clear, direct, unfussy, completely in command of a scene he knew intimately.

ONE SUMMER when a hectic wave of impressionism was agitating the students' colony, several canvases were brought into the Shinnecock class showing lurid patches of yellow and blue. When Chase saw them upon the screen he began to hem and hum, tug at the string of his glasses, tap his stick upon the floor, and twist his moustache. Finally, with a slight frown, he turned upon the perpetrator—it was seldom necessary for him to ask his or her name. "And it was as yellow as that?" he asked.

"Oh yes, Mr. Chase. Really it was. The sun was right on it, you know, and it was very yellow," the pupil babbled on, imagining that she was being very convincing. "Hm," was Chase's reply, after another glance. "And September not here yet! Give the goldenrod a chance, madam, give the goldenrod a chance."

Asher Brown Durand (1796-1886)

Asher Brown Durand was a man who practiced what he preached—"Go first to nature to learn to paint landscapes." The revolutionary aspect of that statement can only be understood in historical context. Coming at a time when American nature painting was dominated by European esthetics, he may well have been the first to advocate a direct response to nature, placing highest value on seeing and feeling for oneself. He urged painters to be influenced by weather, by atmosphere and light. And he took to the hills and returned with fresh, moisture-filled pictures. In 1855 he painted "In the Woods," large and refined, and no doubt based on sketches completed in the field. From North Conway, New Hampshire, that year he wrote a letter describing in great detail the scene he found:

THE REGION of the White Mountains is justly famed for its impressive scenery; passages of the sublime and beautiful are not infrequent, and for those who have the physical strength and mental energy to confront the former among the deep chasms and frowning precipices, I doubt not it would be difficult to exaggerate, and the simple truth would be sufficient to convey the full idea of "boundless power and inaccessible majesty," represented by such scenes. But to one like myself, unqualified to penetrate the "untrodden ways" of the latter, the *beautiful* aspect of the White Mountain scenery is by far the predominant feature. In this respect, this locality (North Conway) possesses advantages probably unequalled by any other,

WILLIAM MERRITT CHASE: SHINNECOCK HILLS, n.d.
Collection, The Cleveland Museum of Art, gift of Mrs. Henry White Cannon, o/c, 40 x 50.

See frontispiece, page 17, for the Durand painting.

both for its immediate prospects and for the convenience of excursions in the vicinity, introducing new and still new beauties for many miles around. It has not been, as yet, my privilege to enjoy many such excursions, nor have I sought it; there is enough immediately before me for present attention. Mount Washington, the leading feature of the scene when the weather is fine, a circumstance too rare, rises in all his majesty, and with his contemporary patriots, Adams, Jefferson, Monroe, &c., bounds the view at the North. On either hand, subordinate mountains and ledges slope, or abruptly descend to the fertile plain that borders the Saco, stretching many miles southward, rich in varying tints of green fields and meadows, and·beautifully interspersed with groves and scattered trees of graceful form and deepest verdure: rocks glitter in the sunshine among the dark forests that clothe the greater portion of the surrounding elevations; farmhouses peep out amidst the rich foliage below, and winding roads, with their warm-colored lines, aided by patches of richly tinted earth break up the monotony, if monotony it can be called, where every possible shade of green is harmoniously mingled. I have seen no scenery in this country presenting so great a variety in color. The bare summits of the higher mountains in sunny warmth, contrast beautifully with the purplish blue and russet hues that graduate from midway down their vast slopes to their forest bases, and the patches of cultivation which seldom venture but a short way up their sides, are rarely offensive through formality of outline, being always agreeably tinted with various colors.

Such are the more obvious features of this locality, but these are not all. An irregular strip of table-land, skirting the bases of the eastern hills, including Mt. Kearsarge, lifts you from fifty to a hundred feet above the bed of the Saco. On this table-land the village of North Conway is situated, and there the public road passes. In approaching the rich meadows which border the river, you descend a steep bank mostly studded with trees, but occasionally presenting a declivity of loose sand not unlike the ashy slope of Vesuvius, out of which often shoot up the shining stems of the white birch mingled with the drooping elm, and suddenly at the base you are surprised with the gleam of a crystal streamlet winding its way among alders and overhanging trees of various kinds, birch, elm, and maple, to mingle with the Saco. On these streams, and there are a number, the artist finds a variety of delicious "bits"; now the luxurious fern and wild flowery plants choke up the passage of the waters, and now masses of mossy rock and tangled roots diversify the banks, and miniature falls and sparkling rapids refresh the Art-student, and nourish the dainty trout. Along these streams at all reasonable times, you are sure to see the white umbrella staring amidst the foliage. I meet these signals of the toiling artist every day, and never without experiencing an internal struggle—a mental conflict. I have a predilection for such secluded recesses of quiet beauty, and many have I found near home, but I am here some three hundred and fifty miles away in search of mountain scenes and passages of middle grounds— the larger and more imposing features of landscape—and yet I find myself like Garrick, between tragedy and comedy, not knowing which to choose. However, unless the elements soon become more auspicious, I shall yield to the lesser charm, and sit down with my "traps" in the "cool sequestered vale," for I have battled with the clouds and rains for the last fortnight to little purpose. Just as I commence my study of the mountains, they are veiled and disappear, and I wait another and another day in hope, till "hope deferred maketh the heart sick." But the clouds do not descend to the valleys, they hide not the secluded stream, and the trees continue in their unveiled charms, lovely in shade as in sunshine, happy as it were in their humility. . . .

Sheridan Lord (1926-)

Modest and self-effacing, Sheridan Lord is a landscape painter whose work is the product of a thirty-year association with the rolling, salt-sprayed hills of eastern Long Island. He was born in New York City, graduated from Yale as a literature major, and studied art at the University of Iowa in the early 1950s. During the summers of his Iowa apprenticeship, he painted the flat, marshy tidal coastline around Mustang Island near Corpus Christi. He has been an instructor at the Brooklyn Museum Art School since 1963. In recent years, he has burrowed into his boyhood hills, producing some sharply observed, finely colored paintings of the Sagaponack landscape he loves—as the following interview attests.

THERE ARE FRIENDS who live along this road and I was out in the backyard and saw this and I asked if I could set up. I liked the rise there. I started to paint and it was a foggy day, Columbus Day. I reserved working on the painting at those times when the weather was gray. It wasn't always misty and then I would have to make adjustments. It would be gray but the muted qualities of the tone weren't always the same. You get a lot of this kind of weather on Long Island and it could be either spring or fall except possibly for that tawny coloring. The light is white, pearly. Its very near the ocean so you get salt in the air. You can see it if you go down to the beach and look with the sun at your back at the horizon line. At the point where the lines converge, there is a great haze. It seems to hover right over the dunes. It is salt. The painting was started on Columbus Day and finished on Thanksgiving.

I want the foreground to take you right in, not to have people be stopped and not cause you to be too conscious of it. Too strong a red or green would arrest you. The changes I make are mostly value adjustments

because of the slight differences in space. I don't want to be mechanical about it but things come into a little sharper focus nearer to you. I try to get a combination of tones which at least seem to be parallel in their relationship to what is going on.

Its hard to see out of doors. I wear a big eyeshade. Where you've got a lot of glare, there's a tremendous amount of reflected light. In this one you had no sun. It was hazy enough, foggy enough, overcast enough so that you had no sun, no shadows, so you had no change of reflections, no business of the sky going white. You know if you look into the sky early or late in the day, the sky is whitish yellow and the landscape against it tends to look rather silhouetted, as the sun rises, the sky gets blue and that comes out in your subject. If you can get a painting going for a gray day, you have it made.

Why do I paint landscape? Its good to be out of the house. I like the feeling of being by myself with huge sky, with bare feet in the earth. I feel better about myself. Not just painting, although I have to do that to feel better. I feel more complete. I don't know what it is about standing out there. Its a very primitive thing, its stripping life to the very bare essentials, to stand with your feet on either side of a potato furrow with the clothes on that you need and that's all, with a countryside that you are devoted to.

I tried to think about things like "it may change" but that's a marginal concern—the problem about real estate and development, the social concern, is secondary. I'm not interested in making a record about this now for when it no longer exists.

It just makes me feel good as a person. For me, it makes me feel strong. It makes me feel clean. The closest feeling it has for me is sports. I used to love sports, everything was very four square, clean cut, playing hockey or football or baseball, that kind of exhaustion, that fulfillment. Did you ever do that, know a nice pleasant feeling of being physically exhausted, of being rinsed out, when you've had a good day or a bad day, if you've struck out three times...some sort of bodily release? I get something very akin to that feeling painting landscape out of doors.

SHERIDAN LORD: Sagaponack, 1970
Collection, Mr. and Mrs. Harry W. Havemeyer, New York, New York, o/c, 40 x 60.

[151

Edwin Dickinson (1891–)

Edwin Dickinson's paintings of places often appear to be seen as if in a dream. A strange time-filled, time-removed quality suffuses his images, a quality captured as much by intense looking as by intense memory. Edwin Dickinson was born in Seneca Falls, New York, in 1891. He carries himself with an almost Edwardian grace, yet his paintings are impeccably modern in attitude, filled with feelings that never descend into sentimentality. In the fall of 1970 I asked him to talk a little about a magical landscape, "The Finger Lakes," he completed in 1939:

THERE'S [a painting] of a balloon ascension that I can recall. It was just a reading of the sentiment of one's recollections. I was brought up in the Finger Lakes region of New York, Central New York. My father had a pastorate there. On the Fourth of July . . . festival . . . a balloonist was hired . . . there was a regular agency where you could get hold of a balloonist. A fellow was hired for the ascension—one place or another—and this time it was in the village of Seneca Falls. [There was] all kinds of fun going on, and singing, and by George, later I went to one of those [Fairs] when I was [on leave] from the ship in the naval service—open cars, you know, there was the moon, candy and popcorn, singing and I pulled the hair of little girls—I was older, of course—it was just wonderful . . . then you'd get down there and you bought whatever those sticky things were called. There was a rumor where the balloonist was going to go up. It just claimed universal attention—it was a pretty lake, the most romantic thing.

The romanticness of the time of my life and whatever was the interest at that time, and they were quite several and diverse. I didn't do any painting right away of the ascension that so impressed me, but I was interested in this early experience of balloons. I was [also] interested in rocks and cliffs and gullies because Central New York is just a mass of little canyons from the Minnesota ice sheet which carved the Finger Lakes.

Georgia O'Keeffe (1887–)

"I'll tell you the dirt resists you," Georgia O'Keeffe once said, "it's very hard to make the earth your own." From Sun Prairie, Wisconsin, where she was born, to Abiquiu, New Mexico, where she lives, Georgia O'Keeffe has claimed as her own not only the earth and all its forms but also the sun and sky as well. In her ripening years, O'Keeffe has been recognized for what she is, not simply America's finest living woman artist, but one of the finest painters this nation has yet produced. She was briefly a commerical artist in Chicago and then a supervisor of art in the public schools of Amarillo, Texas. She was both wife and protégée of Alfred Steiglitz, who presented her first public exhibition at his 291 Gallery in New York in 1916. She first visited New Mexico in 1929, but came there to settle only after Steiglitz died in 1946. She flew around the world in 1959 and at the age of 73 went down the Colorado River in a rubber raft. A triumphant retrospective exhibition, organized and shown in late 1970 and early 1971, has enabled young artists and a new public to discover for themselves the range and depth of her vision. Her paintings of the sky above the clouds have enlarged the entire scope of landscape painting, encouraging each viewer to regard the whole earth as one place, waiting to be claimed. Her first statement below is from an interview with Katherine Kub in 1960 and reacts to news of man's first earth orbiting; the second from an interview in 1970 with Grace Glueck.

WELL YOU SEE we haven't found enough dreams. We haven't dreamed enough. When you fly under even normal circumstances you see such marvelous things and such incredible colors that you actually begin to believe in your dreams. Flying around the world so fast to me seems a dream, even if I know it is probably a reality. I was three and one half months flying around the world . . . to do it in a day seems like a dream.

I was flying and I saw them—the most extraordinary white. It looked as if you could walk right out the window of the plane . . . then I saw all those little white clouds, and I kept on thinking . . .

EDWIN DICKINSON: THE FINGER LAKES, 1939
Collection, Chauncey L. Waddell, New York, o/c, 23½ x 28½.

GEORGIA O'KEEFFE: SKY ABOVE THE CLOUDS II, 1963
Collection, Mr. and Mrs. Potter Palmer, Lake Forest, Ill., Abiquiu, New Mexico, o/c, 48 x 84.

Jane Wilson (1924-)

Jane Wilson was born in Seymour, Iowa, lived on a farm there, and studied art at the University of Iowa. Very much a cosmopolitan painter, she matured as an artist after coming to New York and participating in the hectic and stimulating period when abstract-expressionism made New York the art capital of the world. Many of the swinging, calligraphic gestures that characterized abstract-expressionism found their way into her large and loosely brushed paintings of sky and land. Though her recent painting has focused on tightly organized still-life compositions, her sky paintings remain vivid demonstrations of how the once-new freedom of abstract-expressionism found enduring form in the landscape. The following is from an interview:

I GREW UP in Iowa on a farm and needless to say I spent a great deal of time out of doors. It was an identity which in the city you have by going on a bus. There you wander around the countryside; its what farm kids do. I came to New York and was absolutely overwhelmed by abstract-expressionism. I don't know what my feelings really were except that I couldn't seem to paint then. There was that terrible thing of leaving school . . . and finding out whether you're going to be a painter or not. I painted abstractly for a while. It seemed to be the only direction to go in. I slowly found out that subject matter was terribly important to me. My composition was going toward a horizontally oriented construction which read as either still-life or landscape, but on an abstract level. It seemed to have planes, things were on it, above and below. It was about gravity, let's say, the contact and the weight of air and the color was going very definitely in the direction of landscape. One day I painted a little landscape with trees and bushes. It wasn't something I had seen, it just came out. Then gradually I began painting more and more landscapes. They were generalized feelings of proportion, the weight of the sky and how much earth was meeting it. By the time I had finished the painting it had become a very specific place, yet all those experiences came out of memory. It became a specific experience; it wasn't a specific place but it seemed to be.

For the first two years I did mostly sweeping skies and low clouds. I had a conversation once about the search for a specific sky. I thought it must be in England because of seeing Constable, or Holland because I was very intrigued with Dutch landscape, and I went to the Midwest and there was the sky, this very heavy thing like the sky over Paris. It was that particular sky I was looking for, trying to get at in my painting.

JANE WILSON: INTO EVENING, 1960-1961
Collection, Whitney Museum of American Art, gift of the Friends of the Whitney Museum of American Art, o/c, 60 x 80.

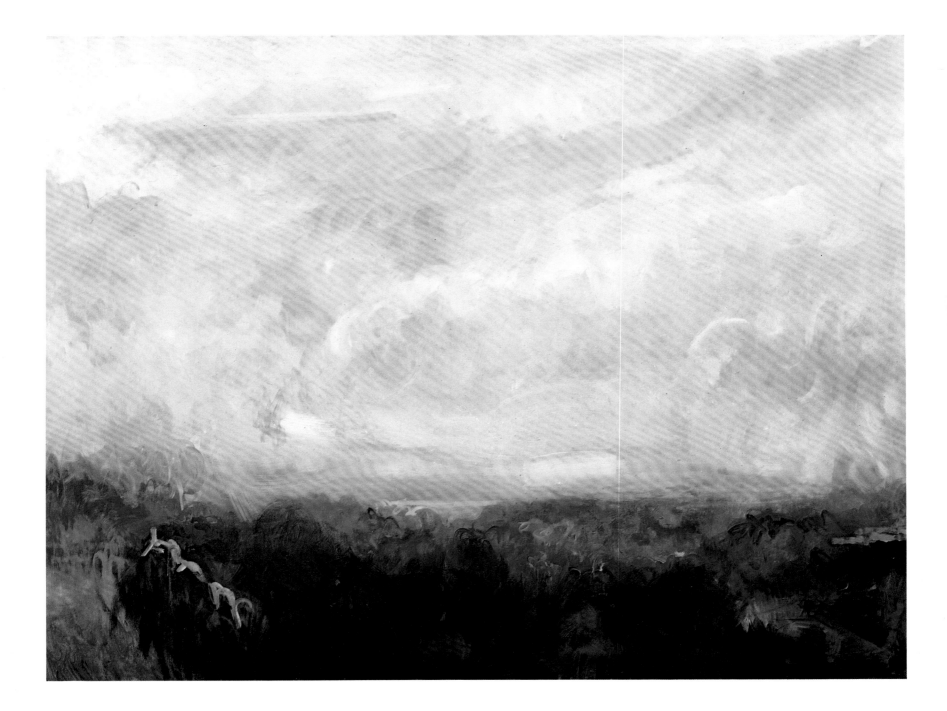

Van Dearing Perrine (1869-1955)

In the late 1800s a little colony of New York landscape painters gathered in Ridgefield, New Jersey, and established a "Barbizon of the Palisades." Deeply committed to the rugged outdoor life, they built bark studios in the woods along the rocky ridge overlooking New York. Van Dearing Perrine, now almost forgotten, joined the group after he finished studying at Cooper Union and built a studio half way down an old ferry road that ran from Englewood Cliffs to the margin of the Hudson River opposite Spuyten Duyvil. Living in lonely isolation, he painted forceful and moving pictures of the sheer rock face behind his home. He was known in his own day as the Thoreau of the Palisades, and wrote eloquently about nature, formulating a world view based on his local observations.

WHEN DARKNESS compels me to lay aside the day's work and with supper over, I ascend the little road beneath the great forehead of rock, now dark and mysterious against the great starry dome where it intersects the milky way almost at the zenith. How tiny the road seems as it winds suddenly around some dark shadow, then as suddenly out again into the starlight. And over there across the river lies the great city. How it deceives the eye with its quiet insignificance. I could draw a hair from my head and holding it at arm's length cover it all from Harlem to the Battery. And now a large neighboring planet moves in and out behind the rocks at the head of my path and all the earth seems to sink beneath me. . . . I leave the road for a shorter cut to the top through a steep dark pass from which I emerge as from a cave in the earth and oh wonder! all of the stars from the east to the west, from the north to the south! . . . almost with fear . . . I watch the mighty night roll westward . . .

Beauty is that which fits into its environment and expresses its character in that relationship. In the middle of a forest a tree grows straight because it is protected by other trees. On the Palisades, a seed finds among the rocks a little soil that the wind has blown or water has washed into a crevice. Awakened by the sun and rain, that seed grows into a dwarfed, twisted tree, leaning out from the face of the cliff. The straight tree of the forest would be out of place there. Gnarled—some might say ugly—that tree expresses the character of its environment . . . its beauty consists in its unity and dramatic cooperation with its surroundings . . .

It is not my purpose to paint the surface of things which all may see, unaided by imagination. To imitate the outward and visible forms of Nature, to paint faithful descriptions of the Palisades, accurate in form and color, is a form of landscape art which does not make the slightest appeal to me. Great rocks, great trees, great rivers of themselves mean very little to me, except as symbols of a great Universal Power, an Eternal Vital Principle, which makes and shapes tree and rock and river equally with myself. It is thus that I feel in this great Power—call it Eternal Motion, if you like—something linking me to all the universe, even to the remotest star, and linking all to myself. When I feel that, I am awed and reverent. The whole world appears to me as one vast miracle, and I am a part of the whole. It is this stupendous miracle of creation which takes possession of my thoughts and compels me to seek some form of expression, as men have sought in all ages. Some have found their means of expression in poetry, others in philosophy; I find mine in painting. . . .

. . . does not the . . . history of the whole world repeat itself anew each day? . . . Contention, always contention. It is that part of Nature's design which makes character. The contention with wind causes the tree to drive her great roots more firmly, more deeply into the earth—and in and through them she draws her life. Life is contention . . . to govern ourselves rightly is to conquer the whole of creation. This much has been beaten into me by the wind and the rain and to it I have said amen.

VAN DEARING PERRINE: PALISADES SNOW, 1907
Collection, Mary Perrine, New Canaan, Connecticut, o/c, 35 x 42.

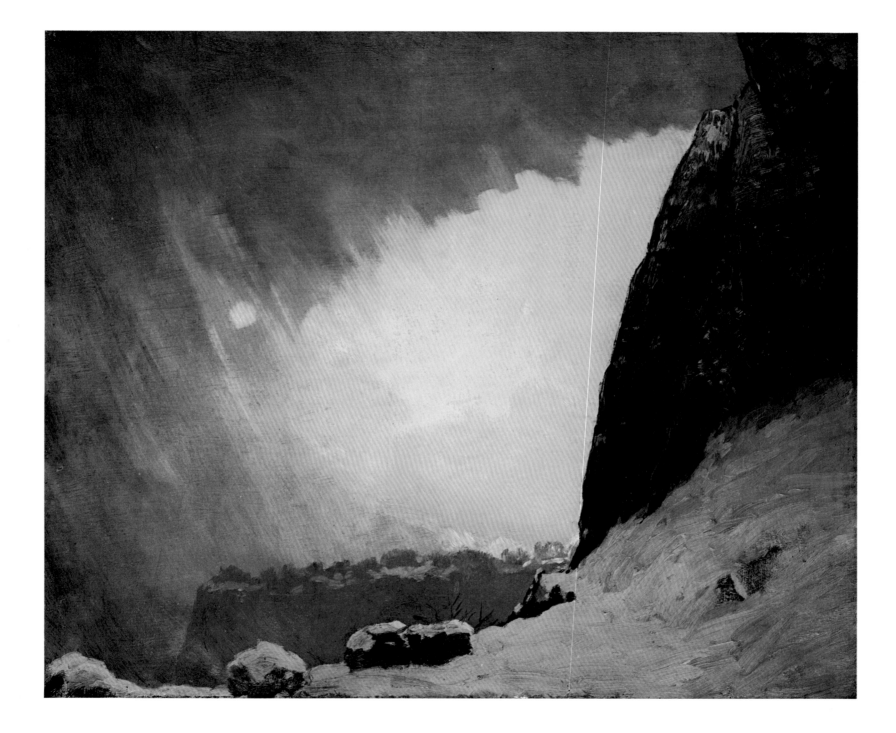

Friends of the Earth in the United States, and sister organizations of the same name in other countries, are working for the preservation, restoration, and more rational use of the earth. We urge people to make more intensive use of the branches of government that society has set up for itself. Within the limits of support given us, we try to represent the public's interest in the environment before administrative and legislative bodies and in court. We add to, and need, the diversity of the conservation front in its vital effort to build greater respect for the earth and its living resources, including man.

We lobby for this idea. We work closely with our sister organizations abroad, and with new and old conservation organizations here and abroad that have saved so much for all of us to work for.

We publish—books, like this, and in smaller format—because of our belief in the power of the book and also to help support ourselves. Our environmental newspaper is " Not Man Apart."

If the public press is the fourth estate, perhaps we are the fifth. We speak out for you; we invite your support.

Friends of the Earth Foundation, also in San Francisco, supports the work of Friends of the Earth and organizations like it with projects in litigation and in scientific research, literature, and education.

Publisher's Note: The book is set in Centaur and Arrighi by Mackenzie & Harris Inc., San Francisco. It was lithographed and bound by Arnoldo Mondadori Editore, Verona, on coated paper made by Cartiera Celdit and Bamberger Kaliko Fabrik. The design is by David Brower. The Layout is by Kenneth Brower.